THE ART OF TRAVELING STRANGERS

www.mascotbooks.com

For more information, please contact:

Subplot, an imprint of Mascot Books

620 Herndon Parkway, Suite 320

Herndon, VA 20170

info@mascotbooks.com

Library of Congress Control Number: 2021911449

CPSIA Code: PRV0921A

ISBN-13: 978-1-64543-901-1

Printed in the United States

AUTHOR'S NOTE

This is a work of fiction. Names, characters, and events are the product of the author's imagination or used in a fictitious manner.

The art-historical information in this book, though, is very real, as are the museums, galleries, churches, and other locales. As of the date of this writing, all the venues (except for the Egg and the Eye restaurant in Los Angeles) can still be visited, though some under different names. The Grand Hotel Firenze is now the St. Regis Hotel. The Biffoli Shop near the Florence Cathedral is currently called Aromi Firenze. The Grand Hotel Roma is also a St. Regis Hotel.

All company and/or product names may be trade names, logos, trademarks, and/or registered trademarks and are the property of their respective owners.

To receive a free companion guide
with images of the artworks in this novel, go to:

ZOEDISIGNY.COM/BOOK-COMPANION-GUIDE

The Art of Traveling Strangers

A NOVEL

ZOE DISIGNY

SUBPLOT

For Cruiseman, the wind beneath my wings

You use a glass mirror to see your face;
you use works of art to see your soul.
GEORGE BERNARD SHAW

ONE

THE ODOR—A PECULIAR BLEND of disinfectant, ozone, and jet fuel—tainted the air but enticed me. I liked the smell of escape.

Taking a deep breath, I pressed my head against the cold window and watched Los Angeles shrink below me into a Cubist painting. Those once massive buildings of concrete, glass, and steel were now the abstract geometric shapes of Picasso. I smiled. Life imitating art. That idea had always intrigued me—the belief that art could change our perception of reality. But this time, my attraction to the concept was even stronger. It offered hope. If chaotic LA could transform into a well-designed composition, why couldn't I?

Leaning back in my seat, I embraced the escapist fantasy and pondered the art form I'd want to mimic. Certainly not Cubism. It was too cerebral, and I already spent way too much time in my head. Expressionism was also out—too emotional. But the work of Niki de Saint Phalle struck a chord. She was part of a twentieth-century art movement intent on creating a new reality. I liked that, and I adored her work. She was known for her whimsical sculptures of triumphant women—an art form I'd be happy to emulate. I envisioned myself as one of her creations: an

imposing female figure wearing bold primary colors, lustrous metallic wings, and twirling confidently on tiptoe. But just as that vision began to take hold, a cabin light above me blinked off.

"Ladies and gentlemen, the captain has turned off the No Smoking sign, and you are free to smoke at this time. Please refrain from smoking in the aisles, lavatories, and non-smoking sections of this aircraft. Thank you for your attention and enjoy your flight."

Enjoy my flight. Now that posed a challenge. Although I was grateful to be traveling to Europe, far from the emotional turmoil of home, my getaway plan had a serious flaw: the thirty-something woman seated next to me.

She chewed her gum with mindless enthusiasm while reading the July issue of *Fashion First* magazine, apparently to discover the health benefits of crotchless pantyhose. Her name was Viv Chancey, and I, Claire Markham, a thirty-something myself, would be her art guide in Europe for the next three weeks.

"Ya know, I never thought of it before," Viv said, "but I think they're on to somethin' here. I'm gonna get some. Don't get me wrong. I hate pantyhose. They're just so damned uncomfortable. But sometimes a girl's got no choice, and they're a hell of a lot better than garter belts or girdles. Know what I mean? Remember girdles? So stupid. What teenage girl needed a girdle? But we all bought into it back then, hook, line, and sinker. Ya know, you should get some too. Pantyhose, I mean. The crotchless kind." She turned back to her magazine, looking so pleased to have enlightened me, a response to her call to action seemed unnecessary.

I breathed a silent sigh of relief and returned my attention to the window. My Cubist painting had now morphed into the San Bernardino Mountains, home of Big Bear Lake and my daughter's summer camp. I'd taken Amber to camp only two days earlier. We'd sung her favorite camp songs as we snaked up the mountain: "Make New Friends," "This Land is Your Land," and "My Bonnie Lies over the Ocean." My voice faltered on the last song, an unwelcome reminder that I would be "over

the ocean" soon and far from Amber.

After I'd helped her settle into her cabin, we'd hugged goodbye, and I watched her join her friends in spontaneous jubilation. Her long red hair spiraled in the wind while her blue eyes sparkled mischievously, and her freckled cheeks dimpled as she smiled. With each passing year, we looked more alike, and that thrilled me. I wanted everyone to know I was her mom.

I could see the lake below us now and tried to pinpoint the exact location of her camp, wishing I could parachute down and steal her away. But that was a purely selfish thought. Amber loved being at camp. And I'd already exceeded my lifetime limit for selfishness.

Catching one last glimpse of the lake, I pictured her standing on the shore and squealing as the mountain-cold water splashed her toes. It made me smile. As much as I wished I could reinvent my life, it didn't mean without her. She was the best thing in it.

"Hey," Viv said, "I got lots of stuff to read here. Help yourself." She plopped a stack of magazines on my lap, all fashion rags with people like Brooke Shields and Cindy Crawford on the covers.

"Oh, thank you." I offered a disinterested smile and scanned the glossy covers for a featured article to read. *Clown Makeup Be Gone!* My, what a serious topic. *Ten Things to Do with Your Old Falsies.* Ah, guaranteed titillation with that one. *Is He the Great Pretender?* Oh no, way too close for comfort.

I handed the magazines back to Viv. "Thanks anyway. I think I'll just rest my eyes for a minute." Reclining against the headrest, I took another deep breath, hoping to recapture that earlier whiff of escape.

"Okay, suit yourself. Are ya gonna sleep? It's kinda soon for that, don't you think? The stuff I read about flying says it's best to wait 'til after they serve a meal before ya try to sleep. That way, you won't wake up because you're hungry. I don't sleep good on planes anyway. It's too bumpy. Some people love that, though. I have a friend who flies all the time and thinks the best thing about flying's all the bumps. Can you imagine? Ya wanna chill-pill? It'll help you sleep. I got a bunch if you need one."

"No. What I need is peace and quiet. Do you think you could help me out here?" I immediately regretted my comment. I usually filtered my thoughts better than that.

"Well, aren't you Miss Cranky Pants. I was just trying to help." Viv popped her gum as if adding an exclamation point.

"I'm sorry. I guess I'm a little uptight at the moment. Thank you for your offer, though."

Viv chewed in silence, but not for long.

"Ya know, the pills I got are good for lots a things, not just sleeping. They help bad moods too. They can really take the edge off. Here's one for you just in case."

Viv pressed a small, round tablet into my hand. It reminded me of the pill bottle in my purse. The one Viv's husband gave me right before we left for the airport. The one he said was only a precaution and not to worry. But I hadn't stopped worrying since I got it.

I looked down at the pill in my palm, and a lump rose in my throat. The thought of spending three weeks with Viv in Italy and Paris overwhelmed me. Yes, I was qualified to be her art guide, but not her caretaker. Taking care of myself was hard enough.

For one irrational moment, I wanted to tell Viv everything—everything about my marriage, my mother, and my shattered heart. I wanted her to understand how emotionally vulnerable I felt. But I barely knew her. She was my employer, and I couldn't risk coming off like a basket case. I needed to lock those negative feelings away and stay positive. I excelled at that.

Slipping the pill into my pocket, I noticed that my cuticles were raw from my nervous picking. How did I get here? Things were different before. I wasn't a basket case. I'd led a normal life. A few ups and downs and danger zones to avoid, but I'd learned to navigate them well. At least until my fourteenth wedding anniversary, a year and a half ago. That marked the start of a maelstrom I'd been caught in ever since. Every time I thought I could escape, it scooped me up again.

TWO

"**ISN'T THIS PLACE CUTE?** The *Beachfront Bugle* calls Café Piccolo the best up-and-coming restaurant in town. And it's so close to our house." I surveyed the garden terrace with its trickling fountain and candlelit tables, hoping Kurt would approve.

"Sure, it's fine," he said, eyeing the menu. His smooth, angular face looked like carved marble in the shadowy light.

"You don't think it's going to be too cold, do you? I could have made reservations inside, but I thought outside would be more romantic."

"It's fine, Claire."

I handed him an envelope. "Happy anniversary."

He looked up, surprised. "Should I open it now?"

"Of course, open it," I said, bouncing in my chair with excitement.

Kurt opened the envelope slowly as if to tease me. I couldn't wait. "It's tickets—one for the PGA Championship Tournament and one for your flight." I beamed at him. I never knew what to get for Kurt. He had such specific tastes. But this time I knew I'd bought the ideal gift.

"Wow, thanks, Button. This is so thoughtful." He slid the tickets back in the envelope and reached across the table to pat my hand. "But you know, if everything goes the way I'm hoping, we won't be living here

in August."

"What?"

"Not to worry, though. We'll just need to change the plane ticket, that's all."

"What do you mean we won't be living here?"

"Well"—he looked pleased with himself—"I hesitated to say anything before, but things are going so well with my sporting goods store right now, I think it's safe to say we could be living in Dubois by August. Happy anniversary!"

My heart sank. I knew this could happen, but I never thought it would. I should have objected to a business in Wyoming the minute he brought it up. But he was so excited. And I didn't want to burst his bubble. Didn't want to make waves either. It was easier to hope this pipe dream would dissolve on its own than to contradict Kurt.

"Wow. That's . . . quite a surprise." I could feel my hands begin to fidget. "I don't know what to say."

"Well, you could start with 'congratulations.'"

"Yes, of course, congratulations, but"—I swallowed—"I don't want to move to Wyoming. We're established here."

For the first years of our marriage, I had followed Kurt wherever his employment took him and never objected. I liked the excitement of moving and enjoyed my new role as a supportive wife—something I knew he needed. Kurt's work was hard on him, or perhaps I should say Kurt was hard on himself. My mission was to bolster his spirits and show him his worth—something his parents never did. I felt sure with enough love, he would blossom.

I wanted only two things in life besides Kurt—my own career and a family. Given our gypsy lifestyle, I put my vocation on hold and focused on a baby. But now that we'd settled down—or so I thought—it was time to pursue my profession.

Kurt stared at the envelope on the table, creasing its flap with origami precision. His lips pressed tightly together like the folds in the paper. His grimace alone should have warned me—now was not the time to

plead my case. But he'd caught me off guard, and I couldn't stop myself.

"What about my job? You know how hard it was for me to get that tenure track position at the college. If we leave, I'll have to start all over again. And there's no guarantee I'd even find a job in Wyoming. Art history professors are not exactly in demand." My voice cracked as it rose to a higher pitch. "This is a problem for me. We need to talk about this. Please."

"There's nothing to talk about, Claire. You've pulled this stunt way too many times—acting like everything's fine until all of a sudden it's not. I can't read your mind. You know full well how much this means to me, and you never said a thing about wanting to stay here until now. And now is too late. But you are right about one thing. This *is* your problem." He stood up, aligning the carefully crimped envelope with the table edge. "So you're going to have to figure this one out on your own."

I watched him walk out of the restaurant with the slow, deliberate steps he took when trying to control his anger. My stomach tightened into a familiar knot. But maybe he had a right to be mad. I'd never objected to moving before, so how was he supposed to know what I felt about Wyoming if I never told him? Did I always do that—pretend things were fine when they weren't? Did I really expect him to read my mind, or did I simply want him to be sensitive to my needs? And was that the same thing?

As I lingered in the restaurant, my thoughts kept going in circles. And even though sitting alone at our table for two made me feel self-conscious, I didn't want to leave—not then for home and never to live in Wyoming. There had to be another option.

But the only alternative I could come up with was to live apart and travel back and forth to see each other. I'd heard that kind of arrangement could be exciting and even rekindle the romance in a marriage. But I knew Kurt would never go for it. Keeping two households would be too expensive, traveling back and forth would take too much effort, and he'd never let me out of his sight for that long. So I tried to be more open to the idea of moving. But the more I thought about it, the more

resolute I became about staying put. I had waited so long and worked so hard to get where I was in my job, I could not—would not—throw it all away now.

When I told my colleague and best friend, Mara Bellamy, about my dilemma, she suggested I go to therapy. She'd gone to see a psychologist when her marriage fell apart, and she said he was a tremendous help. I balked at the idea. My marriage wasn't falling apart, and I certainly didn't need a therapist. I needed options. But after days of getting the silent treatment from Kurt, nights with no sleep, and no solution in sight, I asked Mara for her therapist's name. She was thrilled to be able to help and said I would love Dr. Alexander McPherson.

I told Kurt my plan, and he seemed relieved that I was dealing with the situation by going to see a shrink. I guess he thought that took the pressure off of him to talk about it. I, though, felt wary. I had no idea what to expect from therapy, but since I'd hit a wall with Kurt, I decided I had nothing to lose.

～

Waiting to be called into the doctor's inner office, I flipped through his magazines and began to doubt the wisdom of being there. What could a shrink possibly do to solve my problem? I threw the magazines back on the table and got up to stretch. Moving always helped me think. Maybe the doctor could give me strategies to get Kurt to talk. That alone would make the visit worthwhile. I smirked, recalling Mara's comment about Kurt's communication skills. Talking to Kurt, she said, made her feel like a courtroom lawyer cross-examining an unwilling witness.

"Come in," Dr. McPherson said. "May I call you by your first name?"
I nodded.

"Okay, great. Please sit down, Claire." He gestured toward the couch before sitting in the armchair facing it. I knew he intended for the arrangement to appear conversational, but it felt confrontational to me. It only lacked an interrogation lamp.

The cold leather couch sent a chill through my body on contact, and I crossed my arms over my chest. Scanning the room to avoid the doctor's eyes, I noticed a tall mahogany cabinet crammed with books and a large window, its light softened by cream-colored sheers. A small ink drawing beside the window depicted a man and woman reclining together in a loving embrace while being transported over a village by a winged horse. I recognized the artist as Chagall.

"Tell me why you're here, Claire."

Although I'd agreed that Dr. McPherson could use my first name, it annoyed me when he did. It seemed phony, like now we were pals, and I should have felt comfortable divulging all. But I didn't. I felt manipulated.

"Is that a Chagall?" I asked.

"Yes, it is. Do you like it?"

"Yes, a lot." I got up for a closer look, an unusually bold move on my part, but it was meant to signal that I was calling the shots, not him.

Unlike the images in most doctors' offices, this drawing was an original. A nice personal and revealing touch. The good doctor appeared to be a romantic. But looking at it longer, I came up with a different perspective. Maybe the work's true purpose was to send subliminal vibes to the couples he counseled.

I returned to the couch and considered the doctor. He looked nothing like Kurt. He seemed more like the sensitive type—slight of build; sweet, almost effeminate face; and disheveled blond hair, as if he ran his hands through it too often. He was nice-looking in an understated kind of way. Soulful-looking.

"I'm glad that piece pleases you," he said, undisturbed by my bid for control. "I take it as a good sign when my clients notice it. To me, the work is all about trust. The man and woman embrace, trusting themselves in each other's arms, but they make an even bigger leap of faith. They trust the horse to fly them safely where they want to go." He stopped for a moment to look at the drawing. "For counseling to work, there must be that kind of trust. My clients need to feel safe in my care. They have to believe that I can help them achieve their goals."

I knew it. The artwork functioned purely as a manipulative ploy.

"Do you feel safe enough with me, Claire, to tell me what you'd like to accomplish with therapy?"

I didn't, but I felt . . . something. Not safety or trust—something else—something I couldn't identify, but it compelled me to admit what I wanted to deny.

"My marriage is a mess, Dr. McPherson."

"I'm sorry to hear that," he said, his eyes filled with concern. "It sounds like you need couples counseling. And please, call me Alec."

"There's no way my husband will do counseling. Can't you work with just me?" I stopped short of using the doctor's first name—much too chummy.

"I can, but it won't be as effective if your goal is to improve your marriage. Have you asked your husband if he'll do counseling with you?"

"No, I already know he won't."

"Oh, that's too bad."

What did that mean? I thought. *Too bad Kurt wouldn't do counseling, or too bad I answered for him without asking first?* I pulled my skirt self-consciously over my knees.

"So, without your husband here, what are you hoping to gain from individual counseling?"

"I don't know . . . sanity, I guess." I gave a nervous laugh and picked at my fingers.

Dr. McPherson didn't smile. "Why do you say that?"

"I'm just kidding." Couldn't the man tell when someone was joking?

He still didn't smile. Instead, he slid his fingers across his lips, in a way that was both thoughtful and sensual, appearing in no hurry to say anything.

"I think I'm frustrated," I finally blurted out.

"Okay, then, let's talk about that. What's making you frustrated?"

I wanted to say *he* made me frustrated, but I held back. I was paying for this and decided I should at least try to get something out of it. "I'm frustrated with my husband. He won't talk to me."

"He won't talk to you at all, or just about certain topics?"

"No, he talks, some, but not about the elephant in the room. He wants to move to Wyoming, and I don't."

"Okay. What happens when you share your feelings with him about this move?"

"He told me it's a done deal, and I have to face it."

"How does that make you feel?"

"Frustrated, like I said."

"And what do you do with those frustrated feelings? How do you express them?"

"What do I do? Nothing. What can I do? He already said what he thinks, so there's nothing more for him to say, I guess. It's frustrating to me, sure, but I can see his point."

"What about your point, Claire? You have a point too."

"Yes, well, he doesn't think so."

"And how does that make you feel?"

"Like I said, frustrated. Are we going in circles here?"

During the silence that followed, I twisted in my seat, suddenly unable to find a comfortable position, until his voice interrupted my squirming.

"Do you ever yell at him? Stomp your feet? Storm out?"

"No," I said with indignation, wondering what kind of unhinged neurotic he took me for.

"Do you pout or withhold affection?"

"Well, I guess I pout, but so does he." No way would I admit to withholding affection. "I'm not sure where you're going with this, Dr. McPherson."

He looked at me with the softest eyes I'd ever seen on a man. "You say you feel frustrated, but from your responses, it sounds like you're intellectualizing your feelings rather than allowing yourself to feel them." He rubbed his lips again. "How often do you get angry, Claire?"

I bristled at the question. "Anger is a waste of energy, a totally nonproductive emotion. It just makes people do crazy things."

I cast my eyes to the floor, far from his gaze. What was I doing there?

"I'm not going back to that guy," I told Kurt when he came home from work that evening.

"What guy?"

"The shrink."

"Not a good fit, huh? Well, there are lots of therapists out there. I'm sure you'll find one that works."

"Yes, I suppose." I dragged my feet into the kitchen to start dinner. Cooking had never been my strong suit, even on a good day.

I scanned the contents of the pantry, refrigerator, and freezer. Nothing inspired me. I could have fixed macaroni and cheese—our favorite family comfort food—but even that left me feeling cold.

As a last resort, I pulled out the only cookbook I owned, *The Joy of Cooking*, and flipped through the pages for a recipe. But instead of seeing words, I saw Dr. McPherson's soft blue eyes and his fingers gliding lightly across his lips.

THREE

"**WHERE WAS ALL THAT** advice I paid for, those great words of wisdom?" I asked Mara the next day in our office. "All we did was go in circles."

"What are you talking about?" Mara said, glancing up from the slides on the light table. The eerie glow below her chin made her look like a fortune teller in a penny arcade booth.

"My session with Dr. McPherson. It was a total waste of time. The man has no sense of humor, and I don't think he likes me. When I said I knew Kurt wouldn't go to counseling even without asking him, I think Dr. McPherson judged me, sized me up as a controlling wife."

"Whoa, Claire, that's a leap. Lots of wives know what their husbands want without asking. And besides, you're not exactly what I'd call a controlling wife. Just the opposite."

"Well, maybe," I admitted. "But I expected more. When I told him I was frustrated, he told me I was intellectualizing my feelings instead of feeling them. What's that supposed to mean?"

"Well, he does have a point there. You *are* an expert at hiding your negative emotions. The way you say you're upset about something is how other people say, 'pass the salt.' You're a master at presenting the

facts, but not at showing your darker side. And anyway, therapy takes time. Be patient. He truly *is* an excellent therapist."

I didn't want to hear that Dr. McPherson was an excellent therapist. I wanted to find someone else.

But I never bothered looking. I also never bothered canceling the appointment I had with him the following week or the ones I had after that. Over the next few months, the doctor and I built a rapport. I learned that he had three kids, loved to cook, and was an avid art collector. By spring, I was calling him Alec.

"Do you remember when I asked you about anger in our first session?" Alec said as I sat in my usual spot on his couch.

"Yes."

"Do you remember saying it was a nonproductive emotion?"

"Yes. I know I said something like that, and it's true."

"Everyone gets angry, Claire, and I think your negative feelings about anger keep you from showing it. But that can be as nonproductive as expressing it inappropriately."

"How can I show anger when I don't feel it?" I was eager to keep the exchange going. I had come to appreciate his insights, and I loved the way our conversations inspired me to think.

Alec looked down at the floor and moved his fingers across his mouth in thought. His averted eyes gave me a chance to openly study that now-familiar gesture and enjoy the full sensuality of it.

He looked back up, catching my gaze and holding it. "I'd like to do some guided imagery with you, if that's okay."

"What's that?"

"It's an exercise that focuses on the use of mental pictures to get in touch with one's true self. It's based on the concept of mind-body connection. Do you want to try it?"

"Okay, what do I do?"

"I want you to lean back and close your eyes," Alec said in a soft voice that coated my senses like honey. "Now, I want you to visualize a specific time in the past when you got angry. Maybe when you were a little girl, or maybe later. And once that scene is clearly fixed in your mind with all its details, I want you to feel that anger, explore its energy, and then control it by taking several deep breaths until you can let it go."

He paused, allowing me to sink back into my past. I could see nothing that made me angry. Instead, I found myself fixated on the way he smelled—like Dial soap.

He must have sensed I needed more guidance. "If you're struggling to visualize anger, try to imagine a specific time you felt provoked or maybe resentful, even a little bit." I heard him inhale through his nose and exhale slowly through his mouth ... again ... and again. I felt myself floating on his breath. Time disappeared.

"Where are you, Claire? Bring it into focus. How old are you? What do your shoes look like? Are you wearing any jewelry?"

I fingered my wedding ring and saw myself in my platform sandals and one of my favorite outfits from when I was first married—a bright yellow dress with long bell sleeves and a short, flared skirt.

"Is it daytime or nighttime? Are you inside or out? What does it smell like, sound like? Maybe you're in a car ..."

Yes, in a car. Kurt and I were driving home from a party.

"Actions speak louder than words," Kurt said. "You can talk all you want, but that doesn't do shit."

Kurt drove erratically. He was drunk and mad at me, disapproving of my behavior at the party. I'd been laughing and talking and dancing while he slouched alone on the living room sofa, drinking Scotch. The livelier I became, the quieter Kurt got. I was probably too loud and maybe too flirty, but it was all in fun. I didn't realize my behavior was out of control—*his* control.

"What about the Declaration of Independence?" I argued, my voice rising. "You can't say those words didn't do something." I crossed my arms and thrust my back against the seat. I had no idea how we got on this subject. I only knew he'd yanked me from a fun party, and I was mad too.

"Don't raise your voice at me." He switched to a low, threatening tone. "Don't you ever raise your voice at me again."

I started to say something but thought better of it. Kurt was seething. His jaw clenched. We drove on in silence.

"Hey, you," Kurt shouted through the windshield. "What're you doing?"

We were about to pull into our driveway, but a man walked in front of it. Kurt slammed on the brakes and jumped out of the car, leaving it running in the street with the door open. Throwing a single punch, he knocked the startled stranger to the ground.

"Get off my property. Now."

The man scrambled to his feet and ran. Kurt got back in the car and lurched it into the driveway. I sat perfectly still. Had that innocent man taken a hit meant for me? My body went cold.

Kurt shut off the engine and turned my way. His upper lip stretched tight across his teeth, his words measured. "And don't you say a goddamn thing."

I gasped. Where was I?

Alec flew from his chair and dropped to his knees beside me. "It's okay, Claire. You're okay. Take deep breaths." He watched me closely, running his hands through his hair. "There you go. Feel better now?"

I nodded, seeing my distress reflected in his eyes.

"I'm so sorry. That exercise was meant to help you, not scare you." He fingered his hair again.

"We need to talk about what just happened here, what frightened you.

But only when you're ready."

I looked at his sorrowful expression and felt a sudden urge to hold his sweet face in my hands. "I don't want to talk about it," I said with a shiver.

"Are you chilled? Can I get you some tea or coffee? There's a kitchen down the hall."

"Yes, thank you. Hot tea would be nice." I needed a moment alone to replace that disturbing memory with a pleasant one, as I always did.

Alec returned minutes later with my tea and pinned me with his eyes. "Are you afraid of your husband?"

Cradling the cup with both hands, I took a sip and dodged the question. "It's hard to say what I'm afraid of. It's just a feeling I get sometimes." I sipped my tea again. "But you know, it's funny you should mention my husband. While you were gone, I was thinking about him and how he likes to surprise me. One time in college, we broke up at the end of the school year, and we both went home for the summer. He lived locally, but I lived in Chicago.

"Anyway, I came back to my parents' house one evening, and there he was in the living room with a giant bouquet of flowers and the most adorable sheepish grin you ever saw. Without a penny to his name, he managed to fly all the way from Los Angeles to Chicago just to win me back. He said he would do anything to make it right again."

I took another sip of tea as the charming image of Kurt erased the frightening one, and I hoped my story would satisfy Alec. I didn't need to talk about my fear of Kurt. That incident in the car happened years ago, and I saw no reason to talk about it now. Yes, Kurt could still be scary, but I'd learned how to handle it. As long as I didn't cross him, I had nothing to fear.

"You know," I said, looking into Alec's eyes, "he really does love me."

Alec held my gaze. "Do you love him?"

I wasn't expecting that, and I giggled awkwardly before finding an answer.

"Yes, I think I do. But it's complicated. We've hurt each other so much over the years. I sometimes wonder if there's any real love left under all

the scars or if it's just the scars that are holding us together."

"Experiences both good and bad do provide the glue for a relationship," Alec said. "But it's up to the partners to decide how that glue's working. Do you see it as keeping you stuck or keeping you whole? It's your perception that matters."

I gave the question some thought. "Right now, today? I'm feeling stuck, but I don't always feel that way." I looked down at my lap, smoothing nonexistent wrinkles from my skirt.

"Okay, let's do this. What made you fall in love with Kurt in the first place? Try to bring those feelings back."

"Well, since I was only sixteen when we met, I guess I fell in love like a teenager does."

"And how's that?" Alec asked, his gaze penetrating mine.

"Blindly," I said.

He smiled.

"No, I mean that. I know they say all love is blind, but when you're sixteen, love really *is* blind, or maybe the word I'm looking for is superficial. I fell head-over-heels for a storybook prince, not a real person. I was infatuated with the fantasy of him, impressed because I thought other people were impressed. He was tall, handsome, and hit home runs. What more could a sixteen-year-old girl want? He was perfect." I gave Alec a pathetic smile. "It never occurred to me that no one was perfect, that I wasn't supposed to be perfect, and that love was more than looking good together."

Hearing my words play back in my head, I added with a sigh, "And it's taken me all this time to figure that out. What an idiot I am."

"You're not an idiot, Claire. Be kind to yourself. Are you still trying to be that perfect person you thought you were supposed to be?"

"Well, if I am, I'm failing dismally. It seems no matter what I do, I can't make Kurt happy."

"No, you can't. Only he can do that. You need to focus on yourself. What makes *you* happy, Claire?"

"I don't know what makes me happy anymore." I ran my finger across

my thumb, searching for a hangnail to flay. "My daughter, certainly. But other than that? My job. It's sure not my marriage. That just reminds me what a failure I am."

Alec looked at me with tenderness. "You're not a failure, Claire. You're a smart, caring, accomplished woman. You're also a strong woman, but you don't see yourself that way."

He leaned forward in his chair and for a moment I thought he would hug me, but he placed his palms flat on his thighs instead. Was he holding himself down, trying to stop the urge to touch me? My face flushed. He was so supportive and warm. So unlike Kurt. I looked down at his long, sensitive fingers then quickly to the floor, far from the promise of his wedding ring.

FOUR

THE ENTIRE NEXT WEEK, I kept imagining Alec looking into my eyes and wanting to hug me—in line at the grocery store, driving Amber to soccer practice, and even in my classroom while replacing the slide projector bulb. The recurring image made my spine tingle as if fingernails were skimming along my vertebrae. The sensation spread throughout my body like the tiny bursting bubbles of the finest French Champagne, infusing me with a drunken, carefree buoyancy.

That week, life felt effortless, no matter what came my way. On Monday afternoon, Amber had yet to start her science project that was due Tuesday. Stay up until two in the morning to finish it for her? Easy. On Wednesday, I took Kurt's car keys to work by mistake, and he needed to drive to the airport to catch a flight. Cancel my class midstream to race home in time for him to dash off in a fit of rage? Piece of cake.

Not until Friday, when I parked my car outside Alec's office for my weekly session, did my buoyancy turn to butterflies—my innocent week-long fantasy feeling less chaste by the second and more troubling.

I walked from my car in slow motion. The butterflies now tickled the base of my throat, and I swallowed hard before opening his reception-room door. Although I usually sat, I didn't this time. I was too nervous.

As Alec guided me into his office, my sleeve brushed against his arm, making my skin prickle with excitement. I felt foolish, like a student with a hopeless crush on my teacher. I knew what it was like to be the teacher in that situation, and I always sympathized with the lovestruck pupil the way a caring parent might. Perhaps, Alec felt like that toward me now. Could he tell I was smitten?

I walked to the couch and sat with my knees together, my feet flat on the floor, and my hands folded neatly in my lap—the erect posture of a prim schoolgirl.

Alec eyed me, a determined expression on his face. "I've been doing quite a bit of thinking lately about your therapy, and I believe we've made some significant progress over the past few months, don't you?"

I nodded, puzzled. This was not the way we usually started our sessions.

"It's something to be proud of," he went on. "You've not only acknowl-edged that you're frustrated in your marriage, but that you have trouble feeling anger, that you struggle with the need to be perfect, and that sometimes you feel like a failure. The fact that you can now recognize these aspects in yourself and are willing to address them is a huge step forward, and I'd like to see that progress continue."

I nodded again, wondering why he felt the sudden urge to list my accomplishments like a summary of his latest clinical study.

"As I'm sure you know," he continued, "my job as your therapist is to ensure that you get excellent care." He paused to lick his lips. "But I no longer believe I'm the right therapist to give you that care."

What was he talking about?

"Please know, I've given this a great deal of thought, and I will do everything I can to help you move on." He folded his hands in his lap and looked at me patiently, like a kindly old grandfather.

I stared back at him. My jaw dropped. Was he dumping me?

"There's another therapist I can recommend," he said, filling in the silence. "Her name's Suzanne, and I truly believe at this stage in your therapy, she's a better match for you than I am. Let me get you her information.

He *was* dumping me!

"Here you go." He handed me Suzanne's card and continued talking, but his words ran together in my mind—words like "positive" and "for the best" and "happiness."

"Claire? Claire?" I glanced up, realizing I'd frozen in place, staring at Suzanne's business card. Alec was looking at me with that concerned-grandfather expression again. "I sense that you're sad about all this," he said. "Would you like to share with me what you're feeling right now?" I shook my head.

"Okay. I see you're going to need time to process this, and I completely understand that you may not be ready to talk about it yet. That's fine. But please feel free to set up another session with me when you are ready. I'd like to help you work through this transition if you need me. I'm sure you'll come to see this was the right decision. And I honestly believe Suzanne is an excellent fit for you, should you choose to go with her." He extended his hand with unfamiliar formality.

I took it, feeling none of the delight I'd expected from holding his hand. Instead, I felt like I'd stepped onto the set of *The Twilight Zone.*

"It has been a pleasure being your therapist, Claire." He opened the door. "And please don't hesitate to reach out to me if you need to. Goodbye for now, and all the best to you."

Walking to my car, I felt even more like a schoolgirl than before, and my initial hurt feelings shifted to indignation. *How dare he dismiss me!* I slammed my car door and smashed my foot on the accelerator, peeling out of the parking lot. Alec was right—everyone got angry, and I was *not* intellectualizing this time.

For the next two weeks, I felt disjointed. I snapped at Amber for no reason, only to immediately apologize. I groused incessantly to Mara about the quality of our students' work—a role she traditionally played. And I despaired over Kurt's moody silences—not that he noticed. But

worst of all, I couldn't stop thinking about Alec. I vacillated between resenting him and missing him.

As the days progressed, I discovered all kinds of things I missed about him—the way he fingered his mouth and ran his hands through his hair, the soothing sound of his voice, and the kindness in his eyes. But I also missed the intimacy of our conversations. I had told him things I'd never told anyone, and I sensed he not only understood my feelings but shared them. I missed his quirky sense of humor, too, and his love of words.

"We often perceive responsibility as a burden," I remembered him saying, "but if you analyze the word, it actually means the ability to respond. And isn't that something we all want to do—respond?"

I missed the way he looked at me when he spoke and the logic of his thoughts once spoken. Basically, I missed his whole being. And it infuriated me.

On Saturday morning, at the end of the second week without Alec's therapy, I woke from a frustrating dream. I would run toward a cliff with the intent of flying, but when I lifted off, I'd plunge, awaken with a jolt, and fall back asleep to start again. Now completely awake, I turned the thwarted feelings from my dream into a new determination to succeed—not at flying, but in my marriage.

Stepping into the shower and gasping from the first sting of its heat, I had an epiphany. I didn't need a therapist. I simply needed to put more energy into my relationship. Dumping half a bottle of shampoo on my head, I worked my hair and myself into a lather. What did therapists know, anyway? They were all a bunch of quacks. Kurt and I just needed some quality alone time. That was the answer. I turned the water on full force, determined to rinse the soap and my frustrations down the drain.

Later that morning, as I gathered the plates for our traditional weekend waffles, I turned to Kurt and put my plan into action. "Since Amber's going to Disneyland today for Sarah's birthday, why don't you and I do something fun ourselves?"

I watched the fragrant steam escape from the waffle iron and, in its ghostly swirls, envisioned Kurt and me embracing like the couple in

Alec's Chagall drawing.

"That's not fair," Amber whined. "You never do anything fun when I'm around."

"You know that's not true, pumpkin." I coaxed a waffle onto Amber's plate. "We do lots of fun things together, but today it can be just Daddy and me for a change." I looked over at my husband. "What do you think, Kurt?"

"Huh?" Kurt said, balancing on the back legs of his chair, his head buried in the sports section of the *LA Times*.

"Let's go on an outing today, a bike ride, maybe. Wouldn't that be fun?"

"Can't," he said. "My knee's been giving me tons of trouble lately. Riding a bike's one of the worst things I could do."

"Okay, how about a stroll on the beach? We could walk to the pier for lunch. Isn't walking supposed to be good for your knees?"

"You know I can't stroll. Walking at a slow pace like that totally screws up my back."

"Well, what do you want to do, then?"

"Watch the Angels on TV. They're playing at one today."

"Oh."

"And anyway, I invited Ken to come over and watch the game with me. I didn't think you'd mind." He looked up briefly from the paper.

"No, that's fine." I flopped a waffle on his plate and shoved it in front of him. "Here."

Grabbing the calendar section of the newspaper, I plunked down at the table no longer hungry.

Amber tugged on my sleeve. "Mom, it's time to go."

"Oh, okay." I looked over at Kurt, and my sullen mood turned to active resentment. He was doing exactly what he wanted. Amber was doing what she wanted. And me?

I grabbed my purse and Amber's hand. "We're leaving," I said without turning around. "I've got errands to run and won't be back until later. Sarah's folks will bring Amber home after Disneyland."

Kurt uttered a faint "um-hmm" as I closed the door behind me.

I sat in my car for a minute before leaving Sarah's house and watched the girls hop in circles on the front lawn until they tumbled to the ground with the giggles. As I drove away, I envied their carefree abandon and couldn't remember the last time I'd felt such joy.

Meandering through Sarah's neighborhood, I breathed in the beauty of the blooming jacaranda trees laced high above the streets. Their brilliant lavender canopies made the whole community look like a wedding venue. As the opulent display scattered petals around my car like purple snowflakes, I heard Alec's voice in my head: *What makes you happy, Claire?*

I pondered the question and gave myself the same answer I'd given him. I didn't know. I didn't even know what would make me happy for one afternoon.

Heading toward the freeways, I took the first on-ramp I saw—the northbound 405—and drove in the fast lane on autopilot until I noticed several drivers flipping me off. I'd been so consumed with my pity party that I hadn't realized how slow I'd been going. I quickly changed lanes and chided myself for my poor freeway etiquette and my "poor me" attitude while my stomach chimed in to scold me for not eating breakfast.

I know, I thought, *I'll go to The Egg and the Eye. Perfect. I haven't been there in years.*

My spirits lifted as I envisioned the restaurant's menu and the charming Craft and Folk Art Museum on the ground floor. I smiled. This really would make me happy.

After a brief look at the exhibit, I climbed the steep stairs to The Egg and the Eye, pledging to revisit the gallery once I'd satisfied my complaining stomach. Getting in line to put my name on the waiting list, I scanned the busy restaurant and admired the colorful crowd. I loved

people-watching, especially people in the arts. They made such bold visual statements. One woman wore a black-and-white polka-dot dress with a red cummerbund, while another wore a yellow-flowered head-scarf and matching glasses. I was still surveying the room and enjoying the show when my whole body seized up. It couldn't be. I looked away and back again. Not possible. My hunger pangs turned to butterflies, and I spun toward the staircase, hoping to escape unseen.

"Claire? Claire Markham, is that you?" His familiar voice made the back of my neck prickle.

"Alec?" I said, pretending to be surprised. "Fancy meeting you here." I was trying to act breezy, but the dated cliché just sounded dumb. I giggled self-consciously. He gave me a warm smile, ignoring my obvious discomfort.

We stood in awkward silence for a moment. "Would you care to join me?" he asked. "I waited half an hour before I got a table. If you put your name on that list now, it'll be lunchtime when you get seated."

I had intended to decline his offer, certain it was merely a polite gesture, when my stomach gave a deep, prolonged moan, as if responding to the news of the extended wait.

Alec laughed. "I take that as a yes." He led me to his table, pulled out my chair, and took the seat facing me, just like he had in therapy. My throat tightened.

"How do you like Suzanne?" he asked.

"Who? Oh, Suzanne. Um . . . I haven't had time to set up an appointment yet. I've been so busy lately." I looked away—my face burning—and changed the subject. "So, how's your practice going?" I winced, remembering the sting of his rejection.

"I quit," he said.

"What?"

"Yep, I quit. It got way too emotionally draining for me, and I felt, I don't know, like I'd lost my touch." He looked pensive for a moment and then smiled. "But I'm a teacher now."

"Really? Just like that?"

"Well, not exactly. I've been teaching psychology classes at night for years so when a full-time position came up at the college, I went for it. I just found out two days ago I got it, so I quit my practice. Well, I'm in the process of quitting anyway." He sounded relieved.

"Congratulations. That doesn't happen every day."

"Yeah, I know. I'm really lucky." He gave me a shy smile and looked around the crowded room. "Don't you just love this place? I come here all the time. Do you come here often?

"No, not nearly as often as I'd like." I toyed with the menu, trying to think of something else to say, something to match his convivial mood and make me seem unfazed by his presence.

"So, what's your favorite omelet here?" He asked.

"Oh, It's hard to choose, but I guess I'd have to say the African omelet. It's just so different, with that curried beef and those dried apricots and apples. I've never seen it on any other menu."

"Hmm . . . well, you're much more adventurous than I am. I'm almost embarrassed to say it, but my favorite is the bacon omelet."

"Ha. You're kidding. Out of fifty omelets with an unheard-of variety of unique ingredients, you like the bacon one best? You *should* be embarrassed." My flippant response surprised me. I sounded like I was talking to a comfortable old pal, not a smoldering old flame who'd dumped me.

"Well," he said thoughtfully, "I guess I could be daring and add something more exotic like . . . oh . . . I don't know . . . American cheese?" He grinned and ducked, pretending to dodge a flying object launched by me.

I laughed at his antics. His playfulness was disarming. Was he trying to make amends for rejecting me? If so, he was doing a good job. As Alec continued to survey the menu, I surveyed him. His hair seemed scruffier than I remembered, in need of a haircut. And his casual clothes, an untucked green safari shirt over baggy brown cargo pants, made him appear ordinary and dull, like my retired next-door neighbor who watched TV all day in the garage. Did I really have a crush on this man? I observed him some more and noticed, for the first time, how his round, wire-rimmed glasses made him look a titch like Benjamin

Franklin. Not even close to a heartthrob.

But it still bothered me that he'd dropped me as a client. I never stepped over any line with him. I'd wanted to but didn't. And he obviously had no amorous feelings for me. I fantasized that he had, but he hadn't. So, what went wrong? I watched him rub his lips as he continued to peruse his menu, but instead of feeling a tingling spine, I felt only rising irritation over being dumped. Why would he do that to me?

Perhaps that guided imagery fiasco when my horrible memory of Kurt resurfaced made him feel inadequate. Or maybe he thought we'd gotten too close as friends, and that created a conflict of interest for him. Of course—I grinned—that must have been it. He couldn't be my friend and my therapist. He had to let me go. But in my muddled state of mind, I had interpreted his professional behavior as a personal rejection. Truth be told, I had no idea what he said to me in that last session. I was too busy feeling jilted. No wonder he acted so friendly toward me now. He thought he'd explained everything. He thought I knew that ending my therapy had nothing to do with rejecting me.

Alec looked up and smiled. It was the smile of a pal, not a paramour, and a rush of relief engulfed me. Not only had my feelings of abandonment flown but so had the butterflies. And they had taken that gnawing sensation of guilt with them.

"Did you look at the art show yet?" Alec asked.

"Only briefly. I'm going to spend more time after breakfast. My stomach wouldn't let me concentrate before."

"Oh, yeah, she was pretty vocal." He chuckled. "Mind if I join you downstairs? I haven't checked it out yet, and I'd love to hear your art historical perspective."

"Well, I'm not sure how much I can contribute. Folk Art isn't my area of expertise. I'm just an appreciator."

"Same here. I love the stuff. It's so raw and honest. The best of it seems to have completely bypassed the artist's critical brain and gone straight to pure expression."

"Well said. That's what speaks to me too." We smiled at each other,

basking in the comfortable camaraderie of our rekindled friendship.

～

I drove home that afternoon with a refreshing sense of well-being. Spending the morning with Alec as a pal totally eclipsed my therapy sessions with him. And I now felt completely certain I didn't need therapy. I never did. I simply needed a male friend, not a psychologist, and definitely not a lover, just someone to talk to with a male perspective.

Understanding the role Alec could play in my life made me see my marriage differently. I realized how naïve I'd been, thinking Kurt could fulfill every need I had and feeling rejected when he didn't. So what if he didn't talk much? So what if he had a bad temper? Nobody was perfect. I needed to appreciate his loyalty and how well he provided for Amber and me instead of expecting the moon and letting an irrational fantasy interfere with my perfectly fine marriage.

After all, Kurt did change his mind about the move to Wyoming. He said the business didn't look as financially viable as he'd thought, and perhaps he should sell. But I felt sure he changed his mind because of me and didn't want to admit it.

Most importantly, though, I knew he loved me, and for that alone, I should have been thankful. All in all, I had no right to complain. If I needed something more from life, it was up to me to make it happen.

Pleased with my solution to the problem, I felt excited to share it with Kurt, thinking he would be proud of me too. But then I changed my mind. Kurt was possessive. He didn't like me having friends of my own, let alone a male friend. In his mind, the purpose of the opposite sex was sex. He'd never comprehend nor condone my interest in having a platonic relationship with a man. So there was only one thing to do—not tell him.

FIVE

WITH BASEBALL SEASON IN full swing, I found it easy to go out on my own for a few hours on the weekends. Kurt enjoyed nothing more than staying home watching TV with a friend. And Amber, more often than not, wanted to play at Sarah's house. She had a pool.

As long as I transported Amber and was home before dark, everything went smoothly. Kurt rarely asked about my outings, but when he did, I told him the truth—except about Alec. And that one little omission worked well. Kurt had no issues with my day trips, and I found it much easier to handle his moodiness with my new friend as an outlet.

Alec and I spent our time together in art museums and galleries, tucked-away parks, and tiny cafés. We never ran out of things to talk about or ideas to share.

"You're kidding me," I said as we stood in the Norton Simon Museum, admiring Romanelli's *Dido and Aeneas*. "You know this story?"

"Of course I do, you doubting Thomasina. Why wouldn't I?"

"Because I show my students this piece all the time, and nobody knows the story."

"Nobody knows Virgil's *Aeneid*? Well, obviously, none of your students went to Oak River Academy. If they had, they would have learned

the story." He lifted his chin, aware his smug, private-school attitude would get to me.

I batted his shirtsleeve. "Okay, smarty-pants, what's the story? I bet you don't know it."

"Well"—he hesitated—"here's what I remember. Aeneas got shipwrecked near Carthage, and Dido helped him out, hoping he'd stick around and run Carthage with her. But when Aeneas got word from the gods that it was time to go found Rome, he left Dido to fulfill his destiny. See—told you I knew the story."

"Well, that's not the whole story. You left out the part about Dido and Aeneas falling in love and living together. You also failed to mention that when Aeneas left, Dido was so heartbroken she climbed onto a funeral pyre and stabbed herself to death."

"Yeah, well, it was high school, and they did tend to avoid topics like, oh . . . you know . . . illicit sex, living in sin, suicide. Things like that."

"But that's the heartbeat of the story." I paused, stifling a grin. "It didn't do them any good anyway."

"It didn't do who any good?"

"Oak River Academy. I've heard about that school, and downplaying sex didn't quite work, did it? I mean, the Oak River girls aren't exactly known for their purity."

"Hey, watch it," he said, pretending to be offended. "Now you've gone too far. And you know what that means?" He gripped my shoulders and looked sternly into my eyes. "You must be punished, the old-fashioned private-school way. Where's my paddle?"

"Oh no, Dr. McPherson, not that." I pressed my hands together and gazed heavenward.

"Okay, maybe later." He laughed. "Let's go have lunch."

I knew something was changing but refused to accept it. I'd built a wall of denial instead. We were simply good friends having fun. But the more we saw each other, the closer we got. Sometimes we even seemed to blend into one person, especially when it came to art. We both believed fervently in the transformative power of art. Alec had

seen firsthand how life changing art therapy could be and how it helped clients identify their feelings, while I could attest to the way studio art classes increased problem-solving skills.

"And yet," I complained, "what are the first classes to be cut when the budget dips? Art classes."

"Right," he agreed. "It amazes me how our educational system dismisses the arts as frivolous when every move an artist makes involves a judgment call. There are no correct answers to be memorized when it comes to creativity." He smiled at me. "But I guess I'm preaching to the choir."

And then there were the sparks, those sharp electrifying sizzles that happened spontaneously in the middle of a meal, a conversation, or an art gallery. They were quick, heart-stopping, and I knew they were mutual, but neither of us acknowledged them.

We didn't acknowledge our spouses, either, except to follow an unspoken agreement to share only the most mundane rituals and innocuous irritations of married life.

"What is so difficult about putting down a toilet seat?"

"I know better than to get in her way when she's on a mission. Nothing will stop her, especially logic."

"Okay, okay, this may be way too picky, but toothpaste tubes have caps for a reason."

On the last weekend in August, as Alec and I sat on a bench in Hancock Park overlooking the La Brea Tar Pits, I—without thinking—broke our tacit agreement.

"You know, when I was in therapy, you asked me if I loved Kurt, and I said I thought I did. Now it's your turn. Do you love Lara?"

Alec sighed, looking at a sculpture of a prehistoric mammoth trapped in bubbling tar.

"Well," he began, "we dated in college and got along great. We both

took psychology and psychoanalyzed each other all the time. She was good at it."

"Objection," I teased. "The witness is avoiding the question." I looked at Alec with mock seriousness. "Do you, sir, or do you not love your wife?"

In the pause that followed, my heart hammered in my ears, like the pounding on a door that should never be opened. I paled. What was I thinking? How could I have been so stupid to ask that?

"When I say she was good at it," Alec continued, oblivious to my blanched face, "I mean she was good at nailing my weaknesses. I was lazy, slow to respond, a dreamer instead of a doer. The list went on and on, and it's not to say that she was totally wrong, but after a while, I felt like a punching bag."

"Oh, that sounds terrible. But I'm sure you straightened all that out once you got married. So tell me, how are your kids doing?"

Alec ignored my question. "The odd thing is, the more she criticized me, the harder I tried. And the harder I tried and fell short, the madder she got. I realized she had a lot of anger inside, and I bore the brunt of it. We were in a downward spiral, and I was gathering the nerve to break up with her when she told me she was pregnant. And that was that. We got married. No child of mine was growing up in a household without a father."

"Oh, Alec, I'm sorry. I should never have asked you that. None of this is my business."

"But you did ask it. And you deserve an honest answer."

"No, it's okay. I don't need to know. I don't want to know." I dropped my eyes and knitted my fingers together on my lap, cradling the knot in my stomach.

Alec put his hands on mine. "The answer is no, Claire. I don't love my wife." He gently separated my clenched fingers. I watched them loosen and open to his touch. As he stroked the flesh of my palms, I raised my eyes to meet his.

"I love you, Claire."

And at that moment, the world went silent. The traffic on Wilshire Boulevard, the children giggling on the lawn behind us, the dogs barking orders on the sidewalk—everything hushed.

I snatched my hands away, and the sounds of reality came roaring back. "You don't mean that. You can't." I blinked quickly, as if trying to bat away his words and keep them from breaching my carefully built wall. "This isn't how . . ."

He cupped my chin in his hands. I stopped protesting, stopped blinking. He drew me closer, caressing my face with his tender gaze until our mouths touched, and my wall crumbled.

I was unprepared for the passion Alec stirred in me—a desire so unexpectedly intense, it blindsided me. This was wrong. I knew it. But my emotions didn't care, and they propelled me—with no regard for my safety—into the eager arms of a man equally starved for affection.

∽

Alec and I met every chance we could, even if only for an hour or so. Anything was better than being apart. We discovered a secluded corner of El Dorado Park, and it became a favorite hideaway. As we nestled there one afternoon, Alec asked, "Do you ever wonder if some things were meant to be?"

It was late October, and the oak trees were turning a seasonal yellow, ignoring the eighty-degree temperatures and dry Santa Ana winds.

"Yes, all the time," I said. "I think we were meant to be." I kissed him softly on the mouth and snuggled against his shoulder. "Is that what you think?"

"I do. But I don't know. It's complicated." He paused for a moment, tracing the freckles on my nose. "Have you ever heard of Joseph Campbell?"

"I have, but I don't know much about him. He's a philosopher, right?"

"He's lots of things, but he's mostly known for his work in comparative mythology and religion. I heard him speak at the Esalen Institute in Big

Sur. You would have loved him. He thinks our biggest mistake as humans is that we sleepwalk through life. We don't stay alert to its possibilities, and they pass us by. He says we need to tap the life within us to find the life we were meant to live and to follow our bliss."

"That's a lovely thought," I said, sitting up to look at him. "I wouldn't say I'm living the life I'm supposed to live right now. But I know the love I have with you is the love I'm meant to have. I always believed love like ours existed. And I knew one day I'd feel it."

Alec smiled. "You're such a Pollyanna, Claire, and I adore that about you."

<p style="text-align:center">⌒</p>

But by December, my Pollyanna shine had tarnished, and I was having a hard time living a lie.

"What's the name of that novel about Michelangelo?" I asked Mara as we sat down in our favorite Mexican restaurant. "You know the one. I think Irving Stone wrote it."

We were celebrating the end of finals week and the close of another year. The restaurant appeared to be celebrating, too, with its multi-colored serapes decorating the food tables, wide-brimmed sombreros doubling as lampshades, and brightly colored, papier-mâché piñatas hanging from the ceiling above the bar. Unlike the restaurant, though, I was not in a festive mood.

"*The Agony and the Ecstasy*," Mara said. "Why?"

"Yeah, that's it, and that's me. I'm in ecstasy with Alec but in agony over our situation."

"Relax. Conflicting feelings are perfectly normal. You just have to go with it and let things work themselves out on their own. Your problem is you think too much." Catching sight of the waiter, Mara shot her hand straight above her head, waving frantically. "Excuse me! Excuse me. Could we have two margaritas here, please? With salt? Yes, thank you." She turned back to me. "Okay, where were we?"

"I think too much," I said, frowning at Mara's cheery face. "But I feel awful and so dishonest. It's not fair to anyone. This has been going on for four months. And I'm sure Kurt suspects something."

I picked at my cuticles, not ready to hear my next pronouncement. "I have to leave Kurt, but I'm scared to."

Mara cocked her head. "You're scared to leave, or you're scared of Kurt?"

"Both."

"I can see how leaving would be scary—the unknown and everything. But why are you scared of Kurt? It seems you've always been afraid of him somehow. And I don't get that. To me, he's just a puffed-up blow-fish." Mara giggled. "Remember that huge Kermit the Frog balloon from the Thanksgiving Day Parade last year? It got punctured by a tree limb and shriveled its way down the parade route. I bet if you poked Kurt, he'd deflate just like that."

"Believe me. He's no harmless balloon."

"What's that supposed to mean?"

"Oh, nothing. It's . . ." I glanced around the room, searching for a reason to change the subject, but Mara was not about to let me slide.

"It's what, that he's a bully? Damn right, he's a bully. And you're a perfect victim. Are you even aware of how you act around him? You're like a Stepford wife. With me, you're talkative and opinionated. With him, you're timid as a mouse. You act like his servant instead of his wife. What's with that?"

"I do not. I just try to make him happy. That's what wives are supposed to do." I stopped, remembering Alec's words: *only he can do that.* I qualified my statement. "At least, that's what I thought wives were supposed to do."

"Well, forget that. He's not happy no matter what you do, so you might as well do what you want." Mara raised her dark brows. "I mean, what's the worst that could happen? He pouts?" She thrust her lower lip forward in an exaggerated sulk. "He leaves you?" She shrugged. "Well, that's what you say you want. So, really, what *is* the worst that could happen?"

Mara reached across the table to touch my wrist. "But are you sure you want to break up with Kurt? What does Alec say about all this?"

"Oh, he feels the same way I do. He wants a divorce too." I stabbed at the salsa with a chip, unable to keep "the worst that could happen" from my mind.

"You know I like Alec, but have you thought this through? You get the best of a man when it's an affair. Think about it. When you're with Alec now, he's focused one hundred percent on you. He's on his best behavior. You can bet that's not the case when he's with his wife. Things could be very different if you had Alec full time. Have you considered you might have the best of both worlds right now with Kurt and Alec?"

I admired Mara, a true free spirit—nothing like me. She followed her every emotion, responding to life's challenges spontaneously and reveling in their unpredictable jolts, like a bull rider in a rodeo. She encouraged me to do the same, but I wasn't that spontaneous and not at all fond of rodeos.

"I know you're trying to help me, Mara, but I'm not you. I can't love two people at once. And I know Alec and I only have stolen moments now, but with him it's different. It's not about the thrill of forbidden fruit. I've never met anyone I'm this compatible with. We talk all the time about everything—philosophy, psychology, art . . ."

"Okay, okay. Just be careful. I'd hate to see you get hurt."

But there was no avoiding it. The hurt had already begun. I woke every morning plagued by guilt and gripped by the fear that my indiscretions would be discovered. Only in Alec's company could I glimpse the other side of my dread—the happiness that awaited us. I knew I had to end my marriage. And I imagined a thousand parting scenarios. But I couldn't bring myself to do it. I was too scared.

SIX

THE RINGING WALL PHONE disrupted my worried thoughts. January had come and gone, and I still hadn't left Kurt. I sat alone in the kitchen. The lecture notes for my upcoming class spread across the table in front of me.

The phone rang again.

"Hello? What? No! Oh, my God. Is someone with you? Hold tight. I'll be right there." I grabbed my keys and bolted for the door.

The call came from my father. That morning on their driveway, two weeks short of her sixtieth birthday, my mother had dropped dead. And as far as I knew, she'd been in perfect health.

Speeding through the Long Beach streets to the freeway, I could think of only one thing—what to wear to her funeral. A bizarre first thought for anyone, but even stranger for someone like me who had little interest in fashion. Mentally perusing my closet, I visualized my new velvet jacket and remembered how my mother disliked it.

❦

"Get with it, Mom. Even I know velvet's in."

"I don't care if velvet's in or not," she said. "You look like a velvet Elvis painting in that thing."

"I do not! I think I look like one of those sexy women in the Black Velvet Whisky ads." I tossed my hair and struck the pose of a runway model.

"Fine, suit yourself," she said, her hands raised in defeat. "You always do."

⌒

I shook my head to clear the memory. What an odd thing to think about. Instead of collapsing in sorrow, I rehashed trivia.

Turning into my parents' retirement community, I wound slowly through the empty streets, passing rows of precisely manicured yards with identical one-story stucco homes. I pulled into my parents' driveway, expecting it to look different somehow. But it didn't. There was no hint that my mother had died there. No heart-wrenching sign of a life extinguished without warning. Instead, it seemed like she'd never been there at all—never been anywhere.

"What do you think, Mom? Should I wear my velvet jacket to your funeral?" I fell silent, waiting for the tears to come, waiting for a sickening swell of grief to engulf me. But it didn't happen.

⌒

As The Poseidon Solution's boat splashed through the waves, taking my mom's ashes out to sea, my family huddled at the stern.

Kurt stood next to my father, his hand on my dad's back—a caring gesture he was making just for me. I was crazy about my dad. Kurt wasn't. Seeing the two of them together, though, warmed my heart, and I thought how phenomenal Kurt had been from the moment my mom had died, offering to help in any way he could.

But that was Kurt. He came alive in a crisis, and I used to think of him as a white knight, galloping in at the perfect moment to assume the role of hero. I hadn't imagined him like that for years. But seeing his kindness toward my traumatized dad moved me to nostalgia, and I wished for a moment I could put him back on that white horse and make everything fine again. But I couldn't. Too much had happened.

I stood between Amber and my older sister, Bergie—a flight attendant living in New York. She'd flown in immediately upon the news of our mother's death to take charge of everything, as I knew she would. Bergie wasn't her real name. I just called her that—short for the nickname Dad had given her—Ompsie-Berger. Our father called me Smooie-Pooie. We both agreed that Bergie got the better name.

"I couldn't have done this without you," I said, pressing my cheek against her shoulder.

Bergie looked at me and smiled, her eyes wet with tears. "And I wouldn't have let you. You would have been a disaster."

I elbowed her, acting offended, while a familiar feeling of comfort enveloped me. As a kid, Bergie had been my closest friend, not because we had so much in common but because we had so *little* in common—no competition. Bergie loved to cook, sew, shop, and read detective stories. I read All About Books and had no interest in cooking, sewing, or shopping. We felt close not only because of our unspoken non-compete clause but because of Bergie's skill as a wildly entertaining benevolent dictator. Even though everything had to be her way, it was always fun. In the world of my childhood, Bergie seemed larger than life, and I felt safe—both then and now—with her around.

The boat slowed, and I reached for Amber's hand. She moved closer, wrapping her free arm around my waist. Amber was a hugger, and my body responded with the same flood of warmth to her every embrace. When not actively hugging someone, she was more than likely doing cartwheels. I found her love of life inspiring and her boundless energy staggering. Releasing me from one last squeeze, she dropped her arm back to her side and stared quietly into the water. Seeing her so still seemed odd.

"Are you okay?" I asked, leaning down to her ear. "You don't feel seasick, do you?" She shook her head. "What are you thinking?"

"Sarah said when they used to bury people at sea, they stitched them up in canvas bags and sewed the last stitch through their noses to make sure they were really dead."

I scrunched my face at the disturbing image and tried to reassure her. "Well, that's not going to happen to Mema. She was cremated, you know."

"Yeah, I know."

"Is that upsetting to you?"

"No, it just means she'll be fish food that much faster."

Even in my own state of denial, Amber's matter-of-fact indifference to her mema's demise shocked me. I had heard that kids her age looked at death more with curiosity than sadness, and I knew she hadn't been close to her grandmother—who preferred discipline to doting—but I still expected her to show some kind of sorrow.

I stared at the water along with Amber, and my mind began to drift. Maybe the whole concept of death went beyond her comprehension. It had certainly gone beyond mine the last time death swooped into our family, three years before Amber was born. I tried to push that horrific memory away, but it pushed back, tearing me apart once more.

"Bergie, come get me," I pleaded through the phone. "I can't reach Kurt, and I think I'm in labor. But it's way too soon. Something's horribly wrong."

Shortly after reaching the hospital, I gave birth to a baby girl. The staff whisked her away to an incubator and transferred me to a standard room—sterile and cold.

"It's a girl," I said when Kurt arrived. "They took her away."

"I know. I already talked to the doctor and went to see her."

"Isn't she beautiful? She's so tiny and delicate, like a snowflake. I want

to call her Noel." I played the sound of her name over in my head.

"But they say she's not fully developed inside. Did they tell you that? Did they tell you she has severe complications?"

I searched his eyes, wishing with all my heart he would say I was wrong, that I'd misunderstood, and that she was fine. But he said nothing.

"What does that even mean, 'severe complications'? It sounds so mechanical. She's not a robot, for God's sake. She's a baby. *Our* baby." I looked down at my fingers, tormenting my nails.

Kurt sat next to the bed, calming my agitated hands with his. "The doctor told me they want to airlift her to Children's Hospital. They don't have the resources she needs here."

The doctor had told me the same thing, but I'd pushed it out of my mind. It was too frightening to think about.

"But she's going to be okay, right? He told me it'll be a long haul and several operations, but everything's fixable if she's strong enough. He told you that, too, right?"

Kurt nodded and looked away. We sat in silence, lost in our separate thoughts, waiting to hear when Noel would be airlifted. If there was one thing we'd perfected in our marriage, it was the art of not talking. But even without words, I knew we felt the same—frightened.

When the doctor finally entered the room, Kurt and I looked up expectantly. He came over to the bed and put his hand on my arm.

"She didn't make it," he said softly. "I'm so sorry." His face was lined with concern, his eyes tired.

"It's for the best," Kurt said, standing up to shake his hand. "Thank you. We know you did all you could."

"I'm sorry," the doctor said again. But I could barely hear him. I felt like I'd sunk underwater, as if the room had changed to a liquid and now floated in slow, nauseous circles around me. I struggled for air, but there was none. Some brutal force had crushed my lungs and clamped my heart in a merciless grip. Nurses swooped in like seagulls, flying about my bed in a white blur. Finally, the pain in my chest subsided, and I caught my breath.

"Feel better now?" one nurse asked.

I nodded.

"Good. You're going to be okay. It wasn't a heart attack. It was your chest muscles contracting in a spasm and squeezing the air from your lungs."

I shut my eyes. Just a spasm squeezing the air from my lungs. And all the joy from my heart. I looked over at Kurt and tried to speak but couldn't—my throat sandpaper, my heart dust. I kept seeing Noel's little face and hearing Kurt's words: *it's for the best.*

The gray sky darkened along with my thoughts, and I glanced across the boat at Kurt. It hadn't occurred to me before, but at that moment, I realized precisely when he'd stopped being my white knight—when he fell off that horse for good. I shuddered and pulled Amber close as the captain began to speak.

"We gather together today not only to mourn the loss of Emma Louise but to celebrate life. In this tender time of grief, it's important to remember how precious life is and that we all need to live our own lives to the fullest and hold sacred the time God has given each of us here on Earth."

I whispered to Bergie, my voice bitter, "This is baloney. No one ever called her Emma Louise. He didn't even bother to do his homework. He's just going through the motions."

Bergie hugged me, her body quaking with mute sobs. I put my arm around her waist, wanting to comfort her. But more than that, I wanted to feel what she felt.

Shivering in the damp winds blowing off the water, I continued to observe the captain's lackluster performance, deciding it was unfair to criticize him. I was no more emotionally involved in the process than he was. Perhaps that's why his service bothered me so much. It made my own disconnectedness all too clear.

The wind picked up as the captain prepared to lower my mother's

ashes into the sea. I wrapped my arms tightly around my velvet jacket and silently watched him. I watched my family. And I watched the remnants of my mother slip into the soulless, gray-black ocean that, for some chilling reason, made me think of the River Styx in Dante's *Inferno*.

"What's wrong with me?" I asked Mara two weeks after the funeral. "I should feel something by now. I know denial is the first stage of grief, but I should be beyond that. Where's the sadness, the anger?"

"It'll come," Mara reassured me.

"But you know," I said, "it's more than that. It's not only feelings. It's memories. I don't remember her."

"What? Of course you do. You've talked about your mom lots of times."

"Yes, but that was all recent. I can't remember my mother from my childhood."

"You're kidding, right?"

"No, I'm not. I never gave it any thought before she died, but now when I try to recall my childhood with her, I draw a blank."

Mara knit her brows. I knew how strange this must have sounded, especially to her. Mara's mother had died years ago, and she seemed to remember everything about her, placing her on a pedestal and living her life with her mom's words in mind. How comforting it must have been to feel that constant, loving guidance.

"I don't know what to tell you, Claire. Maybe get out some old photo albums. That should trigger something. And, anyway, this is probably part of being in shock. Your mom died so suddenly." She gave my hand a reassuring squeeze. "It's going to be okay, sweetie. I'm sure of it."

I went home that day after my last class and began searching old family albums, hoping a photo would trigger a flashback. There weren't many of my mother and even fewer of the two of us together. One black-and-white image showed my mom, my sister, and me smiling sweetly on a

narrow residential sidewalk. Both my mother and sister wore tailored pencil skirts while I sported layers of petticoats peeking out under my dress like the fluffy edges of stacked pancakes. I appeared to be about six, but I didn't remember the picture being taken or even where we were. Frustrated by my lack of progress, I set the album down on the coffee table and called my aunt in Kentucky.

"Hi, Aunt Ginny. What can you tell me about Mom?" I should have said "how are you" first, but the purpose of my call embarrassed me, and I wanted to get it over with.

"Well," my aunt began, "your mom and I were never close. I was so much older, and I think she disapproved of me. She was very proper, and I was a bit of a wild child. Of course, our parents didn't help things. They made her attend the same local college I did and join the same sorority. She wanted to go away to college and be her own person but never got a chance."

"But I mean . . ." I hesitated. It felt odd asking for memories that should have been mine. "What was she like when I was little?"

"Well, you know, we didn't see each other much after college and even less once we both had kids. She was so busy with you girls and teaching. I don't know how she did it sometimes, especially with your dad gone as much as he was."

"Okay, well, thanks for your help, Aunt Ginny. Talk to you again soon."

Not the results I'd hoped for. But what did I hope for? I looked down at the photo album on the coffee table. Stories. I wanted stories about my childhood with my mom. I wanted to feel something for her, feel guided by her.

I called Bergie. "Do you remember anything about Mom?"

"What do you mean?"

"I mean, what memories do you have of her from when we were kids?"

Bergie paused. "I don't know. Nothing specific comes to mind at the moment, but of course I have memories. I mostly remember getting in trouble and you sneaking into my room to console me. Do you remember that?"

"I do. But I only remember you and me in your room. I don't remember Mom."

After a few more failed reminiscences, we said our goodbyes. I hung up the phone and tortured my thumbnail, feeling like an M. C. Escher print—like one of his interlocking designs where each shape defines the next. But my Escher print had a few shapes missing, throwing the entire composition askew. Looking down again at the photo album, I wanted to cry.

What kind of daughter grows up not remembering her mother?

SEVEN

A MONTH TO THE DAY after my mother's funeral, Kurt and I separated. The timing couldn't have been worse, but I thought I'd prepared myself. I felt sure the hardest part would be saying those fateful words, "I want a divorce." I feared his reaction and knew I'd need all my strength to get through that. But the rest, I'd told myself, would transpire as a matter of course, like the predictable division of amoeba cells.

I was wrong. Nothing went the way I'd imagined. How could it? How could ending fifteen years of marriage and breaking up a family go as planned?

"Hi, I'm home," I called, walking through the door after my Getty Museum field trip in Malibu. "Kurt, you here?"

No response. He must have been playing golf. It was a perfect March afternoon to be outside, and I planned to go out myself to do some gardening before getting Amber. March was my favorite month. The sun started setting after seven p.m. The air remained winter-crisp but warmer, and the foggy days of late spring were still two months away.

I climbed the stairs to our bedroom. The afternoon sun streamed in through the windows, creating brilliant geometric patterns on the plank

floor. I pulled my blue cotton dress over my head, draped it on the back of the antique rocker, and sat down to kick off my heels. I didn't have to wear high heels to work, but I wore them anyway. They made me feel more confident. I'd been teaching college for seven years but, sometimes, I felt like an imposter bound to be discovered one day. And even though I consistently received high ratings as a teacher, the more I taught, the more critical I became of my skills. As the saying goes, "The more you know, the more you know you don't know."

I leaned back in the rocker, feeling it sway beneath me, and reminisced about Amber as a baby. I breastfed her in that chair every two hours for months, mesmerized by her perfection and aware of how lucky I was to have her.

Running my hands with nostalgic pleasure along the polished arms of the rocker, I caught a faint smell of lemon oil. The housekeeper must have come. I yawned, recalling how early I'd gotten up that morning. Perhaps a short nap before gardening.

But wait. It was Saturday. Our housekeeper didn't come on Saturdays. So why did it smell like she'd been there? I scanned the room. It looked spotless. Then I noticed a piece of lined white paper with a short, handwritten message placed squarely in the center of the bed. The handwriting was Kurt's.

I can't do this anymore.

You want something else? Have at it.

But that rosy life you're looking for? It doesn't exist.

Roses have thorns.

And I won't be around to stop the bleeding.

Happy now, Button?

I reread the note, this time hearing the bitterness behind the words, especially his use of my pet name—Button—spit out like dirt.

"Oh my God . . . oh *my* God." I leaned against the bed to steady myself. "He's gone."

My gaze flew around the room, searching for some other sign of his absence, and I noticed that everything on his bedside table was gone

too. My heart leaped to my throat. Throwing the note on the floor, I rushed to the closet. My side was undisturbed, but his side was stripped bare. I ran to the bathroom. His end of the vanity was spotless, the sink carefully scrubbed, the chrome faucets gleaming. Even his mirror sparkled as if he'd never brushed his teeth or splashed his face in front of it. I threw open his medicine cabinet. No shaver. No deodorant. No comb. I couldn't even smell him. The scent of chlorine was too pungent. He had tried to erase all traces of himself, undoubtedly hoping I would feel the emptiness without him. My mouth went dry.

On the other side of the vanity next to my sink, I noticed my diaphragm case, the only object sitting out on the shiny tiles. He'd clearly placed it there to unnerve me. When I reached over to put it away, it sprang open. My hands flew to my mouth, and I dropped the plastic case and its contents into the sink. The smooth rubber diaphragm cap, designed to thwart pregnancy, had been perforated with two carefully punched holes and one smoothly cut slit. Together they formed a smiley face. I stared at it. The face went in and out of focus. I heard a laugh—a slow, building, demented cackle. It was me. I'd snapped. This was all too absurd for my rational mind to grasp. I rubbed my eyes and looked again at the meticulously violated diaphragm.

"You sick son of a bitch," I muttered.

Returning to the bedroom, I put on my robe and slippers and padded down the stairs to the living room. My stomach roiled—exactly what he wanted me to feel, unsettled in my own home. He was trying to intimidate me, make me afraid to be alone. I began to pace, wishing Amber were there, but I still had an hour before picking her up.

I stopped. Oh, God—Amber. What would I tell her? This figured into his plan too. He wanted to make it as difficult for me as he possibly could, make me think I couldn't handle it, make me beg him to come home.

I started pacing again, my head swimming, until a wall piece caught my eye—our wedding invitation. I'd framed it when we came back from our honeymoon, and it had hung in that same spot for fifteen years. But

something looked different. On closer inspection, I saw the invitation had been altered, torn into tiny pieces, and reassembled back into the frame with each ragged edge slightly askew. I knew he didn't think I'd notice it right away. He'd intended the symbolic desecration as a heart-rending surprise for later, a reminder of what had been destroyed. I shivered. I could see him doing this. I could see him doing all of this in that methodical manner he adopted when he got angry.

Whenever I thought of the word "premeditated," I thought of Kurt's slow boil, how calm and deliberate he became, controlled and focused, funneling his seething emotions into carefully calculated moves. He kept himself from exploding that way, from hitting something or someone. But it didn't always work.

I went to the kitchen for a glass of water and plunked down at the table. My hands trembled. Although I'd been visualizing life without him for months, I couldn't believe it had finally happened. And it felt nothing like I thought it would. I expected to feel relieved and free to be myself. But as I sat at the table in the silent stillness of that afternoon, I felt uncertain and overwhelmed by a melancholy awakening to my own mortality. I was thirty-six and starting all over. I looked at Amber's artwork on the refrigerator. Starting all over as a single mom.

"Beware of what you wish for, kiddo," I said aloud. The wisdom of the cliché boxed my ears and filled me with dread. I tilted my head back, my breaths shallow. What had I done?

After a while, I sat up straight, sucked in a deep draught of air, and, with new determination, raised my glass. "You're going to be fine, Claire. You're going to be just fine."

I stayed in the kitchen until it was time to get Amber, my thoughts free-falling. Kurt had entered my life twenty years ago, but our first date remained as clear to me as the day it had happened. I was sixteen; he was one year older.

"Hi," I said, opening the door and smiling up at Kurt's clean-cut face. He reminded me of the Marlboro man, only without the cigarette, of course. None of the athletes in our high school smoked.

"Are you ready?" he asked, looking down at me with a shy smile, his chestnut hair combed in a thick wave above his jade-green eyes. He was impeccably dressed. A starched blue shirt tucked precisely under a brown belt accentuated his trim waist and, by contrast, his broad shoulders. The crisp vertical creases in his khakis echoed his posture. And although he attempted to hide his nervousness—the little-boy vulnerability behind his manly façade—I sensed it anyway, and it made him irresistible to me.

"Yep, I'm ready," I said, still beaming. "Mom, Dad, I'm leaving. Be back by ten."

We walked to the car without talking. I felt petite and sheltered with Kurt towering above me, completely protected from harm, the way I'd felt as a young girl with my dad.

Although this marked our first official date, Kurt and I shared the same biology class at school and had been eyeing each other all semester. The sexual charge between us was formidable, connecting us from the very start more powerfully than words ever would.

I hadn't asked Kurt about our destination that night. And he didn't say. But when we drove up to the North Woods Inn—that cozy log-cabin restaurant with the fake-snow roof—I felt confused. The North Woods Inn had been designated by all the high schoolers as that special place you took your sweetheart, your one-and-only, not just a date. I searched Kurt's face for clues. He smiled and took my hand, announcing to me and the world—without saying a word—that I belonged to him.

My mind floated forward to the present, and I chuckled at my innocence back then, my total blindness to being railroaded. He never asked me to be his steady girl. His actions simply decreed it. But at the time, it

felt romantic—a bold declaration of affection from such a bashful boy. I couldn't have been more thrilled if he'd hired an airplane to fly overhead with a banner reading, "I love you, Claire." How could I resist such a grand gesture? Kurt Markham—the most desirable boy on campus—had picked me.

Ha. How things had changed. At sixteen, I'd hit the jackpot. And now, at thirty-six, I'd gambled it all away.

EIGHT

"WHAT'S GOING ON, MARA? Why is everything happening at once? My mom dies, my marriage ends, and now this? It's too much. I needed that job. And besides, work is the only thing holding me together right now." I sighed into the phone, staring at my gloomy reflection in the night-blackened window.

It was May, and I'd just learned that my summer class had been canceled due to low enrollment. This had never happened before. And I adored those classes. Every July, I left the classrooms, textbooks, and slides behind to teach art history in Europe. Although I knew nothing about where to shop, eat, stay, or catch the local action, I knew about art, and it was art that sustained me.

Standing in front of my favorite masterpieces, I felt transported to a world far from my own—a sensual paradise where colors, textures, lines, and shapes created music without sound and stories without words. A realm where history came to life and artists' lives became history. A secret place that spoke to me like no other and one that could never hurt me.

"Seriously, what am I going to do all summer? It's too late to pick up another summer class. Amber will be away at camp"—I paused—"and,

of course, Kurt's gone for good." That was the first time I'd said *gone for good* out loud. The words echoed in my head, tinny and hollow like empty soup cans clanking down the road.

"Wait a minute," Mara said. "Was that regret in your voice? You don't want him back do you?"

"No, it's not that. It's . . . I don't know . . . it's hard to explain."

"Well, try me."

I closed my eyes, seeing myself as one of those lone tumbleweeds blowing aimlessly across the road. "It's just that I've never lived on my own before. Of course, I do have Amber, but that's different. She's my child—my responsibility. And sometimes, all I do is worry."

Even though I believed I was better off without Kurt, being a single mom overwhelmed me. And although I knew I'd brought it on myself, I didn't know how ill-equipped I was for the job, or any of the things happening to me, for that matter.

"I mean, what if I can't make ends meet? I thought I could, but without summer pay, what if I can't? I'll be alone *and* broke."

"There's nothing wrong with being alone, Claire. Once you get used to it, you might even like it. Look at me. I'm perfectly happy living by myself."

"But it's more than that. It's Amber. Is she going to get through this okay? She seems fine, but who knows. She never sees or even talks to her dad. He always has some excuse why he can't be with her. It's heartbreaking. I think he's ignoring her to make it harder on me. How could he be so cold? And there's nothing I can do about it."

"Hon, Amber's going to be fine, but I'm not so sure about you."

I kept going, steamrolling over Mara's input. "And then there's my mom. We were never close. And I didn't like how strict she was with Amber. But it seems like everywhere I go, I see mothers with their grown daughters, and my heart aches. That could have been us. I should have spent more time with her, been more attentive. But now our story's over, and I still can't remember most of it. All I've got are the final chapters. The rest of the book is blank."

"It's only been a few months, sweetie. You're still in shock. Give it time. Your memories are in shock too."

"Yeah, I suppose, but you know the worst part? Alec. I hardly see him. It drives me wild. At least if I were in Europe, there'd be an ocean between us, and I'd have a distraction."

I doodled on the notepad by the phone—two winged hearts pierced with fishhooks. Ever since Kurt left, my longing for Alec had intensified. Our affair now approached eleven months, and I felt I needed him more than ever. He completed me. Nothing worked without him.

"Listen to yourself, Claire. You've made a married man the center of your world. You deserve better than that."

"I know. I can't help it. I'm in love with him." I sighed. "But you're right. I've got to get my act together. I could die tomorrow."

"Okay, now you sound like a drama queen. Everything'll be fine. You'll see."

"Yeah, well, thanks for the encouraging words."

I hung up the phone and caught myself fingering my ragged nails again. "Enough!" Shaking my hands, I noticed their flapping reflection in the window, along with my haggard face.

"Come on," I told my double, "it can't be all that bad. Staying home this summer will be good for you. Think of it as an opportunity. You can finally do something about your screwed-up life."

The face in the glass stuck out its tongue.

"Now, now, none of that negativity. We need to rise above. What we need is an improvement plan."

I moved closer to the window, hoping to see a more enlightened person looking back. But she wasn't there.

"I know"—I gave myself a wry grin—"I could read *Smart Women, Foolish Choices* or write letters to my inner child.

"Wait, I've got it." My voice oozed sarcasm. "I could make an appointment with that nice Dr. Alexander McPherson. That would solve everything . . . oh, God, this is never going to work."

The next day, I met with my handful of students and gave them the bad news: their class in Italy had been canceled. With the anticipated trip only two months away, they responded with the same shock and disappointment that I had. All except one—Scarlett. She'd never enrolled in my classes before, so I only recognized her as a new face and a new name on the roster. Apparently, she'd heard about the trip from the advertising flyer and had decided to sign up. The class was open access.

Scarlett stayed behind that day after the rest of the students had left. She was a tall, robust, pleasant-faced woman with explosive dark brown hair curling around her shoulders. She looked only slightly younger than I was and wore a gray, oversized, off-the-shoulder sweatshirt, black stirrup pants, and shocking pink leg warmers with black high heels. I knew the movie *Flashdance* had inspired her outfit, but it still puzzled me. Why would anyone in Southern California wear leg warmers as street clothes in May, let alone with high heels? I never understood that one.

Scarlett walked over to my desk, smacking her chewing gum until I looked up. "My husband will pay you to take me to Europe," she said, her words tumbling over each other, her dark chocolate eyes wide with excitement.

"Pardon me?"

"No, really. He knows how much I wanna go to Europe and how I've been counting on this trip. You got no idea how much I've counted on this trip. And Tom, he's such a sweetie. He'll do anything for me, but he's super protective and won't let me go with just anyone. That's why I signed up with you. He thinks teachers are a good bet, and it took me forever to find your class, so I can't give it up now. It's primo for me. It's got practically everything—Milan, Rome, Venice, Florence. Of course, Paris would be nice too, but that's okay. I'm dyin' to go to Italy, and I've already got a babysitter lined up for my son, Jason, so that's not a problem." Scarlett stopped, pummeling her gum with an energy

that made her large hoop earrings bounce.

I stared at her for a moment, trying to sort out her rapid-fire words. Did she honestly think I could teach the class for her alone? She clearly didn't understand how the program worked. It needed at least twenty students just to cover expenses. That's why the class had been canceled in the first place. Didn't she get that?

"Well, that's a lovely offer, but it simply won't work." I stood up and ushered her out the door.

"Have a nice summer, Scarlett. And who knows, maybe the class will be offered again next year."

"I'm Viv."

"Excuse me?"

"I go by my middle name, Vivien. My mother, she was cuckoo over *Gone with the Wind*, so she named me Scarlett Vivien. Isn't that nutso? I like Vivien better than Scarlett, don't you? I mean, Scarlett was so vain in that movie, and Vivien Leigh, well, she was just so classy. She married Laurence Olivier. I mean, it doesn't get better than that. But you can call me Viv. Everybody else does. And my husband really will pay you to take me to Europe."

"Okay, Viv," I said, baffled again by her runaway words. "I've got your phone number right here on the roster. I'll let you know if anything changes. Have a good summer."

On my way home that afternoon, I bought a package of Wafers-N-Cream cookies and planned to eat them all, knowing full well they would make me sick. But I didn't care. I already felt sick. Dunking my first cookie in a glass of milk, I called Mara.

"Well, I told them," I said, devouring the cookie and grabbing another. "I told my students the class was canceled. You should have seen their faces. They looked like I feel."

"So sorry, Claire. It's a shame, really, and such rotten timing for you. You just can't seem to get a break."

"I know. But listen to this. One new student came up afterward and said her husband would pay me to teach the class just for her in Europe."

"You're kidding."

"Nope, that's what she said. But I'm sure her husband has no idea what that means, and that's assuming he even offered it at all."

"Why do you say that?"

"Well, she seemed a little ditzy. And what husband in his right mind would go for such a thing, anyway? The costs would be astronomical compared to the original trip. The whole idea is ridiculous."

"But what if it's not?" Mara said.

"What?"

"What if it's not ridiculous? What if her husband is ultra-wealthy and he's willing to pay anything to make his wife happy?"

"That's absurd. Why would she join my class in the first place, then? Why wouldn't he take her to Europe himself?"

"Well, I think the answer to that is obvious. Sure, he could take her to Europe, but I doubt he's an art historian, and she signed up for an art history class. So that must be her thing. He's just trying to give her the quality educational experience she wants."

"No, Mara, you don't get it. Even if what you're saying is true—highly unlikely—the college would never go for it. You know that. They can't go for it. You're as unrealistic as she is."

"Well, maybe you're right. I just wanted something to work out for you."

"I know, and I appreciate it. But something working out for me right now doesn't seem to be in the cards."

I hung up the phone and returned to my cookies and milk. As long as I concentrated on the crunch of the wafers and the smooth texture of the filling, I could keep myself from sinking.

The phone rang.

"Okay, how about this?" Mara said. "Cut out the middlemen. Forget the college and the tour company. Take her on your own. That would cost him less, and you might make more. And with only one student, it'd be a snap."

Just the thought of teaching one person threw me into a panic. "No,

it wouldn't be a snap. It'd be a nightmare. I'm terrible with strangers one-on-one. It's the reason I've never been a tutor. I'm a lecturer. Give me a big impersonal group any day. I could pontificate to them until I'm blue in the face. But one single, solitary stranger? I couldn't do it. I'd be tongue-tied."

"Give yourself some credit," Mara said in her cheerleader voice. "You're better one-on-one than you realize. I've seen you in student conferences."

I pushed Mara's pep talk aside. "But it's much more than that. What about the logistics of all this? There'd be no organizational structure from the college to back me up, no support staff handling the planning and all those daily details, and no one onsite for troubleshooting. I'd be responsible for all of that on top of teaching."

"So what?" Mara challenged. "So what if you're in charge and have to make all the arrangements yourself? You can do that. You've taken students to Europe for years. Sure, you always had support, but you know what needs to be done."

I shook my head. "Do you realize I'd be on duty all day, every day with absolutely no break from this complete stranger? I mean, we'd be joined at the hip." I envisioned Tweedledum and Tweedledee, hobbling through Italy with legs tied together for a three-legged race. "I can tell you right now, sweetie, it's not a pretty sight."

"Trust yourself, Claire. You'll be fine. And besides, what's the worst that could happen?"

"Ahhh." I smiled. "I believe, the last time you said *that*, I was headed for divorce."

Mara laughed. "Well, think about it—what *is* the worst that could happen?"

Following Mara's advice, I spent the rest of the afternoon thinking about the worst and concluded—once I'd decimated the bag of cookies—that the trip was a bad idea. Taking a neophyte through Italy all by myself was a huge responsibility. What if she wandered off and got lost in the tangled alleyways of Venice or fell on the cobblestones in Florence and

broke her ankle? What if the gypsies in Rome stole her passport? I alone would be liable. I couldn't risk it. Yes, I needed the money, but if I were frugal, I felt sure I could make it until my fall paychecks.

I sat on the sofa, convinced I'd made the right decision and miserable about it at the same time. Looking around the room, I tried again to imagine being home for the summer—without a job and alone with myself. I heard the antique clock ticking in the hallway and the refrigerator humming in the kitchen. I noticed a thin line of dirt on the baseboards and a tiny crack in the wall above the window. I curled up on the couch in a fetal position. The refrigerator stopped humming, but the clock ticked louder. Turning over on my back, I looked up at the ceiling, and the room began to shrink. My chest filled with feathers, and my breaths came fast and shallow. A familiar craving gnawed at my heart. I called Alec.

NINE

WE MET AT THE Dreamytime Motel—not the classy or romantic setting I would have preferred, but he was with me, and nothing else mattered. The minute I saw him, the minute he stepped across the threshold, the suffocating feathers in my chest vanished, and my breathing deepened as if I were trying to breathe him in, hold him within me forever.

We crashed together, and the props of reality melted away. Nothing existed except us, not the room, not the bed, nothing. We lay together enmeshed in each other's arms, naked and warm, allowing no space to come between our bodies as we nuzzled and kissed, caressed and probed, emboldened by the primal sounds of our raw pleasure. We undulated over and under each other in a spontaneous ballet—our bodies rising and falling to the same instinctive rhythm, a desperate searching, a longing for fulfillment over and over again.

Deliciously exhausted and aware of the parameters of my own body once more, I looked at Alec, feeling both deep contentment and an uncontrollable giddiness. Life was good. No, life was great!

"A quart low, were you?" I teased. "That was amazing." I kissed his

cheek. "*You* are amazing. I think this calls for a celebration."

I reached into the ice chest I'd placed beside the bed and popped a bottle of Champagne, pouring each of us a glass. "Here's to us and our unbelievable love."

"Yes, unbelievable."

We clinked glasses and leaned back against the headboard, sipping our celebratory bubbles. "It's remarkable how you center me," I said. "A few hours ago, I was ready to throw in the towel, and now I could take on the world."

"You center me too."

He downed the rest of his Champagne, and I poured him another glass. "So, any idea when you might be able to get away again?" I tried to sound nonchalant, but I already ached from the thought of being apart.

"No," he said, gulping a mouthful of Champagne. "But I *do* have something to tell you. Something important."

"Okay."

I set my glass on the bedside table and adjusted to his serious tone with cautious optimism. Was this it? Was he leaving his wife? We'd talked about the idea often, but the timing never worked. It was Christmas, or one of the kids' birthdays, or his wife's birthday, or the moon and stars weren't in proper alignment. It was always something.

Alec chugged the rest of his drink. "I started therapy last week."

"Okay," I said, forcing an understanding smile. Therapy wasn't what I'd hoped for, but at least it was a step in the right direction.

"Couples therapy."

"With Lara?"

"Yes, with my wife." He turned toward me, eyes awash with pain, and gripped my arms. "I have to try, Claire. Don't you see?"

My gut wrenched. "No, I don't see. No!" I yanked my arms away from him and hugged my shoulders.

"I have three children, Claire. I have to try for their sakes. What you and I are doing isn't fair to them, and it isn't fair to you. I love you. You know that, but I can't see you anymore." He wrapped his arms around

my waist and buried his face in my lap—his whole body quaking with sobs.

I rocked side to side in a daze, clutching my shoulders and staring at a cigarette scorch on the nightstand. My eyes brimmed with tears, but I refused to let them escape, as if hoarding their moisture could extinguish the excruciating fire burning within.

~~~

The next day, I told Mara what had happened.

"Are you kidding me? He made love to you and *then* said it was over? What an asshole. You should have hit him with that Champagne bottle."

"I didn't hit him with anything. I just sat there and rocked while he cried." Looking down at my hands, I saw my cuticles bleeding. "He did the right thing, you know. And I'm sure this sounds completely crazy, but it makes me love him even more. He chose his family over his own happiness. That took courage."

"Are you on drugs? He did the right thing? He hurt you terribly! How could you put a positive spin on this? You are such a Pollyanna."

"Funny, that's what Alec used to call me too." I dropped my head and pressed my fingers to my eyes.

"Okay, look," Mara said, "you had to know this affair with Alec would eventually go nowhere, right?" She placed her hand on my knee and focused on my swollen eyes. "Even if he did leave his wife, rebound relationships never work in the long run because they don't give you time to find yourself, to be independent. You need to stand on your own two feet first. You'll be much better off that way. You'll see. And besides, he turned out to be a chickenshit. You're lucky he ended it when he did. He just saved you from an ocean of hurt."

But I was already drowning. Every cell in my body screamed for the love that had kept me afloat, a love so rich and layered, so full of complexity and compatibility, so much like oxygen that living without it made each breath painful.

I desperately wanted to feel strong, to walk confidently toward the future, but I had no strength, no confidence, and no idea how to handle another loss. So I did what I knew how to do. I kept up appearances and locked away my shattered emotions. At least, I thought I had.

# TEN

**THE LAST WEEKS OF** the spring semester slid by me unnoticed. I trudged through my days by rote—carpooling, running errands, lecturing, grading papers. Dinners fell by the wayside. More often than not, Amber and I made cheese chips in the microwave or ordered pizza. Kurt had disappeared entirely from our lives. He was building a new one that didn't include Amber. She pretended not to care, but I knew she did, and my heart ached for her. It was only the two of us now, two wounded birds making it up as we went along. But at least we had each other.

On one of the last days of the spring semester, as I packed up my school bag for home, the dean peeked his head into my classroom.

"Come see me. We need to go over your fall schedule."

I sat in his office prepared for the usual routine. He would hand me my fall contract with my schedule of classes. I would look it over, check the accuracy of my pay rate, and then sign and date. We would share a few pleasantries—"Got any special plans for summer?"—and I would be on my way. He was a good dean, and we'd become friends over the years.

"Here you go," he said, sliding my contract across his desk. "You're not going to like this. I know you requested an extra class for the fall, but Marty Slakkar did too. As you know, he has tenure, and you don't

yet. So I'm afraid I have to give the class to him."

My eyes popped. "What? But I need that class."

"I'm sorry, Claire, there's nothing I can do."

"No, you don't understand. I desperately need that class. I need the money." I felt my face on fire and my palms sweating.

"I do understand, Claire. I know things are tough for you right now, and I'm truly sorry, but my hands are tied here."

"Your hands aren't tied. I see them. There's no rope around them, no cord. They're fully capable of doing something, but they're not. They're sitting there folded on your desk, doing nothing." I shoved back my chair and stood. "You're the dean. You can do something about this. You can add another section. I'll teach any day, any night, anytime. I don't care. I have to have another class."

"Settle down, Claire. It's not like you to get hysterical." He kept his hands folded calmly in front of him.

"Well, meet the new me!" I snapped.

"Sit down. Let's discuss this like the rational people we are."

I ignored his request. I needed to stand, if for no other reason than to quell my sudden urge to lunge at his throat. I had to calm down. This kind of behavior could ruin my chance for tenure. But with my world collapsing around me, I could see only two options—implode or explode.

The dean sighed. "I cannot add another section, Claire. All of our courses are capped because of the government budget impasse. We have no money to expand our offerings. The college is already dipping into its reserves. We're lucky to hang on to what classes we do have."

"But what am I supposed to do? I've been counting on that money." I grabbed the edge of his desk and leaned toward him, shaking. "I've been teaching here for almost five years. I get excellent reviews. Students transfer from Marty's class to mine all the time because all he does is show videos. And he gets rewarded with an extra class? That's bull—oney!" I twirled quickly to hide the scowl on my face and raced from his office.

～

"Shit, shit, shit!" I dumped my school bag out on the living room sofa and began sorting its contents. Putting things in order usually centered me, but not this time. This time it made me more agitated. I shoved the papers onto the rug and stabbed them with my high heels. Looking down at the trampled documents, I saw the roster from my canceled summer class.

"This is all your fault!" I grabbed the list, ripped it to shreds, and wadded the pieces in my hands. Feeling crushed like the roster, I slumped to the floor and squeezed my eyes as tight as my fists. The refrigerator droned a requiem, and the clock ticked out of sync with my throbbing head.

Why was I losing everything at once? Was I being punished? Guilt seized my body, and my mind spiraled beyond reason. Did my mother die and leave me without memories as punishment for not caring enough about her? Was my bad marriage my penalty for being so weak? Did I lose Alec because I wasn't good enough? And did I lose my classes for that same reason?

I curled into a ball, my heart sinking. And what about Amber? I pictured her innocent face and thought how she, too, bore the brunt of this. When I lost my mother, she lost her grandmother. Because of me, she lost her father. And now, my reduced income was her loss too. How were we going to get by? I wrapped my arms over my head. I had no business being a mother.

I didn't know how long I stayed folded up on the floor, or how long I let feelings of hopelessness and self-reproach engulf me, but at some point, I heard Mara's voice.

*Give yourself some credit*, she said.

I rolled over onto my back, looked up at the ceiling, and listened.

*You know what needs to be done. Trust yourself.*

I sat up. My fists remained clenched, but my mind slowly opened.

*What's the worst that could happen?*

"Ha, good question," I said, "excellent question in fact." I loosened my fingers and dropped the crumpled bits of paper onto the coffee table.

With a tiny smile, I moved up onto the couch and began sifting through the fragments. But after a few minutes, my smile dimmed as I realized they were too small and damaged to read. "This is impossible. I'm looking for a broken needle in a mangled haystack." I gazed at the table, flicking the useless shreds with my fingers. What was I going to do? What *could* I do?

I gathered up the scattered mess and threw it into the trash along with my hopes. One scrap fell on the floor. Leaning down to pick it up, I noticed six legible letters. They spelled "Chance," and my heart leaped.

Spurred by renewed optimism, I dumped the contents of the wastebasket back onto the table and carefully separated the puckered bits, smoothing them out one by one. With the fragments now flat—but still largely unreadable—I pieced them back together, hoping I got it right.

"This can work," I told myself. "This has to work."

I sat up straight, sucked in a deep breath, and dialed the phone. "Hello? May I speak to Scarlett Vivien Chancey?"

# ELEVEN

**VIV EXPLODED WITH UNBRIDLED** excitement while I struggled with paralyzing doubts. But eventually, after several phone conversations confirming dates, destinations, transportation, and countless other travel and financial logistics, a solid plan for the three-week trip came together.

Viv insisted on the same basic itinerary through Italy as initially planned for the class but with one adamant addition—four nights in Paris at the end. I was thrilled. I often fantasized about living in Paris and never tired of visiting the dazzling City of Light.

Tom, Viv's husband, established from the beginning that he would arrange the flights, hotels, and rental car in advance. He would also cover all my expenses and pay me three times more than my usual summer stipend.

And best of all, with extra money like that, Amber could join me at the end of the tour. It would be her first trip to Europe and her first time on a plane. But a little nine-year-old girl flying all alone to Paris was out of the question, so I asked Bergie to come along. She jumped at the chance. That way, Amber would only fly by herself from Los Angeles to New York. Bergie would meet her at JFK, and the two of them would fly the Atlantic together—a perfect solution.

Amber had wanted to go to Europe with me for years, and now was the ideal time. Perhaps this trip could compensate for the turmoil the broken marriage had brought to her life. Maybe it could assuage the guilt I felt for no longer providing my daughter with an intact family. But my biggest hope was that the trip would become a cherished childhood memory for her—something I didn't have with my mom. It was a lot to wish for.

⌒

To finalize our plans, Viv, Tom, and I met for dinner at a Long Beach restaurant of Tom's choosing. I had driven by it several times but had never eaten there. It looked unassuming from the street—edging the parking lot of a strip mall—but once inside, it had an upscale European feel, with its understated decor and tuxedoed wait staff. Arriving first, I perused the leather-bound menu, impressed by the gourmet selections. A few minutes later, Viv and Tom strolled through the door hand in hand. They made a lovely couple.

After a delicious meal (for which Tom insisted on paying), we got down to the nitty-gritty of the trip. Tom—a tall, streamlined, Scandinavian-looking guy with delicate features—handed me one thousand dollars in traveler's checks. I looked at him, shocked. What on earth was all that extra money for? And why did he give it to me? Those checks should have been in Viv's name.

Appearing to sense my unspoken questions, Tom laughed. "You should see the expression on your face. Don't worry Claire, Viv will have her own traveler's checks to use as she pleases, but these checks in your name are meant to cover the trip incidentals, things I can't prepay, like food, gasoline, museum tickets, and parking fees. It may seem like a lot of money now, but I can tell you, after working as a financial speculator for twenty-two years, I know how fast money can disappear."

Okay, but one thousand dollars? Really? Had he never heard of Frommer's *Europe on $25 a Day*?

I made a mental note driving home that night to put "generous" and "trusting" on the list of glowing descriptors I was collecting for Tom. I also considered adding "rescuer." This trip was going to save me. Not only would it save me financially, but it would also whisk me away from my misery and give me something else to focus on. There would be no time for wallowing over my losses in Europe. I would funnel all my energies toward Viv and provide her with the best art history instruction possible. That was the least I could do for this art-loving woman and her life-saving husband.

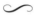

The day finally arrived. A friend dropped me off at Tom and Viv's apartment in Playa del Rey so we could drive to LAX together and go over any last details. I helped Tom load our suitcases into his car while Viv lingered inside, saying goodbye to their son, Jason, and giving final instructions to the babysitter.

Having stowed the last bag, Tom turned toward me. "Are you familiar with anxiety disorders?"

"Pardon me?"

"You know, people who have panic attacks?"

He threw the question out as if it were an idle curiosity, an innocuous bit of chitchat to pass the time.

I shook my head no and puzzled over the question. What a bizarre thing to ask. He was even worse at small talk than I was. Out of all the things he could have said—like, "Are you excited about the trip?"—why would he bring up something so random?

I gulped. Unless it wasn't. *Oh no.* My eyes widened. *Oh no, no, no . . .*

"Well," he said with an unconvincing smile, "don't worry too much about it. She's got her medication in her luggage and her purse. But here's some more for you just as a precaution." He handed me a translucent orange bottle of flat, round pills. I tried to smile.

On the way to the airport, Tom recited the checklist he'd made for our trip. "Okay, ladies, let's go over this one more time. Plane tickets, passports, traveler's checks, lire, francs, hotel and car vouchers, international driver's license, plug converters, travel iron, Pepto Bismol . . ." Tom's voice droned on and on. He listed everything. Everything except the anxiety pills.

Why didn't he mention her medication? Was it a secret? And how bad was she, anyway? I didn't know anyone with an anxiety disorder. I'd never seen anyone have a panic attack. And I had no idea what I should do if she had one. So, as is typical with the unknown, my mind prepared for the absolute worst, conjuring an array of vividly disturbing scenarios that I'd be handling all alone in Europe for the next three weeks.

"Ladies and gentlemen, the captain has turned off the Fasten Seatbelt sign, and you are free to move about the cabin."

I unbuckled my seatbelt, opened my carry-on bag, and pulled out my art history notes, glancing over at Viv every few minutes.

"Why do you keep looking at me? I know you don't want my magazines. Want some gum?"

"No, thank you. I'm just checking to see if you're okay."

"I'm fine." Viv gave me a puzzled look. "Are *you* okay?"

"I'm fine."

Viv eyed the notebooks piled on my tray. "What're you doin'?"

"I'm reviewing my notes on the artworks we're going to see. It's exciting."

"Reviewing notes is exciting?"

"Yes, well, reviewing and planning our daily itineraries. I like to plan."

"I like plannin' sometimes, too, but most times, I like goin' with the flow." Viv clasped her hands behind her neck and chewed her gum contentedly.

I returned to my notes but couldn't concentrate. My mind, already traumatized by my own emotional turmoil, was now paralyzed by the thought of Viv's panic attacks.

An hour into the flight, our meals arrived, providing a welcome distraction and a gourmet experience—one of the outstanding things I discovered about flying first class. We enjoyed Pâté en Croûte, chateaubriand carved seat-side, asparagus with hollandaise sauce, and twice-baked potatoes. Viv ate all of hers and half of mine.

Shortly after dinner, the cabin lights dimmed, and the movie screen in front of the bulkhead lowered. We watched *The Witches of Eastwick*, starring Susan Sarandon, Michelle Pfeiffer, and Cher.

"Don't you just love Cher?" Viv asked, leaning close to my ear. "I watched every episode of *The Sonny and Cher Show*. They shoulda never divorced."

"Shhh."

"Did you know Audrey Hepburn in *Breakfast at Tiffany's* was Cher's inspiration growing up? Mine too. Have you seen pictures of her lately? I mean, Cher. Her clothes are outrageous. I love 'em. But the best outfit was at the Academy Awards last year. Did you see her in that Bob Mackie getup, the one with—"

"Viv, please, I am trying to watch this."

"—the one with the Bride of Frankenstein headdress?"

"Viv!"

After the movie, the cabin lights stayed low to encourage sleep. We had about seven more hours before landing.

"I'm gettin' some shut-eye," Viv said, pulling a pink sleeping mask from her purse. "You ever use these?"

"No."

"They're really great. I thought it was a bunch a hooey at first, but when Tom started using one, I gave it a try. Of course, his isn't pink. His is black and doesn't have the sleeping eyelashes on it, but anyway, they really work. I read all about 'em in *Cosmo*. Turns out, it needs to be nice and dark to trip the snooze button in our brains. And that's

where these cuties come in." She brandished her mask at me. "Wish I had one to share with you, but this is all I got. Maybe the stewardesses have some. Want me to flag down a stewardess for ya?"

"No, no, that's okay. I don't need one. Thanks anyway."

"Suit yourself." Viv pulled her pink blindfold over her eyes and nestled down in her seat. A second later, she popped back up, flipping the mask from her eyes to her forehead. "Oh, and another thing, people who wear these things sleep through the night better than people who don't. You should get one and use it at home." She slid her mask and body back down before I could respond.

I watched her for a while, expecting her to resurface any minute with another essential tidbit. But soon, her breathing slowed, and she started making soft, puffing sounds. It appeared she needed to express herself even in her sleep.

My body gradually relaxed, and I turned toward the window to watch the snowy-white clouds cluster in the sky. They looked like cauliflower to me—a side dish that appeared too often on my plate as a kid. Maybe it was my mother's favorite vegetable, but more than likely, it was my father's. In my family, everything revolved around his preferences. I had no idea what hers were.

Leaning back in my seat, I tried to recall more about my childhood. I remembered several dinner discussions with my father, especially a heated one about communism. And I smirked at the memory of my sister helping me bake my first cake, which came out looking like a ski slope with moguls. But I couldn't remember a thing about my mom.

Glancing across the aisle, I noticed two women—mother-daughter ages—playing cards and smiling with identical mouths. How lovely. The two of them on a trip to Europe together, forming lasting, meaningful memories. I turned away and longed for sleep.

Reaching into my pocket, I found the "chill-pill" Viv had offered me earlier. I popped it into my mouth, sagged back in my seat, and tried to think of something pleasant—something other than my mom's death, Kurt's desertion of Amber, Alec's rejection of me, or my new worry—Viv.

Within minutes, I felt the deep pull of sleep and the disturbing invasion of dreams.

$\backsim$

"Stop," I shouted. "Stop." I leaped from my seat and chased Viv up the aisle, grabbing her around the waist as she slammed through the cockpit door and lunged at the captain's neck. "Stop it. You're choking him."

Viv looked back and gave me a well-placed donkey kick.

"*Oof.*" I collapsed to the floor. "Let him go," I pleaded as I grabbed her foot in a last-ditch effort to save the captain. "You're going to kill him."

Viv peered down at me with maniacal eyes, then up at the ceiling. Still clutching the captain's throat, she released a plaintive scream: "Beam me up, Scotty!"

$\backsim$

I woke up panting and forced myself to take several deep breaths. Although relieved to discover it was only a dream, I looked over at Viv to confirm she still sat next to me.

"Cabin crew, prepare for landing," the captain said over the PA. I knew it was silly, but I found his functioning vocal cords reassuring.

"Wow," Viv said, leaning over me to look out the window. "I can't believe we're almost there. This was the longest goddamn flight in the world."

"You certainly got that right," I said, wanting to close my eyes again but afraid the nightmare would return. Instead, I organized my bag while Viv watched the stewardesses hunt down those seat backs and tray tables not in their upright and locked positions.

The plane landed about fifteen minutes later with a neck-snapping jolt, followed by such urgent braking that once the fully loaded 747 finally ground to a halt, many of the passengers broke into spontaneous applause.

"Ladies and gentlemen, welcome to Milan's Malpensa Airport."

I hadn't thought about the airport's name before, but in my current state of mind, it sounded ominous. Although the word "Malpensa" had no official meaning in Italian, the almost identical word *malpensante* meant "badly thought out." I began to wish we'd flown into Rome instead. I would have much preferred the airport named Leonardo da Vinci.

⌘

"Jesus, Italians are nuts," Viv said as we drove toward the city in our new black Mercedes—the top-of-the-line rental car Tom had insisted we get. "Look at that guy up there. First, he tailgates that car, then passes him, layin' on the horn like a lunatic, and now look at him. He's flyin' like a bat outta hell. He's got to be going over a hundred." Viv sounded more exhilarated than concerned.

"Yep," I said, "driving in Italy takes some getting used to, especially once we're off the autostrada and on the city streets. Then the games really begin."

"What d'ya mean?"

"You'll see in a minute."

I turned off the freeway and came to a stoplight at a claustrophobic intersection bordered by towering stone buildings and narrow sidewalks usurped by parked cars. A squat old woman shrouded in black ambled into the street, braving both the sizzling summer heat and the notorious Milan traffic.

Seconds later, a tiny Fiat 500 and a motorcycle squeezed in on either side of our car—three abreast in one thread-like lane. The motorbike grumbled aggressively at the woman, who continued crossing the street, unhurried. The moment her back foot lifted off the pavement and onto the sidewalk, but before the light turned green, the Fiat and motorcycle roared off as if racing in the Grand Prix. The cars behind us honked for me to follow suit until they lost patience and drove over the curb

around us. The light was still red and the dowager barely out of the way.

"Holy shit, I see what you mean."

The remainder of the drive to our hotel—a nail-biting zigzag through the congested city streets—felt a little like playing dodgeball as a kid but with much higher stakes. Our destination, though, the Hotel Dei Cavalieri, was worth the effort.

Designed in 1949 by Gio Ponti—one of the most prominent Italian architects at that time—our luxury hotel was renowned for hosting international celebrities from the worlds of fashion, entertainment, and culture. More important to me, though, was its location—city center and ideally positioned for our art-viewing pleasure. From here, we could walk to the Duomo, Milan's extravagant cathedral; the Pinacoteca di Brera, with its significant collection of Renaissance and Baroque paintings; and Santa Maria delle Grazie, the convent where Leonardo da Vinci's mural of the Last Supper barely clung to the wall. Just thinking about those art venues steadied my nerves.

We checked into our suite—a large, welcoming space with high ceilings, crown molding, and tall windows framed by red velvet drapes. The late-afternoon sun invaded the room, its takeover thwarted only by a carved mahogany chest casting a long shadow across the floral carpet.

Once settled in, I suggested we walk the short distance to the Piazza del Duomo to see the Milan Cathedral. We took Via Giuseppe Mazzini straight from the hotel to the Piazza, and in six minutes, the majestic cathedral appeared before us.

As the white marble façade gleamed in the waning sun, I launched into Viv's first art history lesson, feeling entirely out of my element with only one student, but determined to give it my all and prove I was worth my extravagant paycheck.

"Although construction commenced in the fourteenth century, completion eluded this cathedral for five hundred years. Hence its rather disconcerting blend of architectural forms." I sounded absurd, like a pretentious professor trying too hard to impress. I cleared my throat to start again.

"The building began as Gothic, a style that sends your eyes shooting heavenward." I looked up and thrust my hands high above my head, creating a pointed arch with my fingertips. But as soon as I did, I felt silly, imagining I looked like an awkward ballet student suddenly inspired to pose. I quickly dropped my arms and scolded myself for feeling so self-conscious. I had to relax. Focusing back on the edifice, I took a cleansing breath and tried once more.

"But the church ended up as Neoclassical, a style that brings you back down to Earth." Pointing out the horizontal features that held the soaring verticals in check, I let my eyes wander over the structure and could feel my brain slowly unwind as I lost myself in the building's details.

I loved how the contradictions of this church gave it such an animated personality. Though often maligned as a hodge-podge—an over-the-top wedding cake—I found its complex profusion of lacy details breath-taking. And instead of seeing its competing styles like squabbling children, I saw them as stages of change all happening at once—the Gothic fervor of youth dancing with the Neoclassical restraint of adulthood. The whole busy thing delighted me and transformed my awkwardness into a passionate urge to share that delight with Viv.

I spun toward her.

"You know," I said, "this is one of the largest and most elaborately decorated Gothic cathedrals in the world. And get this—it has over two thousand statues and one hundred and thirty-five spires. Just look at that thicket of pinnacles reaching for the sky. And up there on the side of the building, look how those flying buttresses spread like wings."

I launched into my dramatization of a flying buttress—a routine I'd created to both enlighten and entertain my students.

But instead of watching me, Viv gazed across the Piazza at an immense stone archway that opened to a vast glass-and-iron-covered arcade.

"What's that? I've seen pictures of it before."

"That? Oh, it's a shopping mall." I flicked my wrist toward the structure. "So anyway, this is how . . ."

"Awesome. Let's go check it out."

"But . . ."

"C'mon, it'll be fun."

"But I was just getting started. This is one of the greatest cathedrals in the world, and you want to go shopping? You cannot be serious."

"Of course I'm serious. What's more serious than shopping?"

I stared at her, incredulous. We didn't come all this way to shop. She could do that at home. This was an art history tour set up especially for her. That's what she wanted.

I could tell from Viv's eyes, though, that I'd lost her. And, bottom line, as my employer, she did have the final say. But how would I give Viv the quality art education I had promised—and that Tom had dearly paid for—if she derailed us with frivolous diversions like this one?

"C'mon, Claire. Let's go."

Viv tugged on my sleeve like an impatient two-year-old until I turned my back on the grand cathedral and reluctantly walked to the *Galleria Vittorio Emanuele II*—the oldest shopping mall in Italy and home to many of Milan's finest boutiques.

Moments later, we stepped through the monumental stone archway and into the four-story arcade. Viv squealed with delight and strode ahead as if she knew exactly where she was going.

"This mall's famous. I remember now. I think I read about it in *W*."

"What's *W*?" I asked with polite disinterest.

"*W*, you know, the swanky society and fashion magazine. I gave you one to look at on the plane." Viv waited for a sign of recognition, but I just shrugged.

"Oh, well, anyway, you'd love the article. It talks about the primo mosaics on the floor right below that big glass dome up there. One image is a bull, and if you grind your heel on his balls and spin around three times, it brings good luck." Viv giggled. "I guess so many people have done it, the balls are almost completely worn off. Isn't that a riot?"

"A riot. Really? That's vandalism! If someone stood in the middle of this mall and ripped apart a designer purse, I bet that would cause a

real riot. But destroying a work of art is supposed to be funny? How could you think I'd like that?"

Viv was too entranced by the mall to care about my bitter protest. "Oh, look, there's Savini's. Are you hungry? I am. You never know who we might see there. I hear Lana Turner comes here every time she's in Milan. But she's getting pretty old now. And it used to be Grace Kelly's hangout, until she died, of course. Wasn't that tragic?

"But who wouldn't hang out here? Look at this place and all these boutiques. Oh my God, there's Prada. Did you know this is Prada's first store ever? It opened in the early twentieth century. In 1913, I think. I feel like I've died and gone to heaven. It's exactly like everything I've read. Fashion is what Milan is all about."

I could *not* have disagreed more.

# TWELVE

UP EARLY THE NEXT morning, after a needed night's rest, we set out on foot to explore Milan's fine-art treasures. This was our only full day in the city, and I felt eager to rectify our rocky start. But with so much art to see, we needed a well-crafted itinerary to do it justice. And here I would shine. My carefully planned tour would delight any art lover, and I couldn't wait to prove my mettle.

Our first artwork of the day was Leonardo da Vinci's *Last Supper*—the epitome of High Renaissance perfection—a symbolic and deeply human drama painted on a flat wall made to appear three-dimensional.

I began my lecture the moment we stepped inside the cavernous hall, determined to captivate Viv immediately. "The Duke of Milan commissioned Leonardo da Vinci to paint this *Last Supper* at the end of the fifteenth century, and it marks the beginning of the High Renaissance." I paused to let Viv absorb the monumental grandeur of the fifteen-foot-long masterpiece.

"Wow. It's really trashed," she said, as if describing a beat-up jalopy.

I stared at her, dumbstruck. She was in the presence of one of the world's greatest paintings, and that's what she had to say? How could she? I felt personally wounded, as if *I* were the one denigrated. And

I immediately wanted to defend the work—to protect it from such a harsh assessment. Yes, it was marred and faded, but also magnificent. Couldn't she see that? I finally mustered a response.

"Well, yes, it is in bad shape, but it's been through a lot, beginning with Leonardo's choice of materials. Traditionally, artists painted murals using fresco—a technique of applying pigment to wet plaster, which allowed the paint to become a permanent part of the wall. But fresco didn't lend itself to subtle nuances of light and shadow, and that was Leonardo's trademark. So instead, he experimented with a variety of paints and techniques. Unfortunately, his experiments didn't hold up, but the work was instantly recognized as a masterpiece anyway."

"If they knew it was primo from the get-go, why didn't they fix it? It looks awful."

I cringed at the word "awful," but I tried to stay focused on her question, not her dig. "The painting disintegrated so quickly that the friars thought it was beyond repair at first. They even enlarged a door in the wall that cut off Christ's feet. See?" I pointed to the central figure and the top of the filled-in doorway where his feet would have been.

"That was stupid."

I winced again at her word choice but kept going. Perhaps once I'd finished explaining the painting's difficult history, she could get beyond its deteriorated state and the purported idiocy of the monks.

"Well, yes, a bit shortsighted. But eventually, they did try to repair it. The restorers, though, bungled the job. After that, things just kept going downhill. At the end of the eighteenth century, Napoleon's troops threw rocks at the mural for entertainment. Then, during World War II, the building was bombed. But the wall with the painting miraculously survived, and the piece needed fixing all over again. The most recent restoration is still in progress. That's what all those rectangular patches are about."

"It hardly seems worth it now. It really is a mess."

"But it *is* worth it," I said, determined to open her eyes—to pry them open if necessary. "And here's why. Leonardo used a mathematical

system called linear perspective to simulate a real three-dimensional space on a flat surface with more mastery than anyone before him. See how the wall seems to open up like a window, like we're looking into another room?"

Viv gave me a perfunctory nod.

"That's due to linear perspective. It was developed earlier in the fifteenth century." I paused to consider how best to explain the system while Viv busied herself with a fresh stick of gum.

"When parallel lines move away from us into depth—like the sides of railroad tracks—they look like they're angling toward each other instead of staying parallel, as we know they actually do. And that illusion tells our brains we're looking into three-dimensional space. Linear perspective is the re-creation of that same illusion except on a flat surface."

Out of the corner of my eye, I could see Viv contemplating her shoes. I cleared my throat to recapture her attention. "But there's more to it than that. Earlier artists had already depicted converging parallel lines. What Renaissance artists discovered is that those lines proceed into depth according to specific paths that always meet on the horizon— never above it or below it, but always right on it. Artists call that spot the vanishing point."

Viv shifted her weight impatiently. I started talking with heightened zeal, hoping to grab her interest with my enthusiasm. "Isn't it amazing that those lines look like they would actually touch when they never really do? Don't you find that fascinating? How our perception deceives us? And how Renaissance artists were able to recreate that same illusion of depth on a flat surface?"

Viv didn't answer. I started perspiring, feeling like an actor trying too hard to save a bad performance—flop sweat.

"Anyway," I said, "the ceiling beams in this painting are a good example of Leonardo's use of linear perspective. See how the beams angle toward each other instead of staying parallel and how that makes it look like they're moving back in space?"

I nodded vigorously in Viv's direction. But Viv—stifling a yawn—was

scanning the vaulted hall that had once been the monks' dining room. "Okay . . . um . . . let's try something here. So, if Leonardo correctly mimicked the way we see things in the real world, all those ceiling beams would meet—if they were to keep going—at one spot on the horizon of this painted space. Can you see where that spot is?" I tapped Viv's shoulder. "Can you, Viv?"

"What?"

I repressed a sigh. "Can you find the vanishing point in this painting?"

Viv eyeballed me, looking like she was deciding whether to go along or flee. I prepared for the worst.

"Do I get a treat?" she asked.

"Excuse me?"

"Do I get a prize if I do it right? Candy or something?"

My face flushed. This time she really was denigrating me. She had hired me to be her instructor, but now she ridiculed my instruction. What did she expect from me? I looked at the floor and ran my fingertips along my damp hairline, wanting to scream.

Viv swatted my arm. "Hey, I'm kidding. Lighten up. I was just trying to be funny. You're so damned serious."

Viv squinted at the painting and used her fingers to trace the ceiling beams in the air. After a moment, she concluded, "They'd come together right at Christ's head, so that's the vanishing point and the horizon line." She winked at me. "Do I get the candy?"

I tried to take Viv's teasing in stride by pretending to play along. "No candy yet, young lady. We've still got work to do."

Squaring my shoulders, I continued the lesson as if nothing were wrong but couldn't keep the sarcastic edge from my voice. "You're probably asking yourself, why do *you* care about the horizon?" I raised my eyebrows at Viv. "Well, I'm *so* glad you asked. It's because, in real life, the horizon is always at our eye level. You can easily test this out at the ocean. Standing on a beach and looking at the water, the horizon will be exactly at the level of your eyes. If you were to lie down, the horizon would be at your eye level there too. So, knowing that, where's our eye level in this painting?"

"We're the same as Christ's," Viv said without a pause.

"Yes. We're on the other side of the table, eye-to-eye with Christ, who calmly opens his arms as if to welcome us." I spread out my own arms. "Pure genius on the part of Leonardo."

"Hmm," Viv said, looking around the whitewashed room. "Imagine what it must've been like to be one of the guys who ate here. You'd feel like you were chowin' down with Christ right there watchin' your every bite. That must've been a trip."

"Yes," I said, "talk about needing to be on your best behavior."

Viv giggled, and I could feel my edge soften.

"But you know," I said, "Christ's gesture is more than just warm and welcoming. It's also symbolic. His stretched-out arms create an upright triangle with his head at the apex. Do you see that?"

Viv nodded; her eyes remained fixed on the painting.

"And since the triangle—or in reality, the pyramid—is the most stable geometric form, Christ's position symbolizes stability. And for Christians, it's also a sacred shape. Its three sides represent the Father, Son, and Holy Ghost." I glanced at Viv, pleased to see her still engaged.

"But the symbolism doesn't end there. Notice how the room has only three windows, and Christ's followers are placed in sets of three, with each group forming a soft, triangular shape." I drew triangles in the air around the clusters to underscore my point.

"If we put all this together, we've got linear perspective, making the scene look like an extension of our own space; triangles, giving a sense of solid, unshakable stability; and the number three for spiritual symbolism. Not bad, huh?"

"Yeah, pretty slick."

I felt so relieved by Viv's positive response, I even considered forgiving her for mocking me and derailing the previous night's art lesson. Perhaps I had leaped into teacher mode too soon. We had only arrived, and maybe Viv needed to be mindless for a while before beginning to study in earnest. Maybe I had pushed too hard, and she simply pushed back. Whatever the case, we were on track now.

"Well, if you think *that's* slick," I continued, "that's not the half of it. Look at the disciples around Christ. Are they calm and welcoming too?"

"Ha. No. It's like the opposite. They're not even looking at us. And they're not chill at all. Lots of arm-wavin' goin' on." Viv shot me an impish grin. "You can tell Leonardo was Italian."

I couldn't help but smile at Viv's playful observation but refused to be sidetracked again. "Yes, exactly. They're clearly riled up, and who wouldn't be? Christ has just announced, 'One of you will betray me.' And Leonardo has given each disciple a different reaction to that shocking news. Look at how James the Greater, on Christ's left, leans away from him, arms spread wide in disbelief." I mimicked the pose. "It's like he's saying, 'Whoa. Wait a minute here.'

"Now check out Philip, next to James. He rises to his feet, looks directly at Jesus, and as he curls his hands toward his chest, you can almost hear him plead, 'You don't think it's me?' And what about Matthew next to Philip . . ."

"Wait, wait. Let me do this one." Viv turned her face toward me, thrust her arms in the opposite direction—a perfect imitation of Mathew's stance—and gave a convincing shout of alarm: "Did you hear what he just said?" Her voice rose to such a fevered pitch, a few other tourists in the room looked her way.

"You're good," I said with an approving nod. "They do seem to be saying those things, don't they? And look there, three disciples away, on the other side of Christ. It's Judas, the betrayer himself—money bag in hand—glaring stone-faced at Jesus." I scowled at Viv to underscore my point before concluding the lecture, or more accurately, our lively exchange.

"The Last Supper had been depicted many times before Leonardo painted this one, but never from this pivotal point in the story with such a psychologically charged use of linear perspective, or with such moving human insight, all steeped in symbolism."

Viv patted me on the back and grinned. "Ya know, maybe you're right. Maybe it is worth fixin.'"

Leaving the refectory, I felt spent but gratified. I'd managed to capture Viv's interest, and the two of us were on the same wavelength at last. We were also both famished, and that was where my expertise ended. I had no idea where we should eat, but to my surprise, Viv did. She knew of a restaurant called Bice and had its address in her purse. To save time and to appease our grumbling stomachs, we hailed a cab.

Once settled in the back seat, Viv asked, "Was Leonardo gay?"

"Yes, it appears so. Why?"

"One of my friends said he was, and I just wondered if it's true."

"Well, we can't say for certain. He never identified himself as gay, but then, who would? Sodomy was punishable by death or exile back then."

"But if he never 'fessed up to being gay, why do people say he was?"

"Because what we know about his life suggests it. He was never known to be romantic with any woman. He never married. Never had kids . . ."

"That could be true of lots of people," Viv countered.

"He was arrested for sodomy."

"Whoa, that's pretty damning."

"Well, yes and no. Homosexuality was so widespread in Renaissance Florence that the French referred to sodomy as the 'Florentine vice,' and the German slang word for a homosexual was 'Florenzer.'"

Viv's eyes popped. "Jeez Louise."

"Right. And as you can imagine, this was a great embarrassment to the Florentine government, so they set up 'The Office of the Night' to crack down on sodomy. They even had a kind of suggestion box for informants to use. And it wasn't unusual for people to make secret accusations to discredit someone. This seems to have been the case with Leonardo. But since his accuser never revealed himself, the charges were eventually dropped. Still, just because it was anonymous doesn't mean it wasn't true. A second anonymous charge was made against Leonardo later that same year."

"Sounds to me like someone was out to frame him. I bet it was a jealous artist."

"Possibly. But we also know that Leonardo lived with a couple of his young male assistants, and one of them wrote about how much the master loved him. And Leonardo himself wrote that he found the act of procreation disgusting."

"Okay, maybe he was gay, but so what? Why slander a great artist like that?"

"Well, it would have been slander in the Renaissance since you could have been executed for being gay. But now it's just a statement of who Leonardo was. People like to know about great artists' lives."

"Of course it's still slander today. Would *you* like it if somebody called *you* gay?"

"If I were gay, what else would people call me . . . straight?" I found the direction of the conversation annoying.

"No, you don't get what I'm saying. You just wouldn't want anybody to know you were gay, so you wouldn't want anybody to call you that."

"Wait a minute, you think gays should stay in the closet?" I could feel my irritation growing.

"Well, yeah. It's safer that way."

I paused to cool my aggravation. "You know, Viv, I think it's good for people to realize Leonardo was gay if it helps them see that sexual orientation has nothing whatsoever to do with someone's worth. And the gay community needs its heroes, especially now with the AIDS crisis. They need to know they deserve equal treatment and that societal prejudice is outright ignorance."

"Well, maybe, but I don't see the point. Why swim upstream? Sure, it's important to accept yourself, but you don't have to go tellin' everybody else about it. That just opens you up to a shitload a hurt. Makes life more difficult. I'd keep it under wraps if I was gay."

"*Eccoci,*" the driver announced, pulling up to the restaurant on Via Borgospesso—an impossibly narrow street tucked away in the heart of the city.

"*Grazie,*" I said, grateful for both the ride and the chance to change the subject. "Looks like a cute place. I'm starving."

"Me too," Viv said. "And I hear the food's primo."

Stepping through the arched doorway, the restaurant instantly seduced us—pale yellow walls framed by elaborate dark wood molding, leaded glass partitions, white tablecloths, and a striking red plaid carpet on a dark wood floor. And oh, what aromas—fresh garlic, basil, and sweet sautéed onions.

Looking at the menu, I wanted one of everything, but I finally chose tagliolini pasta with fresh porcini mushrooms. Viv ordered osso buco with risotto, and the waiter recommended that we share a bottle of Chianti Classico—a dry Italian red wine with the tantalizing fragrance of cherries. We savored our meals in silence, our senses reveling in the bouquet of smells, tastes, sounds, and the lingering visuals of Leonardo's *Last Supper.*

My thoughts, though, went elsewhere. Alec adored Chianti and loved to make a big production of decanting it like a sommelier. Glasses properly poured, we'd swirl and sip with faux sophistication, laughing all the while at the pretense.

I held my wine glass up to the light and gazed into the ruby-red liquid. We were so much in love. How could he have left me? My stomach twisted as memories of Alec permeated my mind.

"Do you think you're brave?" Alec had asked one precious day when we were alone.

I laughed at the question, assuming it was leading to an amorous scenario where he played a knight in shining armor and I a damsel in distress.

"Of course I'm brave," I said, eying him playfully. But he looked pensive.

"I hope so. To sustain this remarkable love of ours, we have to be."

"Why do you say that?"

He paused. "The reason our love is so profound is because of our openness to each other, our willingness to lay our souls bare and be completely vulnerable. But that also leaves us open to hurt."

"I'm not going to hurt you, Alec. Are you afraid you're going to hurt me?"

"That's not the point. Emotional vulnerability is a tricky thing. Any careless word or act can wound. So we need to be careful not to wound each other and have the courage to stay vulnerable even if we accidentally do. Otherwise, our hearts will harden for protection, and this profound love of ours will be lost."

He kissed me and held me tight, as if I might slip away.

I looked down at the table, my heart as empty as my plate. But he was the one who had slipped away, and I was the one lost.

"Isn't this place awesome?" Viv said, looking expectantly around the room.

"Awesome," I mumbled, "but why did it have to end?"

"Huh?"

"Oh, I mean, too bad the meal had to end." I quickly summoned the waiter—"il conto per favore"—and forced back the tears flooding my eyes.

"Yeah, I'm with ya on that one. My osso buco was delish. But ya know what they say, 'all good things must pass.'" Viv continued surveying the room. "I'm so glad I saved the name of this place. I read all about it in a magazine a bazillion years ago and thought I'd try it out if I ever got a chance to go to Milan. Of course, back then I had no clue I'd ever get to go, but I wrote it down anyway. Ya can't quit on your dreams, ya

know. And I hadn't even met Tom back then, or you, or anything. But here we are. How trippy is that? Did ya know, this place opened in the thirties? And now it's super popular with the 'in' crowd. I bet we just ate lunch with some of Milan's top designers."

"Mm-hmm," I said, struggling to ignore the hollow pain in my chest and stay in the present. I desperately needed a visual distraction and tried to focus on my surroundings: the smartly dressed crowd, the elegant floral displays, the bustling tuxedo-clad waiters—but nothing erased Alec from my mind, and I could feel myself unraveling.

"What's going on with you?" Viv said.

I looked at her, unblinking.

"Hello, anybody in there?"

I wanted to respond but couldn't, my throat choked with repressed sobs.

"Oh my God!" Viv shrieked, seizing my arm and yanking me from my tailspin. "It's him. It's Versace. I'd recognize that face anywhere. He's shorter than I thought. But look at that smile. What a dreamboat."

I cleared my throat. "He's a designer?"

"Of course he's a designer. One of the best. He designs for Princess Diana."

"Oh, yeah, him." I pretended to be in the know instead of in a fog.

"Should I ask for his autograph? I'd die for his autograph. But what if he doesn't want to be bothered? I've got to get it, though. I can't miss this chance. I mean, it's Versace. But what if he doesn't give autographs in a place like this? Then I'll look stupid." She seesawed back and forth, getting more and more worked up.

The panicky edge in Viv's voice finally cleared my head. I grabbed a notepad and pen from my purse and jumped up from my chair.

"Oh, Mr. Versace, I'm sorry to bother you, but I'm a big fan of your work and would be thrilled if I could get your autograph." I flashed my most engaging smile.

He smiled graciously back as he took the pad and pen from my hand. "What's your name?"

"My name? Oh, I'm . . . um . . . I'm Scarlett Vivien Chancey, but you can call me Viv."

"What brings you to Milan, Viv?"

"Oh, I'm here for the art . . . I mean, the fashion . . . and of course, the shopping. Lots of shopping. We went to the *Galleria* yesterday. That was something. There were so many stores. But obviously nothing better than your store, of course. I mean, wow, what can I say . . ." I was blithering like Lucille Ball in an episode of *I Love Lucy*.

"Here you go, Viv. Hope you enjoy your stay in Milan."

"Oh, you can't possibly know how much this means to me, Mr. Versace. I can't thank you enough." Walking back to our table, I smiled at Viv and told myself I could never wallow over Alec like that again. It was over.

Stepping outside the restaurant into a blast of city heat, I returned to tour-guide mode while Viv—still dazed from seeing Versace—focused on protecting her purse with the sacred autograph tucked inside.

"I think the best way to get to the Pinacoteca di Brera is to take the Metro," I said. "There's a stop not far from here. Wait till you see the masterpieces in this museum. They're incredible."

I could feel my spirits lifting and set a brisk pace for our short walk to the Metro stop. At the intersection of Via Monte Napoleone, I paused to look at my map while Viv wandered off in the wrong direction.

"Hey, Viv, it's this way. The Metro's over here."

"Look," she said, pointing excitedly to a handsome storefront as if she'd never seen one before. "It's Valentino. He's one of my faves, but, of course, I love everyone who designs for Jackie Kennedy. Or I guess I should say, Jackie Onassis. They're great pals, you know—Jackie and Valentino— thick as thieves. Did you know Elizabeth Taylor and Audrey Hepburn wear his stuff too? And then, of course, there's 'Valentino red.' I mean, think how totally rad you'd have to be to have a color named after you."

"What's that got to do with anything? We're on our way to the art

museum."

"Yeah, I know. But since we're right here, I'll just take a quick peek. It won't be a minute." She smiled and ducked into the shop.

I stood on the sidewalk, glaring after her. We had no time for this. But I had no choice and reluctantly followed her inside. I grabbed a lone chair in the corner while Viv zoomed around the store, looking like a video on fast forward.

To pass the time, I leafed mindlessly through my guidebook until I saw the name of our current location—Quadrilatero della Moda. I sprang to my feet and scanned the shop for Viv. I had to get her out of there.

"Claire!" Viv shouted from the other side of the store. "Do you know where we are?"

My heart sank as she rushed toward me, waving a brochure.

"Yes," I said, "unfortunately, I do."

"This is our lucky day. We're in the fashion district. Did you know the biggest number of top designer stores in all of Milan are right here?" She tossed the brochure in my lap and galloped out the door.

I looked at the glossy pamphlet. Versace, Pucci, Armani, you name it, they were there. And so was Viv, darting in and out of the shops like an Olympic sprinter, with me jogging begrudgingly behind.

"Oh, my God!" Viv yelled, racing to my side. "There's an open studio we gotta see. This designer label is one of the rising stars in Italian fashion, and it's practically brand new. We're talkin' cutting-edge work here. This is the chance of a lifetime."

But the opportunity was lost on me. In my eyes, the clothes in that studio—the transparent black sheaths with lace corsets underneath— looked appropriate only for a bordello.

"Who in the world would wear that kind of thing?" I said to Viv. "It's obscene."

Viv looked at me with something akin to pity and returned to admiring the racy, black slip dresses inspired—I learned later—by post-war Italian films.

"'Who would wear this?'" She smiled. "Sophia Loren."

"Oh."

And so once again, Viv's shopping passion displaced my plans. We never made it to the Pinacoteca di Brera. But the designer studio we visited that day? Dolce & Gabbana. I'd never heard of them.

Getting ready for bed that night, I rankled over our wasted afternoon. Only two days in and our trip had already careened off the rails. It didn't matter how skillfully I'd plotted our itinerary—Viv still managed to divert it. When it came to shopping, she had the tracking instincts of a bloodhound. Either that or she had her own secret agenda that she planned to carry out regardless of mine. But I found that hard to believe. Viv had never been to Europe and appeared way too scattered to be that calculated. Still, it seemed surprising that she happened to know of a restaurant that turned out to be popular with designers and happened to be in one of the most prestigious fashion districts in the world. That did seem a bit too coincidental.

# THIRTEEN

**I BARELY NOTICED THE** lush green landscape as we drove the next morning from Milan to the charming hillside town of Varese. I was still brooding over the time we had squandered the day before on shopping. Although, I did buy a handsome black-and-white houndstooth coat with commanding shoulder pads that Viv swore made me look "primo," it still didn't compensate for losing an entire afternoon of art.

But even more irksome than that, Viv appeared oblivious to my frustrations. She acted like taking me shopping was doing me a favor—rescuing me from my stuffy self. But she couldn't sidetrack me this time. We were driving straight to Count Panza's villa—thirty-five miles without stopping—to view his remarkable collection of contemporary art.

The Villa Litta Panza, built in the mid-eighteenth century, perched on a hill overlooking the town. It wasn't open to the public, but since special arrangements had already been made for my class, I simply kept the appointment for Viv and me.

As we got closer to Varese, my mood brightened. I considered this one of the highlights of the whole trip. I knew about Count Panza and his collection because he'd recently sold eighty artworks to the Los Angeles Museum of Contemporary Art—pieces by such renowned

artists as Rothko, Kline, Rauschenberg, and Oldenburg. And now, I would be among the select few to see Count Panza's palazzo with its acclaimed site-specific art installations. I couldn't wait to get there, and I was filled with anticipation when we finally pulled up to the villa—an austere building rising straight up from the edge of the street like a huge, forbidding fortress.

"This is it?" Viv said. "We drove all that way for this? It looks like—I dunno—like a place where they lock up loonies."

Although I had to admit the building did look somewhat institutional, I wasn't going to give Viv the satisfaction of agreeing. So I ignored her and hoped fervently there was more to Viv's "loony bin" than this.

The friendly caretaker met us out front, showed us where to park, and escorted us past the unadorned façade into an explosion of Rococo extravagance. It was like opening a geode.

"Holy cannoli!" Viv said, squinting at the glittering world we'd just entered. "This place is over the top."

I gave her a knowing grin as if aware all along how grand it would be. But on the inside, I was having the same reaction as Viv. *Holy cannoli is right!* Twinkling crystal chandeliers, polished marble columns, dazzling gold-framed mirrors. Everything gleamed. The caretaker guided us to the first series of art installations and left us alone—alone in an opulent mansion dedicated to severely simple Minimalist art.

A series of small chambers contained permanent installations by Dan Flavin, an artist who worked with fluorescent tubing. Each glowing room branched off a long, barren corridor illuminated by pink, green, and yellow lights—another Flavin installation. Our slow and silent walk down that hallway felt otherworldly.

We continued through the villa from there, astounded by the combinations of old and new—plain monochrome canvases adorned the walls above ornate eighteenth-century furniture, and simple box-shaped sculptures sat on intricately patterned floors. The contrasts boggled the mind. Eventually, we came upon an installation by James Turrell—a small white room with no furniture or decoration except for a ceiling

square that opened to the sky. A skylight. Viv and I strained our necks to look up at the aperture.

"I'm gonna lie down," Viv said, moving toward the floor.

"What? You can't lie down in an art museum. That's not proper etiquette."

"Who cares? Do you see any etiquette police around? I sure don't. We're the only ones here, Claire."

"Well, that's true," I said, looking down at Viv's recumbent body and thinking how much more comfortable I'd be off my feet. "I guess, in this unique situation, it'd be okay."

Lying side by side in the middle of the floor, we stared up at the open square and the cloudless blue sky beyond for a few seconds in silence.

"Is it supposed to do something?" Viv asked.

"I don't know. I don't think so. Turrell's all about perception. We just need to look at the ceiling and pay attention to the light."

"Well, that's lame." Viv kicked off her shoes and wiggled her toes. "But it's a nice excuse to rest these puppies."

My first impulse—after glaring at her for taking off her shoes—was to correct her assessment of Turrell's work. It wasn't lame. He'd studied perceptual psychology before becoming an artist and was known for his contemplative pieces that encouraged self-awareness, like meditation. Turrell's art took patience. It needed time to reveal itself. I decided to skip the lecture, though, and let Turrell's piece do the talking.

But it didn't. At least not to me. I had never been good at meditating, and the ceiling square didn't help. The clear blue sky just reminded me of Alec's eyes and how I missed him. I told myself I had to stop doing this, mooning over the married man who had dumped me. I had to stop acting like a doormat.

Mara had tried to tell me for years that I let Kurt walk all over me, but I couldn't see it and often denied it—like the time Mara and I wanted to attend a conference in New York, but I was afraid to ask Kurt.

∽

"Oh, for heaven's sake, Claire, just ask him."

"But what if he says no?"

"Don't ask him, then, tell him."

"That's not how marriage works, Mara. I can't just tell him. I need to consult him."

"Is that so? Does he consult you before doing things?"

"Yes."

"Like what?"

"I don't know, but of course he consults me."

"Really? You mean like the time you saved all that money from teaching extra classes so you could take your first trip to Europe together? And when you told him, he spent the money on his new business venture instead of your trip? Did he ask your permission for that?"

"Well, not exactly, but I could see how he felt his business was more important than my trip."

"But what about you? What about how you felt? Did you even tell him how important that trip was to you? How you'd been dreaming of going to Europe with him for years? Stop being a doormat, Claire. Stand up for what you want. You know a doormat can only be walked on if it's lying down."

"I do stand up for myself." I bristled. "You don't know what you're talking about." But even before the words formed in my mouth, I could already taste their insincerity. Who was I trying to kid?

I sighed. Mara *did* know what she was saying. I *was* a doormat. And I still was. Only now, I allowed myself to be trampled by memories alone.

"Come on, Turrell," I whispered, "help me out here."

"Whoa," Viv said, "what's goin' on up there? Do you see that?"

I squinted at the ceiling square, trying to make sense of what I saw. "Yes, I think so. Are you talking about the skylight looking closed all of a sudden?"

"Exactamundo! Isn't that weird? And I can't make it go back. I know that's the sky up there, but now it looks like a flat blue shape. What's goin' on?"

"I think Turrell's working his magic," I said, as mystified as Viv. Nothing had changed, yet everything had changed. Captivated by this sleight of sight, Viv and I continued to focus on the square until a jet flew by and instantly shattered the flat illusion.

"Christ on a bike, did you see that? Now it looks like sky again. The plane's gone, but the blue won't go back to flat." Viv sat up and put on her shoes. "That was so bitchin."

I contemplated the skylight a few moments longer, trying to process what I'd seen. "This makes me think of what Einstein said: 'Reality is merely an illusion, albeit a very persistent one.'"

"You can say that again, except this illusion didn't stick around at all. One minute it was here, and poof, it was gone. So rad. I take back what I said about Turrell. Nothing lame about that guy."

"You know, if you think about it," I said, "Turrell and da Vinci were both experimenting with the illusion of reality, but they approached it in opposite ways. Da Vinci made a flat surface look like a three-dimensional space, while Turrell framed a three-dimensional space that eventually looked flat. And to a good degree, their fascination with spatial illusion is what makes them both leading artists of their times."

"Yeah," Viv said. "But Turrell's illusion was full-on magic, changing right before our eyes." She paused for a second. Her face lit up. "You ever been to the Magic Castle? It's this primo mansion in Hollywood with restaurants and bars and all kinds of secret rooms. Tom's a member, and we go all the time. Turrell's work would be rad in there. And the whole thing started with a family of magicians. Even the mom was a magician. Not just an assistant but the real thing, ya know, sawing people in half and everything. And that was way back in the thirties. They called her 'the First Lady of Illusion.' I bet she would have loved Turrell."

I was only half listening to Viv's ramblings, but the last part caught my attention. "'The First Lady of Illusion,' huh? Definitely has a ring to it."

Driving back to Milan, I couldn't stop thinking about Turrell's piece and how real that illusion had seemed. The experience not only gave credence to Einstein's quote, but made me question all I knew about reality. And I wondered if Turrell's mind-blowing magic trick might have held the key to *my* transformation.

If reality actually was an illusion, and my perception determined that illusion, I only needed to perceive myself as a confident, independent woman, and I would be—no more doormat.

With Turrell's piece, though, my perception had changed automatically. But for this magic trick to work, I had to make it happen intentionally. And how could I do that?

Perhaps I needed to think of a role model and imagine myself as her. Wonder Woman popped into my mind first, but I couldn't get past the costume and had no interest in hand-to-hand combat. Giving it more thought, I envisioned Cleopatra. Captivating by all accounts, men apparently fell at her feet instead of the other way around. That would have been a nice change. And, since nobody knew for sure what Cleopatra looked like, I saw myself as Elizabeth Taylor, floating regally down the Nile, and I heard myself speak Cleopatra's famous line, "I will not be triumphed over." The sound of those words alone inspired confidence. But the moment I began to feel the mantle of Cleopatra's power, I saw Alec floating by on a barge in the opposite direction, and my desperate heart jumped ship, leaving Cleopatra's indomitable spirit behind.

*So much for presto chango.*

Exhausted from our long day, Viv and I decided to go to bed early that evening. I looked forward to a good night's sleep and had just slipped under the covers when I heard Viv in her bedroom, yelling.

"You got some balls calling me like this. I don't give a shit what you

want. This is my life. Keep out of it."

I leaped up and raced to her room.

"Like hell, you will!" Viv slammed down the phone.

"Is everything okay?"

"Yeah, sorry 'bout the ruckus. But that bitch had no business calling me. She's such a sleazebag."

"Who?"

"Sonia." Viv wrapped the phone cord tight around her finger. "I don't want to talk about it. I'll just get teed off all over again. Good night."

She shut her door in my face.

I went back to my room, rattled. Who was Sonia? She certainly made Viv furious, whoever she was. And why would she call her in Italy? Just to irritate her? And how did she get the phone number? The questions piled up in my mind, each one making me more uncomfortable than the last. I already worried about Viv's anxiety disorder, and an upsetting phone call like that didn't help.

Climbing into the car for Venice the next morning, I still wondered about Sonia but didn't ask. Whoever she was, she was trouble. And I wanted nothing to do with it. Although Viv and I had been together now for three days, we'd maintained a purely professional relationship, and I thought it best to keep it that way. I'd been hired as Viv's instructor, not her confidante, and felt I needed to behave accordingly. Her private life had nothing to do with me, and mine had nothing to do with her. But perhaps more importantly, I hoped a professional distance would help me keep my mind on the job and my feelings of loss at bay. We hadn't talked yet about anything personal, and I didn't want to.

A few minutes into the drive, Viv broke the silence. "Do you miss your daughter?"

I sighed. *There goes my professional distance.* "Yes," I said. "Do you miss your son?"

Viv nodded, and her eyes began to pool. Her son, Jason, was a toddler, and until now, Viv had never been away from him for more than a weekend. She had already called home twice, but that only intensified Viv's longing for her son. She talked about how she loved shopping for him and dressing him, how she loved his tiny voice and mispronounced words, and how she loved tucking him in at night.

While Viv continued her wistful monologue about Jason, I thought nostalgically about Amber and her invented vocabulary when she was first learning to talk. "E doodin?" meant "What are you doing?" and "Bee ree coffee" translated to "Be real careful." I remembered reading Amber's favorite bedtime story, *Goodnight Moon*, over and over, until both of us had it memorized but neither had tired of it.

Where did the time go? I couldn't believe Amber was now nine years old. Nor could I believe my marriage was actually ending. So many things were changing so quickly. Melancholy seeped through my body, as waves of uncertainty crashed in my head. Could Amber thrive in a broken home? Could I handle my life as a single mom? Would it have been any different if my mother were alive?

No longer aware of the road in front of me or my hands on the steering wheel, I floated somewhere far away, Alec on my mind. If I could only talk to him, I knew I could deal with all the rest.

"Are you okay, Claire? You're driving super slow." Viv's voice sounded distant and foreign. For a moment, I didn't know who spoke.

"Oh, me? Yeah, I'm fine."

"You really miss your daughter, don't you?" Viv studied my face. "That's what was going on in Milan, too, wasn't it? You had that same spacey look just before I spotted Versace."

"Oh, sorry about that," I said, unnerved by Viv's keen observation.

"It's okay. I really miss Jason too. I know exactly how you feel."

No. She didn't. She had no idea how I felt. How could she? She had a loving spouse and a stable family. Her husband hadn't abandoned her child, and her mother didn't just die, leaving her with no memories. Viv's world was intact. Mine shattered. The only thing that made me

feel whole was Alec. And he was gone too. Emptiness gutted my body and stung my eyes. I had to think of something else. Something uplifting. My mind slipped to the day I turned thirteen.

$$\backsim$$

"Happy birthday, sleepyhead," my mother whispered.

I moaned at her. "It's the weekend. I'm sleeping."

"I know, sweetie, but I have to work today, and I wanted to say happy birthday before I left."

I pulled the blanket over my head.

"Sorry I woke you, sweet pea. I'll just put this here on your bed. Have a fun day, and I'll see you at dinnertime."

I tried to go back to sleep and recapture my dream but couldn't. Frustrated and groggy, I sat up, throwing my covers aside and knocking my mother's gift to the floor.

"Cratzle," I said, appropriating my dad's invented word for crap. "What *is* this?" I picked up the package and tore it open.

A small, red-leather-bound book with blank pages edged in gold nestled inside the box. Lifting the elegant book to my nose, I breathed in the leather scent. It smelled like my father's study, bringing me instant comfort. I opened the book from the back and slowly turned the pristine white pages, imagining the words I would eventually write there, the dreams I would capture. Arriving at the front page, I saw an inscription in my mother's hand, a poem I would soon know by heart.

*Be like the bird who, pausing in her flight*
*Awhile on boughs too slight,*
*Feels them give way beneath her, and yet sings,*
*Knowing she hath wings.*
*-Victor Hugo*

# FOURTEEN

NO CITY HIJACKS THE senses like Venice. And Truman Capote
summed it up best: "Venice is like eating an entire box of chocolate
liqueurs in one go."

But getting to Venice, that final transition from land to sea, was more like
eating a stale box of Cracker Jacks just to get the prize. After parking and
before reaching the water, Viv and I traversed a junky commercial obsta-
cle course reminiscent of the old Pike Amusement Park in Long Beach.

Once at the boisterous dock, we had three transportation choices:
gondolas, *motoscafi*, and *vaporetti*. I always took the least expensive
option, the *vaporetti*, or water buses. Like US city buses, vaporetti
were grungy and often overcrowded, but they would get us where we
needed to go.

Hauling my bag toward the vaporetto stop, I turned to check on Viv
and saw a boat captain helping her into a *motoscafo*—a classic wooden
speedboat offering private transportation. Viv waved for me to join
her. I hesitated. I'd never taken one before but had always wanted to.
They were so sexy and out of my league. But since Viv was already on
board, why not?

Within minutes, we were racing toward our hotel. Standing at the back of the craft, we delighted in everything—the wind restyling our hair, the guttural din of passing boats, the briny smells, and the sights. Especially the sights—the gracefully rocking gondolas tugging against their tall, tethering stakes, the arched bridges reflecting the canal colors like petrified rainbows, and the exotic architecture magically rising from the sea.

The captain deposited us directly in front of our hotel, the Danieli—one of the grand historic hotels of Venice. Equally grand, though, was the bill for our exhilarating boat ride—equivalent to hiring a chauffeured limousine for the day in the states. I handed over the traveler's checks and silently thanked Tom for giving us so much extra "loot," as Viv called it.

The Dandolo family—who supplied Venice with four rulers, or doges—commissioned the Palazzo at the end of the fourteenth century, and it became the most resplendent palace in all of Venice. Entering the Danieli lobby felt like stepping into the Venice of old: handmade Murano glass chandeliers, Persian rugs, hand-carved marble columns, and ornate antique furniture. Even our suite was furnished with over-sized gilded antiques that made me feel like royalty.

By the time we got settled, it was five o'clock, so I suggested we go to the rooftop bar for a drink. I'd been there once before and was pleased to introduce Viv to something other than art. The bar had just opened, and we arrived first. The peaceful rooftop ambiance offered a soothing contrast to the cacophonous traffic on the water below.

We both ordered Bellinis—that classic Venetian cocktail of prosecco and peaches—and walked over to the terrace edge to admire the view, one of the best in Venice. From there, Venetian noblemen of old had scanned the waters for merchant ships from the East.

Also, from that spot, we could see directly across the lagoon to the dignified white façade of the Church of San Giorgio Maggiore. I pointed it out to Viv, explaining that Palladio had built it in the sixteenth century, and his designs represented the epitome of classical calm and harmony.

I told her we would go there the next day to see Tintoretto's mystical painting of the Last Supper.

The air the next morning looked hazy and dense with that famous diffused sunshine so inspirational to Venetian Renaissance painters. It produced a soft, warm light that made the historic buildings glow as we threaded through the noisy crowds along the Riva degli Schiavoni to catch the boat to San Giorgio Maggiore.

Stepping off the water bus, I noticed how the quiet, uncrowded piazza in front of the church stood in stark contrast to the busy promenade we'd just walked. And it reminded me of the differences between Leonardo's *Last Supper* and Tintoretto's.

Once inside the luminous church, I turned to Viv, dislodging my thoughts midstream. "The fact that Tintoretto created his masterpiece on a canvas with oils, as opposed to Leonardo, who worked on a wall with experimental paints, is only one of many differences between the two."

Viv gave me a puzzled frown.

"Remember what Leonardo's *Last Supper* looked like—an evenly lit room with a horizontal table right in front, Christ sitting in the middle with three windows centered on the wall behind him, and his disciples divided evenly on either side?"

"Yeah," Viv said, still appearing perplexed.

"And, if you drew a vertical line down the center of that painting, the right and left halves would be almost identical. Right?"

"I guess." Viv shrugged. "So?"

"So," I said, "I just want you to remember Leonardo's simple, symmetrical composition when you see Tintoretto's version of the same subject. That's all."

Viv shook her head.

"What?" I asked.

"Nothing. You just blow me away sometimes. You're so single-minded.

Is there even room in your brain for anything else but art?"

I narrowed my eyes, instantly defensive. Was there room in her brain for anything else but shopping?

"No, you're right, Viv, not much room at all. Nope, I'm chock full of art, stumbling all over it, in fact." I turned sharply on my heels. "The painting's over here."

"Don't get all huffy on me. I was just trying to point out that all work and no play makes Claire a dull girl."

*Claire is perfectly fine the way she is*, I thought, *no thanks to you.*

We crossed the harlequin-patterned floor in silence, our footsteps echoing off the well-worn stones, our bodies dwarfed by the building's colossal gray columns and massive round arches. It was impossible for me to stay annoyed in such a soothing environment.

Finally facing Tintoretto's masterpiece, I had all but forgotten Viv's snide comment and waved my hand enthusiastically at the painting. "Look at that."

Viv, who'd been gazing out into the vast space of the church, reluctantly turned toward my fluttering fingers. Her eyes flew open. "That's *The Last Supper*?"

"Yes, it is. So, how does it compare to Leonardo's?"

"It doesn't," Viv said. "I mean, they're totally different. There's nothing orderly or—what'd you call it—symmetrical about this picture. It looks like a free-for-all."

"Exactly," I said. "And that's the genius of the work. Who in their right mind would attempt to go head-to-head with Leonardo's perfectly calibrated and universally acclaimed masterpiece? Tintoretto was way too smart for that. He created the antithesis.

"Where Leonardo painted symmetrical order, Tintoretto painted asymmetrical chaos. Where Leonardo depicted Christ with his disciples only, Tintoretto included a slew of bustling servants and even a cat.

"And look at the lighting. Leonardo illuminated his scene with three windows of daylight, the center one framing Christ's head like a natural halo. But Tintoretto gives us a dark, windowless room, and the only

light comes from the flaming ceiling lamp and Christ himself, who radiates an otherworldly glow." I beamed at Viv, caught up in the magic of Tintoretto's visionary drama.

"But even with all the chaotic energy of this piece, Christ is still in the center, holding the scene together. Brilliant composition! And my favorite part of this painting?" I gestured in circles above my head. "The transparent angels swirling around the ceiling. Leonardo would have never painted such mystical creatures."

"Why not?"

"Well . . . can you imagine Tintoretto's ethereal angels cavorting around Leonardo's logically ordered space?"

Viv giggled. "They'd look like party crashers crashing the wrong party."

"Absolutely. They wouldn't have matched the style or the mood of the rest of the painting. And they wouldn't have fit the times, either. For Tintoretto to have even conceived of creating this scene the way he did, and for people to have appreciated its innovative style as they did, the timing had to be exactly right. And it was."

I looked back at the painting. "Tintoretto made this piece almost one hundred years after Leonardo's, at a time when the controlled and rational world of the Renaissance had mostly played itself out, and the emotionally charged Baroque period was on its way."

After finishing that sweeping statement, I heard it in a personal context. Was that going to happen to me? Just the idea of an emotional takeover made my brain whir like the sound of hummingbirds. I shook my head to clear the noise, but it didn't help. I closed my eyes and pressed my fingers to my temples, hoping that would stop my buzzing mind. But that didn't work either. Then I realized the noise wasn't coming from me. It came from *The Last Supper*.

I inched toward the artwork. The whirring sound had now moved above it. I glanced up. The angels. They'd taken flight. I watched in amazement as they soared far beyond the painting's frame and dissolved into the white light of the high windows before diving back into the smoky glow of the art piece.

I turned to Viv, but she wasn't looking. The illusion was all mine, and I wondered what it meant. Could that have been a warning? Was it inevitable that my carefully guarded emotions would eventually spill out like Tintoretto's angels? And, if they did, would I ever be able to contain them again?

⁓

Back at the Danieli, Viv and I returned to the rooftop to relax and grab a bite to eat. We weren't that hungry, so we decided to share a couple of appetizers—foie gras with caramelized figs and cantaloupe wrapped in prosciutto. Despite the delicious food, Tintoretto's angels still winged through my head, and I wished they'd go away.

Trying to think of something else—*anything* else—I saw Viv reach into her purse, and I immediately thought of her panic attacks. Was she looking for her pills? Was she going to have a seizure? I had no idea what to expect and felt I had to say something, but what? The subject had never come up, and I wasn't even sure I was supposed to know.

Then, I remembered a day shortly after Alec ended our affair when I had felt totally out of sorts. Maybe if I told that story, it would prompt Viv to talk about her panic attacks or perhaps even divert her from having one. It was worth a try.

"You know, this strange thing happened to me a while back. It started when I left the house to run errands, and it didn't stop until I had lunch with my girlfriend later that day."

Viv looked up from her purse, brows furrowed.

I knew how out of character I sounded—having no natural inclination to share personal stories—but I forged ahead anyway.

"It was like being in some sort of dream. Nothing around me seemed real, and I thought I couldn't talk. My fingers went numb. My entire body felt odd. But then when I met my friend for lunch, this huge wave of relief splashed over me, like I'd been doused with a bucket of water, and I returned to normal. Weird, huh?"

"So you had a panic attack," Viv said.

"What?"

"You know, a panic attack. I get them too."

"What do you mean, I had a panic attack? Why would *I* have a panic attack?"

"I dunno, but you had one. Numb fingers, feeling unreal like you couldn't talk, that's a panic attack. But they can be worse than that—chest pains, can't breathe. You were lucky."

My body went cold with recognition. Chest pains. Can't breathe. That was exactly what had happened to me when I learned about Noel's death. I felt gripped with fear all over again, but this time, I was afraid for Viv. Is that what happened to her? I shuddered. "So, do you know what causes your panic attacks?"

"Mine? Oh, they seem to grab me when I feel unsafe somehow, and they can be super bad. The pills I have don't always work, either."

My eyes bulged. "When you say yours can be super bad, what happens to you?"

"You sure you wanna know this? I mean, sometimes I puke. I even get this creepy feeling like I'm gonna die. I know it sounds wacko, but I kinda go nuts."

My jaw dropped.

"Don't worry. I'm not gonna have one now. I'm fine." Viv smiled, patting my hand. "Ready to go?"

She might have been fine at that moment, but what about later? What if something made her feel unsafe later? What then?

After lunch, Viv and I took the vaporetto from the Danieli to the *Gallerie dell'Accademia*. It overlooked the Grand Canal and housed a cornucopia of Venetian paintings from the fourteenth to the eighteenth centuries, including works by major Renaissance artists like Titian, Bellini, and Giorgione.

My apprehension over Viv's condition slowly dissolved as I extolled the virtues of Venetian Renaissance paintings with their luscious colors made possible by newly rediscovered oil paints and their detailed textures influenced by Northern European art. Venetian paintings, I explained, glowed with a light inspired by the dewy atmosphere of Venice, and their figures appeared softly rounded thanks to a shading technique called *chiaroscuro*. The paintings were also famous for their idyllic landscapes enhanced by atmospheric perspective—a technique that veiled distant objects in a blue-gray haze.

"What about this one?" Viv asked, stopping in front of *The Tempest* by Giorgione.

Her discerning eye surprised me.

"It's exquisite, isn't it? Giorgione was one of the Venetian Renaissance greats. Legend has it he was tall, handsome, a good musician, and a ladies' man. Unfortunately, he died in his thirties."

"Sounds like too much wine, women, and song to me," Viv teased.

I smiled. "Well, you might be right. According to Vasari, the great historian and gossip of the Renaissance, Giorgione died of the plague after carrying on 'a very pleasurable affair' with a lady already infected."

"Oh, man, that stinks. Poor guy."

"I know. It was a tragedy he died that young. He had so much potential. Even with such a short career, though, he still accomplished great things. He was a master at painting figures in landscapes. And they say he worked only from nature—a novelty at the time. He also met Leonardo da Vinci shortly before painting this piece and seemed to have appropriated his famous *sfumato* technique, where shapes are softened and blurred, making lines and edges disappear. That's how he got that gauzy-atmosphere look—perfect for Venice."

"But what's going on here?" Viv asked.

"Nobody knows. People have suggested lots of theories but nothing with any proof. Most believe a Venetian nobleman commissioned it. But even that's not for certain. You can make it mean anything you want. What do you think the story is?"

"Well"—Viv paused so long, I thought she'd forgotten the question—"she's a whore."

"Really?" I said, taken aback. "Well, some people have suggested that."

"Damn straight, she is. Why else would she be sittin' outside, buck naked, legs spread-eagle like it's no big deal? She didn't have to strip just to feed that bastard kid of hers. And the fancy-pants guy on the left lookin' at her? He's a john waiting for the kid to get off her tit before jumpin' her bones."

I was used to Viv's colorful language, but this was different. It sounded like someone else talking, someone gruff and angry.

"And she's totally wasted. That's how she's dealin' with all this. That's why her kid's stuffed beside her instead of on her lap. Who nurses that way? Of course, that also helps to show off her wares—killin' two birds with one stone, as they say. She might be strung out, but she knows what's what. This ain't her first rodeo."

Viv kept going as if in a trance.

"And she stares right out of the painting—see that?—like whoever's out there might be her next trick and competition for the guy in the picture. Didn't you say a nobleman probably ordered this? And what do they say men want? They want a mama and a slut. Well, here she is, all rolled up in one for 'em."

Viv paused a moment, looking hard at the painting as if searching for more evidence to support her theory.

"And that stormy sky?" Viv smirked. "Enter the so-called moral to the story—the cover-up. Just to give this sleazy scene some fake goodness, to pretend it's got a more holy purpose than the boys pitchin' tents, the storm's a reminder for all those God-fearin' Venetians that no good's gonna come of the sinnin' goin' down here. So they might just as well forget it."

"Wow, that's quite a full-blown scenario. How'd you come up with that? Did you read it somewhere?"

Viv looked in my direction with unseeing eyes.

"Sonia's a prostitute, and I got no clue who my dad is."

"Wait. Sonia? Oh my God. Sonia's your mother?"

# FIFTEEN

**THE ONLY STOP PLANNED** on our way from Venice to Florence was Ravenna. I had chosen the city for its splendid Byzantine mosaics—among the best in the world. In my mind, a visit to Italy wasn't complete without seeing those magnificent works of art, especially the ones in the Basilica of San Vitale—the only major sixth-century church still intact from the Golden Age of Justinian.

My enthusiasm for Ravenna, though, was overshadowed by Viv's shocking confession about her mother. It hung in the air and festered in my mind as I drove. Viv had said nothing more about it, but on our last evening in Venice, as I lay in bed reviewing my notes, I could hear her again through the wall, talking on the phone. This time, I knew exactly who it was, and I got up to listen.

∾

"Who's giving you my phone numbers? I thought I'd left you in the dust for good.

"Oh, Jesus, the babysitter? What a dumb shit.

"No. You'll never see Jason. No! You think I'd let you fuck him up like

you did me? Not a chance in hell! Stay away from us.

"What? You wouldn't dare! I'd slap a restraining order on you so fast your head would spin clear off and roll face down in the gutter. Did you hear that, Sonia? Sonia? You're babbling. Are you drunk? Shit." I heard the phone slam, but Viv kept yelling, "You can't pull this crap on me!"

Seconds later, she asked the hotel operator to place a call, and a few minutes after that, Viv's phone rang.

"Her line's busy? How can that be? I was just talkin' to her."

The phone banged down again, but Viv continued ranting. "Back to work so soon, huh, Sonia? Guess you couldn't wait to get off the phone with your mistake-of-a-daughter so your johns could call through. And you think I'd let you see my son? Ha. Satan'll be ice skatin' to work before that happens. You will never, *ever* lay your filthy hands on Jason!"

Viv's words stuck in my head as we drove toward the heart of historic Ravenna. I wanted to say something to support her. But I couldn't think of what to say. It was all too staggering. And I didn't want her to know I'd listened in on her conversation, either. So I stayed quiet, rationalizing that it would be best if Viv brought it up first and dreading when that would happen. How does one talk about a thing like that?

"Well, here we are," I said, speaking the first words of the entire drive. Viv had spent the trip reading her magazines, eliminating the need for conversation. I had to admit, I felt grateful.

"You go on. I'll wait here," Viv said.

"In the car? You'll melt."

"I'll roll down the windows, and if I get too hot, I'll go sit over there under the trees." She nodded toward a patch of green at the edge of the parking lot. "I'll be fine."

"But what about the mosaics? They're gorgeous, and there's nothing else like them outside of Turkey. You'd have to go all the way to Istanbul to see Byzantine mosaics as spectacular as these. They are *so* important.

You can't miss this. Really, you've got to see them."

"I don't 'got' to do anything, Claire." Viv glared at me. "Look, I'm beat. I need a break. We've seen tons of art—too much art—and I've been a damn good sport about it all. Just leave me alone."

"But . . ."

"Claire, back off."

Too much art? She wanted a break? She'd had plenty of breaks. That's what we'd had too much of—shopping breaks. I sighed, glancing sideways at Viv, who had focused again on her magazine, ignoring me completely. I sighed louder.

But maybe she had a point. Maybe I was overdoing it. She still had to be upset about that horrible exchange with her mom. And who wouldn't be? Having a prostitute as a mother was bad enough, but an abusive one who now wanted a relationship with Jason? I'd be furious if someone like that tried to get close to Amber. Over my dead body. No wonder Viv needed a break.

I stared through the windshield, visualizing the colorful mosaics just steps away inside the church. They would delight anyone, but the building's exterior gave no hint of the wonders within. Early Byzantine churches were plain on the outside to symbolize the insignificance of the body and earthly existence, while their brilliantly decorated interiors revealed the glory of the soul and the transcendent promise of heaven. I ran my hands over the steering wheel, continuing to mentally tour the dazzling church interior.

Wait. That was it. She needed to be dazzled, distracted. Who knew that better than me? Art wasn't the problem. Art was the solution. But how could I get her to see that?

While I considered my options, Viv put down her magazine and arched her back. "You goin' in or what?"

"Well," I said in my most cajoling voice, "I was thinking we should at least get out of the car to stretch our legs. I mean, we've been sitting for over two hours. Is your back cramping up?"

She ignored me.

"Well, mine is. And since the church is right there, why don't we stretch our legs inside? It'll be much cooler, and I think they have a restroom. I mean, we do need to take a bathroom break before getting back on the road."

Viv huffed. "Good God, you're a dog on a bone. Okay, ten minutes, that's it, and then we're outta here. No more stops till Florence. Deal?"

"Deal."

Stepping inside the octagonal church, we encountered a domed space surrounded by a complex combination of arches, columns, and a second-story gallery. I briefly considered explaining to Viv that the gallery was originally reserved exclusively for women, but I changed my mind. I had a mission and only ten minutes to accomplish it.

While Viv loitered indifferently near the entrance, I walked quickly past a handful of other tourists to the apse—the large semi-circular niche at the opposite side of the church. I dropped a coin into the box to turn on the lights. Although San Vitale had plenty of windows, the inside was still dim, and to see the Byzantine mosaics at their best, we needed light. Made of small pieces of colored glass that were often gold-plated, these mosaics glittered like jewels when properly lit.

The lights clicked on, and a collective "aah" emanated from the onlookers. There, in front of us, sparkled a continuous glass tapestry of the most extravagant colors and patterns. Even Viv gasped, dropping her indifference and dashing over to join me by the apse.

"Far out! Look at those details and that color. It's like Oleg Cassini's crazy beaded dresses. Is this where he got it? I know he's an American designer, but he *did* grow up and study in Italy." Viv pointed to the shimmering mosaic of elegantly draped women. "Who're these gals? They got kickass clothes."

"That's *Theodora and Her Attendants*. Some people say Theodora was the most influential woman in Byzantine history."

"What'd she do?"

"She was Emperor Justinian's wife and his top advisor. Many scholars even think Theodora ran the Byzantine Empire, not Justinian. Her

name's on almost all the laws passed at that time, including laws for women's rights, like property ownership rights and divorce rights. She established the death penalty for rape and made the trafficking of girls illegal. And that was way back in the sixth century."

I had always loved Theodora's story. Such a strong woman and a powerful role model. Gazing at the majestic mosaic, I wondered what it would have been like to have been her, and I visualized myself standing on the Byzantine Senate floor, prepared to argue against the law allowing women to be killed for adultery.

I looked around the exalted chambers filled with good ol' boys staring back at me, some with lecherous eyes, some angry at the gall of my presence, while others sat judging or simply amused. Their collective disdain made it clear I didn't belong there, and instead of fighting, I felt myself withering under their imagined gaze. But Theodora hadn't withered. She'd stood her ground and got the law abolished.

"She must have been the world's first feminist," Viv said. "That's so rad. And what a killer getup. Look how that jeweled collar and headdress pop against her purple gown. Primo. Who's the artist?"

"We don't know. There were probably several artisans and at least one master designer who worked on these mosaics. But in the Byzantine period, artists didn't typically sign their pieces. That was considered too prideful. They were seen as simple craftsmen working in the service of God. Quite the opposite of Renaissance artists who were seen as geniuses and whose names have gone down in history. Interesting, isn't it, how perception can change over time." I walked to a display stand next to the apse and found a pamphlet in English. "Want one of these? Looks like it's all about Theodora."

"Thanks, maybe there's something in here about her fashion sense." She opened the brochure and started reading.

"Perhaps, but it's probably just her bio . . ." I stopped, realizing Theodora's bio was the last thing Viv should read. I reached for the brochure. "Here, let's put it back. The bio isn't that interesting." But it was too late.

"Listen to this," Viv said. "This is rad. 'Justinian met Theodora when

he was about forty and she twenty-five. She was a former actress—a profession held in low esteem—and he was a senator. By law, senators were forbidden to marry actresses, so Justinian went to his uncle, Emperor Justin, to get the law rewritten.'" Viv looked at me, her eyes shining. "He must have truly loved her."

"Yes, it sounds that way. Speaking of Justinian, his mosaic is over there on the other side of the apse. It's amazing too. Let's go check it out." I tugged on Viv's arm.

Viv ignored me and kept reading. "'Theodora's father worked in a circus in Constantinople as a bear trainer. Her mother was an actress.'" She paused, nodding at me. "Well, that explains why Theodora was an actress, just following in her mother's footsteps." She flipped the pamphlet over and continued. "'Like most actresses at the time . . .'"

Viv stopped as if the next sentences were illegible. When she began again, she hesitated between words, like someone learning to read.

"'. . . Theodora was . . . a prostitute. She had one . . . illegitimate daughter who bore Theodora . . . her only grandson.'"

Viv looked at me. "You knew this all along, didn't you?" Her voice was cold, almost accusatory, as if I had brought her there specifically to rub her nose in her own sordid history.

"I'm sorry, Viv. I wasn't even thinking about that part of her story when I picked up the pamphlet. Honestly. I didn't mean to make you feel worse. You were so excited about her. I wanted to, I don't know, keep you interested, I guess."

Viv folded her arms and narrowed her eyes at me.

"But look at it this way," I said, grasping at straws. "Think about how Theodora never let her unfortunate situation stop her from becoming who she was truly meant to be—an empress and a powerful champion for women. That took a huge amount of self-confidence and amazing courage. What a role model she is."

Viv looked unimpressed. "Are you done, little Miss Sunshine? Your ten minutes are up."

# SIXTEEN

**ALL I'D WANTED TO** do in Ravenna was take Viv's mind off her mother, but instead, I'd refueled her fury—a rage that now spilled over onto me. We needed to talk. She had to know I was on her side. But how did I broach a delicate topic like that? I couldn't exactly say, "I'm sorry to hear your mom's a prostitute. What a shame." Not the most sensitive choice of words.

So I said nothing, trying, instead, to focus on driving and the cinema of green playing across the windshield. Trees, fields, ponds, tractors, even the red-tiled roofs had patches of green. The repetitive color eventually uncluttered my mind, allowing me to finally speak up.

"Pretty countryside, isn't it? Lots of green."

"Yeah," Viv said, looking up from her magazine.

I gave her a nervous smile. "So, um . . . we need to talk, don't you think?"

"Are we getting close? I'm totally pumped about Florence. Can't wait to go shoe shopping. Florence is famous for its shoes, ya know." Viv chewed her gum with relish.

"No. I didn't know," I said, confused by Viv's new upbeat disposition. Weren't we just riding a Tilt-A-Whirl of despair? Why was she so excited about shoes all of a sudden?

Refocusing on the calming scenery, I decided the shoes were a smoke screen. Her way of coping. I felt sure she needed to talk about her mother, but she didn't know how.

"Um . . . about your mom—"

"Don't worry," Viv interrupted, "I know where all the best shoe stores are. Hey, we must be getting close. I just saw a sign. Firenze means Florence, right?"

*Okay, guess I was wrong.* Apparently, she didn't need to talk about her mom after all. She seemed miraculously over it—her mother, that was, not the shoes.

I returned my full attention to the autostrada, a task that had gotten increasingly easier with each drive. But navigating cities was still another matter, with their countless roundabouts turning every Italian motorist into Mario Andretti. Fortunately, our hotel in Florence—the Grand Hotel Firenze—sat next to the Arno and could be reached from the less-congested side of the river, the Oltrarno.

Like the Danieli, the Grand Hotel Firenze was a historic architectural gem. Brunelleschi, the famous fifteenth-century Renaissance architect, built it as a palazzo for a noble Florentine family, and it became a hotel in the eighteenth century. As I admired its perfectly balanced proportions, I realized I was being treated to some of the best lodgings in Europe—accommodations way beyond my own means.

As we checked into the hotel, my mind returned to Viv. Even though she appeared to be fine, it must have been an act. Traumatic things like that didn't just go away—a fact I knew all too well. I needed to support her. And if that meant shopping until we emptied all the shoe stores in Florence, so be it.

Once in our suite, though, Viv's excitement about shoes dissolved. She flopped onto the loveseat and looked vacantly out the window.

"Want to go for a walk?" I asked. "We could explore the Oltrarno, that area we just drove through." I saw it as the perfect non-touristy neighborhood for clearing both our heads.

Viv shrugged. "Okay. That looked kinda cute. What's there?"

"Lots. There's all kinds of craft and antique shops, cute little bars, and the Pitti Palace. It used to be the Medici family's main residence, but now it's the largest museum in Florence."

Viv's eyes glazed over. She clearly had no interest in museum-going, and to be honest, neither did I. "Don't worry, we won't go to the palace. We can just stroll the neighborhood and wind our way up to San Miniato."

"San what?"

"San Miniato al Monte. It's one of the oldest churches in Florence, with a spectacular view, and it's one of the best examples of Romanesque architecture in all of Tuscany."

"Okay," Viv said with a tepid smile. "Sounds better than sittin' here."

Leaving the hotel, we walked beside the Arno wall, with its tall, wrought-iron lamps looking like sentries guarding against the river's historic floods. We crossed the famous medieval bridge, the Ponte Vecchio—crammed with jewelry stores, souvenir shops, and tourists—pausing here and there to admire a particularly handsome ring or bracelet but buying only postcards for our kids.

Once on the other side of the Arno, we wandered the narrow medieval streets, browsing the artisan workshops that smelled like leather and iron and cut wood. Eventually, we stopped for an espresso at Il Rifrullo, a charming neighborhood bar on Via San Niccolò.

"So, what's Romanesque?" Viv asked as we sat down on the outside terrace with our coffees.

The question surprised me. Viv *wanted* me to talk about art? She *really* must have been determined to keep the conversation off her mother.

"Well," I began, "it was a medieval time period and an art style that lasted from about the eleventh to the thirteenth centuries."

"So, what's the art like?" Viv asked with no real curiosity in her voice.

I thought for a moment, considering how to describe the style. I wanted to refer to the Byzantine mosaics we'd seen in Ravenna. They'd also been created in the Middle Ages, only much earlier. But I didn't dare. So I decided to explain medieval art as if we had yet to see any.

"Art from the Middle Ages can take some getting used to. It's nothing like the realistic works of the Renaissance. To appreciate it, you have to look at it from a different perspective. First, you have to understand what the artists were trying to do and why."

"What do you mean, 'what the artists were trying to do?' They were trying to make art, duh."

"Well, it's a little more complicated than that." The attitude in Viv's voice was like the whistle of a tea kettle. Beneath the sarcastic spouting, she boiled. Although part of me wished I could shake her, I didn't want to upset her any more than I already had and decided to let her boil down on her own. I swallowed my irritation and continued.

"In ancient and medieval times, artists made their livings mostly from religious commissions, so their art needed to express the current beliefs. Ancient Roman artists, for example, depicted their multiple gods as idealized nudes because the official Roman religion believed the gods had perfect human bodies that reflected perfect, immortal souls. Romans also thought their gods' spirits resided in the artworks. So they worshipped the images as idols."

I paused to see if Viv was listening, but I couldn't tell. Her eyes were hidden behind sunglasses, her face expressionless.

"By the second century AD, though, Christianity had spread throughout much of the Roman Empire, and we begin to see artworks reflecting Christian ideas, which were in total opposition to the Roman religion. The Christians believed in only one God whose vast spirit could never be contained in an artwork to be worshipped. And thanks to the biblical story of Adam and Eve, the human body was perceived as sinful, not a reflection of a perfect, divine soul. It was merely a shell the soul was trapped in while on Earth."

Viv still showed no signs of engagement, and it occurred to me that she was like a shell—a seashell—protective and fragile at the same time. I took a sip of coffee and continued.

"So, for the early Christians, ideal bodies in religious art were to be avoided at all costs, not only because the body was sinful, but also

because beautiful bodies invited idol worship as practiced by the Roman religion—their primary competitor.

"The Christian church, though, still needed art with human images to teach the Bible stories to a mostly illiterate population. And that presented a dilemma for the artists. To relay those sacred stories, they needed to create identifiable human forms, but the bodies couldn't be idealized or too realistic for fear of idol worship. They also needed to convey spirituality, but again, it couldn't be in the form of a beautiful body. And the only art to turn to for inspiration was Roman art, where idealized human forms were the very embodiment of spirituality. See the dilemma?"

Viv remained unresponsive, and I imagined her lost in a sea of tormented thoughts. I wished I knew how to rescue her, but the only thing I knew how to do was to keep lecturing.

"But early Christian artists were resourceful and did find a few things in the Roman repertoire they could adapt for their needs, like the rays of light used to identify the Roman sun god. Christian artists took that idea and made it a symbol of Christian spirituality. So the halo, like that brilliant glow around Christ's head in Tintoretto's *Last Supper*, goes all the way back to the pagan Greeks and Romans. How to depict the body, though, presented a more difficult challenge."

"What'd they do, make stick figures?" Viv's tone was pure sarcasm, but at least I knew she was listening. At least I had a chance of wrenching her from her woes.

"Well, they could have, but put yourself in their shoes. You're an artist competing with other artists for those commissions. To win, you must come up with the best solution. I'm not sure stick figures are the best. What do you think might be better?"

"You're asking me? How the hell should I know? I think stick figures would've been peachy-keen."

I'd had it with Viv's attitude but decided to try one last time to turn her around. "Okay, how about this? Pretend you're a medieval artist with a major commission to make a sculpture of—let's say—one of the

saints. Your goal is to create a recognizable but unrealistic image of a spiritually enlightened being. Remember, the body is a sinful shell and can't be perceived as an idol of worship. Got it? Let's start with the head. What would it look like? Is it important?"

"Of course it's important," Viv scoffed. "A person has to have a head, or it's not a person."

"Okay, but what would it look like? What size would it be? What would the eyes, ears, and mouth look like?"

"My guy's head would be big and round with big, wide-open eyes." She tossed the words out with little thought.

"Okay, why?"

"Why?" I could see Viv's wheels starting to turn. "Because the head's where the story comes from. If the figure's gonna tell a story, the head needs to stand out, and the eyes do too. Eyes can tell you a lot about somebody. What is it they say? 'Eyes are the windows to the soul?'" Viv wiggled her eyebrows at me, hinting her doldrums were waning.

"Yep, that's what they say. What else?"

Viv thought for a second. "I'd give him big ears, too, to hear the Bible stories. Oh, and to hear God. That's important. And a big mouth to tell the stories with." At this point, Viv was hooked. "The body would be small, because it's not important, and it would only include enough details to show it's human: arms, legs, hands, feet, no muscles, and for sure no pecker. Wait a minute. The body's bad. It needs to be hidden. Okay, scratch all that. I'd hide the whole body under a big ol' blanket. That oughta do it."

She turned her eyes upward, as if trying to visualize the figure in her head. "This is gonna be one funky-lookin' dude. No one would worship this guy."

"And that's the point," I said. "The figure needs to look 'funky' to solve the problem. It needs to symbolize a human body, not believably depict or glorify one. When we get to San Miniato, we'll see how your idea compares to the artwork inside the church."

I downed the last of my coffee and smiled. Viv seemed to be coming

around.

Leaving a five-hundred-lire coin on the table, we set out again, ascending the tree-lined Viale Galileo and mounting the stairs to the hilltop church.

Breathless from the steep climb, we rested on the terrace, absorbing the sweeping view across the terracotta roofs and treetops. The bright cerulean sky dissolved into the blue-gray haze of the distant hills—a perfect demonstration of atmospheric perspective.

"Majestic, isn't it?" I said, pointing to the cathedral in the distance. "That's the Florentine Duomo. It's one of Italy's largest churches. Only the Milan Cathedral and St. Peter's Cathedral in Rome are bigger."

"Wow, it looks humongous even from here. It takes over everything."

We continued scanning the skyline for a few minutes more before turning to explore the goal of our arduous climb—San Miniato al Monte.

The church's façade, patterned with green and white marble, looked flat and decorative. Five round arches, each supported by green columns, undulated rhythmically across the lower level of the church and framed five rectangles that alternated between green doors and delicately veined white marble panels. The gabled second story repeated the rectangular and arched motif on a smaller scale and added circles, triangles, and diamonds to the mix. The whole thing formed a striking geometric puzzle that continued inside the church onto the floors and walls. On each side of the central aisle, or nave, freestanding marble columns supported round arches that hypnotically moved the eye toward the altar and the apse behind it.

And there, on the elevated choir in front of the apse, stood the intricately carved thirteenth-century marble pulpit I specifically wanted Viv to see.

"What do you think?" I asked, pointing to the figure embedded in the pulpit.

"Oh," Viv said, "it looks like mine." She giggled at how boastful she sounded. "Well, sorta like mine. He's got the big eyes, anyway."

"Yes, he does, and the big head. See how well that works? Because of

its size, the big head is the focal point of the figure, and the big eyes are the focal point of the head. Doesn't he look like he's all-seeing, focused on something beyond? We can recognize his features as human, but he seems more otherworldly than human."

"And his clothes cover his body kinda like a blanket," Viv said, "just as I pictured it. Well, not exactly, but close." She scrutinized the piece. "And look at his little knobby knees poking out against his robe, letting us know there *is* a body under there, but not enough to raise idolatry flags." She flashed me a smug grin.

"True," I said, impressed by Viv's astute observation and surprised by the way she expressed it—like a seasoned art historian. I pointed again to the figure. "And see how he stands so rigid and straight, his back flat against the pulpit and his arms and hands attached to his body? Nothing is carved completely free. This allows him to function as both a figure and a pillar, which dehumanizes him further. He's part of the pulpit, so he can't be misconstrued as potentially real, as capable of movement, or worse, as an idol for worship . . . even with those adorable knobby knees." I grinned at Viv. "This little monk symbolizes enduring, unshakable faith, which is beyond physical reality."

Viv nodded, still visually engaged with the pulpit. "He is pretty rad, but I don't think I could have appreciated him quite the same way if you hadn't made me visualize it first." She turned toward me with genuine gratitude in her eyes. "Thanks, Claire."

I touched her elbow. "You're welcome, Viv."

Heading back down the hill to the crowded center of Florence, I kept thinking about the sculpture and why it captivated me. Yes, I found it charming and innocent in its simplicity, but more than that, I found the monk's spirit inspiring. His calm, erect stance and unwavering, wide-eyed gaze made him look stalwart and confident—a pillar of inner strength.

<p style="text-align:center">✐</p>

Back at the hotel, we planned to rest before dinner, but Viv got side-tracked discussing the best stores in Florence with the concierge. So I went upstairs alone.

Although I was relieved that Viv seemed better—her rekindled shopping instincts a good sign—it still bothered me that she had yet to mention her mother. She must have been worried sick over the thought of Sonia meddling in Jason's life, and I wondered if she'd told Tom about it yet. She needed a sounding board, and I was happy to oblige, but I had to get her to open up first. If she didn't broach the subject soon, I decided I would.

As I settled onto the loveseat, a hotel employee knocked on the door and presented a silver tray with a sealed note for Viv. He explained she'd received a phone call while we were out, and this was the message. I looked at the envelope and figured it was Sonia. My first thought was to throw it away. Viv was finally pulling out of her slump and didn't need another setback. But I changed my mind. This note was the perfect catalyst for a heart-to-heart conversation about her mom. And besides, I'd have been upset if Viv threw away a message meant for me. What if Amber's camp had called to tell me she'd had an accident, or Mara called to say Alec had left his wife, and I never got word? I put the note in my pocket.

At dinner that evening I gave Viv the envelope. She opened it, made a face, and stuffed it in her purse.

"Who called?" I asked.

"No one."

"Well, it had to be someone, and from the expression on your face, it certainly wasn't Tom." This was my chance to take charge and press her into talking about her mother.

"No, it was no one important. What are you gonna eat? I can't decide."

"I can't either, but come on, who was it?" I liked the sound of a new, bolder me, pursuing a difficult topic because I believed it needed to be addressed instead of wishing it away like I usually did.

"I told you it was no one, and it's none of your damn business anyway. So drop it."

The look in her eyes added, *or else.*

"Okay," I said, retreating at the first hint of conflict, furious with myself. Why was it so difficult for me to be assertive? And why was she so tight-lipped? It wasn't like her. We needed to talk about this. Didn't she see those upsetting phone calls impacted me too? Like it or not, we were in this together.

# SEVENTEEN

**I HAD NO INTENTION** of buying anything in Florence, but the next day, after spending hours with Viv in the endless shoe shops, I began trying on shoes for entertainment. At Salvatore Ferragamo, I found a gorgeous pair of hand-stitched black and brown leather sandals that fit me perfectly. Four gently rounded straps of smooth, caramel-colored leather traversed my toes, while velvety-black swaths of suede cupped my heels and encircled my ankles.

Viv looked up from her own shoe fitting and saw me admiring my newly clad feet. "I'm gettin' you those. They're primo."

"Don't be ridiculous." I leaned over to whisper, "Look how much they cost."

Viv glanced down at the price tag and said at full volume, "For shoes like these? That's a drop in the bucket. Anyhow, you're worth it. You've busted your butt trying to cram art down my throat. I mean, into my thick skull. You've earned those shoes." Viv laughed and winked.

"Gee, thanks, Viv. That's a very kind offer from someone who feels like a stuffed goose." I winked back. "But I can't accept it."

"Nope, I'm buying 'em," she said, chewing her gum like she meant it.

But taking advantage of Viv's generosity like that made me feel guilty.

She and Tom had already been so benevolent with the terms of my employment that I couldn't possibly allow them to spend one more cent on me. They were such magnanimous people. They even reminded me of the great Florentine art patrons, like the Medici, exchanging their gold coins for cultural enrichment.

And if Florence was anything, it was culturally rich. Exploring its maze of streets felt like walking through an Italian Renaissance art book, and I itched to turn the pages. But I knew from Viv's determined expression that we weren't going anywhere—like she said—until I owned those shoes. So, in the interest of keeping Viv's art education on schedule and my conscience guilt-free, I bought the shoes myself and quickly guided Viv from the store to the Bargello, the oldest public building in Florence and a treasure trove of Renaissance sculpture.

The austere thirteenth-century stone fortress had always felt ominous to me. For two hundred years, the Bargello served not only as police headquarters but also as a prison. Its courtyard had been the site of public executions—a fact that made me shiver despite the sun-warmed day.

Leaving the haunting oppression of the courtyard behind, Viv and I climbed the massive outdoor stairs and entered the second-floor gallery, where Donatello's seductive sculpture of David awaited us. David, the biblical hero who killed the giant Goliath with only a slingshot, was a popular Renaissance subject, but even more so in Florence, where the brave boy became the symbol of the invincible city.

"Here's the thing about this piece," I began. "It's considered to be the first freestanding male nude since ancient Roman times."

I let that impressive fact sink in before continuing.

"If you think back to yesterday and the monk carved into that pulpit, you can see what a leap this was from the Middle Ages."

"Humongous," Viv said. "How'd they get from that to this?"

"Well, we know medieval figures looked the way they did—symbolic and unrealistic—to communicate, in part, that the body was an insignificant shell and not an idol to be worshipped.

Viv nodded.

"And even though Christianity won out early in the Middle Ages, and idol worship stopped being a real concern, artists continued making unrealistic figures because their only artistic source by that time was other Christian art. Ancient art and knowledge had mostly disappeared when civilization collapsed at the end of the Roman Empire."

"But why didn't they just look around at the real world?"

"Nature wasn't a reference for medieval artists either, because they saw the physical world as inferior to the spiritual."

"What changed?"

"Well, by the fifteenth century, when Donatello created this sculpture, Europe had become re-civilized and safer, which allowed for a better exchange of knowledge and the rediscovery of classical sources, both visual and written.

"As cities like Florence grew more prosperous, people began to embrace the wisdom of the ancient Greeks and Romans, who extolled human achievement and free will. Instead of seeing themselves as puppets with God pulling the strings, they believed that God helped those who helped themselves. And they no longer saw the physical world as inferior to the spiritual. It was an extension. Heaven and Earth, body and soul were once again perceived as reflections of each other, not mutually exclusive.

"So with Donatello's *David,* the idealized nude reappears not as a pagan idol but as a human being triumphing on Earth, with a beautiful body reflecting a beautiful, biblical soul. It represents a daring creative leap."

I continued to gaze at the sculpture, pleased with my streamlined explanation of the complex transition from medieval to Renaissance art. And I felt sure Viv would grasp the revolutionary shift in perspective embodied by Donatello's *David.*

"Why's he wearing a girl's hat?"

"It's not a girl's hat," I said with irritation. "It's either a helmet or a Greek peasant's hat, but it's definitely not a girl's hat."

She should have been ruminating on Donatello's groundbreaking creativity, not the gender of the sculpture's headgear. I had to admit, though, Viv wasn't the first to make that observation, and it did look feminine.

"But you're right," I said. "It does resemble a woman's hat. At first glance, that victory wreath circling its brim looks more like flowers than laurel leaves."

"His long, curly hair makes him look like a girl too."

"To me, it makes him look gentle."

"Okay, gentle, sure, but in a girly kinda way."

"I think you're missing Donatello's message here. He wasn't trying to make David look like a girl; he was trying to make him look too gentle to kill Goliath with his physical strength. David destroyed the giant with his spiritual strength. Look at him. He has the soft, barely muscled physique of a young, innocent boy."

Viv wasn't convinced. "But what about that face? It's so delicate. And that expression—lowered eyes, lips parted into a shy smile. I know a come-hither look when I see one."

"He's not girly, Viv. He's sexy."

"Like a girl."

"No, more like a . . . hermaphrodite."

"What?"

"Donatello not only stripped *David* of any hint of muscle-bound masculinity, but he filled him back up again with such a pure form of sensuality that it's both masculine and feminine."

Viv rolled her eyes. "Bullshit."

"No, wait, hear me out. What you see as girly, I'm calling universally sensual. Look at his *contrapposto* pose, for example."

"Huh?"

"*Contrapposto* pose. It refers to the relaxed stance first used in art by the ancient Greeks. But with Donatello's *David*, it's on steroids." I replicated *David's* posture by shifting my weight onto one straight leg, bending the other, and moving my torso in an exaggerated, S-shaped sway. "I mean, how universally seductive can you get?"

"Okay," Viv said. "I get it. It's more about sensuality than girlishness, but I still see it as feminine. I mean, come on, now—naked except for the hat and the boots? That doesn't scream 'striptease' to you?"

I tried to think of an academic response but gave up. "You got me on that one—definitely exotic dancer material. But that's not exclusively a female thing. Think Chippendales."

"He reminds me of that Randy Newman song. You know the one? 'You Can Leave Your Hat On.'"

"Oh, I do," I said, hearing the erotic striptease lyrics in my head and smiling at Viv's spot-on irreverence.

"So, was this typical in the Renaissance? This something-for-everyone sexiness?"

"No, not so much. Freestanding figures, *contrapposto* poses, idealized nudes, all that became typical. But the supercharged, ambiguous sexuality of Donatello's *David* seems to have been his very own expression."

"Was he gay?"

"Donatello? Well, possibly, but like Leonardo, there's no real proof. We do know he lived with his young workshop assistants, never married, and never had children, but the facts stop there. No accusations were made against him as there were against Leonardo. So in Donatello's case, the claim rests mostly on anecdotes and his sexually suggestive sculptures of males.

"But it's important to keep in mind that he created a wide variety of 'types,' including a decidedly old and unsexy prophet nicknamed *Zuccone*, or 'pumpkin head.' So saying he's gay because he depicted a homoerotic figure like *David* is more speculation than fact."

"Okay, then I, for one, will let sleeping dogs lie. No need to slander another great artist."

"Why do you insist on equating the word 'gay' with slander? We don't live in the Renaissance. It's not a crime to be gay."

"Well, you're sure not shoutin' it from the rooftops."

"No, I'm not, but that's because we don't know for sure, not because I think saying he's gay is slander."

"Like I said, let's just let sleeping dogs lie. Gay or not, his *David* is drop-dead gorgeous." Viv smiled and returned to admiring the seductive sculpture. She obviously had no desire to pursue the conversation further.

I wanted to strangle her but, as usual, I kept my negative impulses under wraps. Why did she think being gay was shameful? Didn't she realize many of the fashion designers she idolized were gay?

My irritation gradually cooled as I joined Viv in silent admiration of *David*. His provocative aura saturated the space around me, stirring my longings again for Alec and reminding me of the sensual bliss we once shared.

It was nighttime at home, and I wondered if Alec still dreamed about me the way he told me he used to.

⁓

"I missed you," Alec said the minute I opened the hotel room door.

We were six months into our affair and hadn't seen each other for two weeks.

"Really? What'd you miss about me?" I asked, feigning indifference.

"Well, I missed those funny little ears of yours, for one thing. And, of course, those freckles." He tapped my nose. "But your mouth? I can't even tell you how much I missed your mouth."

He ran his fingers lightly along my lips, making me shiver with anticipation.

"I had a dream about us last night," he said, wrapping his arms around my waist. "We were in this huge lake in a tiny sailboat gliding toward shore. As we got closer to land, we could see a volcano erupting and the sky blackening with smoke. But our boat kept sailing toward the disaster until, at the last moment, it lifted into the sky and disappeared."

He eased his hands down the small of my back and kissed me deeply. I felt like I was drifting through layers of silken clouds.

"That's a pretty transparent dream," I said, our mouths still touching.

"If only we could just disappear."

∽

I rubbed my face, trying to negate the memory. That was only a stupid dream, and Alec was nothing more than an idle dreamer. "You have to move on," I said out loud.

Viv startled. "Oh, sorry. I'm good with moving on. But it's hard to leave ol' Davy boy here. He really *is* sexy. Don't you wish you could touch him?"

"You have no idea . . ." I mumbled as I turned toward a second sculpture of *David*, only a few feet away.

Clearing my throat to dislodge my wistfulness, I stepped up to the artwork and returned to the task at hand. "Now, this *David* was created about thirty years after Donatello's by another famous Renaissance artist called Verrocchio, which means 'true eye'—a perfect nickname. And, as you can see, this *David*'s beautiful too, but not in the same way. Look how defined and angular the body is."

"Yeah, too bad he's not naked."

"And that's another difference." I was determined to keep the exchange purely academic this time. "Being clothed makes him less alluring and helps us focus on his victorious act instead of his body.

"And notice his confident pose. He raises his head and places his hand flat on his hip instead of gracefully curved like Donatello's. Even the way he holds Goliath's sword is different. Donatello's *David* points the sword toward the ground, while Verrocchio's points it out, making him appear ready to tackle whatever comes next. This *David* is proud of his accomplishment." I nodded at Donatello's. "And that *David* is introspective about his. In both cases, though, the artists created distinct, believable personalities in idealized bodies, just like the ancient Romans." I paused. "So which *David* do you like better?"

"Hmm . . . I dunno. I mean, Donatello's dreamy *David* is so sexy, but his frilly hat and Shirley Temple ringlets still bug me." Viv looked back

and forth between the two. "I like the face on Verrocchio's better. His *David* looks more alert, a more take-charge kinda guy. And he's got better hair."

"Well, you know, Verrocchio created this piece when Leonardo da Vinci became his apprentice. And some say Leonardo modeled for it."

"No shit. Wow. That Leo was a looker." Viv pondered the two sculptures some more. "Ya know, now that I think about it, I for sure like Verrocchio's *David* better. I'll take a doer over a dreamer any day."

*Yep,* I said to myself, *and so should I.*

# EIGHTEEN

**THE STONE-PAVED ROUTE TO** the *Accademia*—home of Michelangelo's *David*—wound tightly around the back of the Florentine Duomo, allowing a detailed view of the cathedral's richly patterned exterior.

"Fantastic from this perspective, too, isn't it?" I said, stopping to admire the elaborate geometric designs of white, green, and pink marble. "And up there is its *pièce de résistance*. The dome that stumped everyone for over a hundred years."

"Why's that?"

"Well, the cathedral's thirteenth-century design called for an octagonal dome larger than any built before, but no one knew how to construct it. So the back part of the church went topless, or scantily clad, until the fifteenth century, when Brunelleschi—a goldsmith by trade—finally figured out a way to solve the problem. And that solution made him the most famous architect of the Early Renaissance."

"Isn't that the guy who built our hotel?" Viv asked.

"Yes, it is. Good memory. He's also the guy who figured out linear perspective—a true Renaissance man . . . uh-oh, look out." I noticed an approaching tour group and backed the two of us out of the way. The guide, sprouting a red umbrella above her head like a flower, stopped

her unruly flock of college students right in front of Viv and me. She looked about fifty, but I figured it was probably just from exhaustion. Her face was filled with frustration. Her body slumped.

"*Excusez-moi, tout le monde.* Excuse me, class. Please to pay attention, everyone, please. *Attention, s'il vous plaît.*" She pointed to the dome. "Who can know architect of cupola?" Her English was hard to understand, but her French was perfect. "*C'est magnifique, non?*" She clapped her hands. "*Attention* . . . please . . ." Her voice sounded like she'd been yelling all day, and it finally trailed off in defeat.

She turned toward three girls standing next to her, the only ones paying attention, and resigned herself to talking exclusively to them. While the guide enlightened the attentive threesome, the rest of the class plopped down in the middle of the walking street, opening backpacks and pulling out snacks.

I'd seen this kind of inappropriate behavior before with tourists in foreign countries. They acted like they were invisible, or more accurately, like the rules of decorum didn't apply to them. It was as if their ignorance of the language gave them a license to misbehave.

My heart went out to the tour guide. Poor thing. She had no control over them. I watched with increasing irritation as the picnicking group snacked on cheeses, salami, and bread until I saw one girl open a bag of egg-shaped candy. At that point, I did something entirely out of character. I took action.

"Hi there," I said, stepping up to the girl with the candy. "You look like Americans. Where's your group from?"

"Costa Vista College."

"That's in California, isn't it? I'm from Long Beach. My name's Claire. Mind if I join you?"

The girl looked puzzled but shrugged. "Okay, want a chocolate egg?"

"Thanks. Have you ever tried standing an egg on end?"

"No," the girl said, giving me that same quizzical look.

"Want to try it?"

"No. I wanna eat it."

"I'll try it," the boy next to her said.

"Great, what's your name?"

"Jim."

"Okay, Jim. First, we need to find something flat and level to balance the egg on."

"I've got a clipboard," another girl from the group said. "We can put it over there on the rim of that pot."

She and her friend walked over to a large potted plant by the Biffoli Shop directly across from the cathedral.

"Perfect," I said, joining the girls and calling back to the group in a loud voice. "So, who thinks they can stand an egg on end?"

"I told you," Jim said, striding over to the plant with three of his friends. "Me."

"Okay, Jim, here you go."

He held the egg horizontally on the clipboard.

"No, not that way. The challenge is to stand it up on one end."

Jim's friends laughed with exaggerated delight at his mistake, and the bulk of the seated kids jumped to their feet to see what was going on. Even the tour guide with her obedient threesome came over.

Jim played around with the candy for a few seconds more before declaring, "It doesn't work. You can't stand an egg up like that."

"Really? Are you sure?"

"Yeah, I'm sure."

"Positive?"

"Yes, positive."

"Absolutely, positively sure?"

"Yes. You cannot stand an egg on one end!" Jim shouted in exasperation, snagging the attention of Viv, the few students remaining on the ground, and a handful of random onlookers.

"Well, don't feel too bad that you couldn't do it. You're in good company. Legend has it the guy who designed that dome up there asked the same question and got the same answer. But it wasn't an idle challenge. He proposed whoever could stand an egg on end should get the

commission to build the dome."

"That's a stupid proposal," one of the last girls to join the group said. "What does standing an egg on end have to do with building a dome?"

"Well, think about it for a minute. For over a hundred years, no one could figure out how to build a dome big enough to cover this church's crossing—that huge area where the four arms of the church meet. But in the fifteenth century, several artists entered a contest for the prestigious and lucrative opportunity to do what no one had done before. Do you see a parallel between the problem of the egg and the problem of the dome?"

"Oh, I get it," Jim said. "Both things were considered impossible, so if you could solve one, you supposedly could solve the other."

I nodded and smiled.

"But it still doesn't make sense. They're entirely different." Several of the students around Jim bobbed their heads in agreement.

"Yes, that's true, but they do have one important thing in common: each problem would require a leap of the imagination to solve it. To successfully construct that dome, the builder had to be a creative thinker, and you also need to be a creative thinker to stand an egg on end, because it can be done. The architect who set up the challenge did it."

"How?" Jim asked.

"By hitting one end of the egg against the surface to flatten it."

"Aw, he cheated," Viv spoke up from the crowd. "Any bozo coulda done that."

"Yeah," a couple of students called out.

I grinned. "Our architect's contemporaries said that, too, though probably not in those same words." I winked at Viv. "And he just laughed at them, saying according to that logic, they were claiming they, too, could make the dome"—I surveyed the attentive faces around me—"but only if they saw *his* design first."

The students exchanged glances, a few nodded with appreciation, while others smiled at the clever trap the architect had set.

"Does anybody know who created that dome?" I asked. "He's gone down in history as the most famous Early Renaissance architect."

"Brunelleschi," said several students at once.

"Right. And the main message of this apocryphal tale is: It's one thing to copy. That's easy. But it's another thing entirely to be creative, to take that leap of the imagination and come up with an original idea."

Sparked by the story, the students turned to each other in spirited conversation, while Jim popped the entire egg into his mouth and gave me a chocolaty grin.

I laughed at him, pleased with myself.

"*Merci beaucoup*, thank you so much," the tour guide called out as she threaded through the crowd to my side. "My name is Simone."

"Hello, Simone. I'm Claire. So nice to meet you." I shook her hand with both of mine. "I'm sorry for kidnapping your group."

"Do not apologize, Claire. What you did was to save me, not kidnap group. The pleasure to make your acquaintance is for myself, *vraiment*." Simone smiled and turned to her class. "Okay *tout le monde, allons-y*. It is time to go." She "resprouted" her umbrella. The students responded quickly, and in seconds they were off, several of them staring up at the impossible dome as they walked away.

Viv sauntered over to my side, grinning. "You sure took care of that buncha yahoos. How'd you know it'd work?"

"I didn't. I just took a leap of faith. That poor woman looked so defeated, I had to do something."

"I'd say you took a leap of the imagination. That was a damn creative solution."

"Well, I don't know about that. If Jim hadn't taken the bait—or I guess I should say the egg—it would have been a whole different story." Although I outwardly declined to accept credit for the successful coup, internally I did a victory dance.

"Okay, shall we go?" I said. "Michelangelo's *David* isn't far. But let's swing by the Baptistery first. It's right over there, and it's just as famous as the Duomo."

Arriving seconds later at the cathedral's Baptistery, I pointed out Ghiberti's gilded bronze doors that Michelangelo had proclaimed as so

beautiful, they were "fitting to be the Gates of Paradise."

"You know," I said, "this was the second set of bronze doors Ghiberti created for the Baptistery. He won a major commission at the start of the fifteenth century for his first set, now on the north side of this building. It was those doors that made him famous. And you'll never guess who the runner-up was in that competition—his fellow goldsmith Brunelleschi.

"Oh, he must have been bummed."

"Yes, he was. In fact, he was so upset, he left Florence and went to Rome. When he came back, though, he won the commission to build the cathedral dome and a chance to become famous in his own right. But the city fathers appointed none other than his archrival—Ghiberti—to be his co-superintendent. Can you imagine? Two fiercely competitive geniuses working side by side like that on the same project—bedlam."

"So why were there so many geniuses in the Renaissance?" Viv asked.

"That's a good question. I think it had a lot to do with the renewed interest in ancient philosophy—a movement we now call humanism. The humanists didn't believe in a preconceived divine plan. Like the ancients, they believed in the power of the individual and the human ability to soar to great heights. And with that kind of optimistic perception, many did." I gazed at Ghiberti's triumphant doors. "It's amazing when you think about it, how powerful perception is."

"And you proved it back there with those students. You perceived you could corral 'em, and whammo, you did. Damn slick if you ask me."

With my confidence bolstered by Viv's praise, I wondered how different I might have been if I'd lived in the Renaissance guided by humanism. And I began to imagine myself as the Renaissance humanist Isabella d'Este—intellect, head of state, art patron . . . and now me.

I sat in my private apartment in my castle in Mantua with Leonardo da Vinci gazing at me. I wore the latest French style, a loose boat-necked gown with long, billowing sleeves, while the artist drew my portrait

according to my wishes and promised me a finished painting. Naturally, I expected the image to reveal my impeccable fashion sense. And the book I was pointing to—my idea, of course—would confirm both my educated status and my patronage of writers. I wondered how long it would take him to produce the final painting and worried it might never come to pass. The master had a reputation for leaving a trail of unfinished works in his wake. I had already commissioned two unsatisfactory portraits but had high hopes that this one by the famous Leonardo da Vinci would at last capture my true essence—a woman more assertive and competent than most men.

$\sim$

Viv's stomach rumbled, pulling me out of my fantasy.

"Okay," she said, "that's it. I gotta eat somethin'. Think you can use your powers of perception to find us a restaurant?"

"Done!" I said, still riding on Isabella's self-assurance. "That one over there looks perfect."

The Buca San Giovanni restaurant was only steps away. It had an outdoor patio with front-row seats for viewing the Baptistery and the Duomo, but Viv and I chose to go inside, apart from the tourist madness and the summer heat. Descending a short, steep flight of red-tiled stairs, we found ourselves in a cool, vaulted cellar with dark walnut wainscoting and ocher-stained walls covered with coats of arms, paintings, and signed photos of celebrities. A plaque claimed the restaurant opened in 1882 and was the Baptistery's sacristy before that. Furnished with white-clothed tables and medieval antiques, the place felt inviting and intimate.

We immediately ordered two glasses of Vino della Casa Rosso and tackled the extensive menu of traditional Tuscan food. I selected risotto with artichokes and ewe's cheese. Viv went for the sirloin steak with green peppercorn sauce.

These decisions made, we sat back, sipped our wine, and soaked

up the atmosphere—animated Italian conversations, clattering dishes, popping prosecco corks, and a parade of waiter-borne plates laden with such delectables as ravioli with saffron cream sauce and beef fillet with foie gras, truffle, and Madeira sauce. The mingled scents of fresh bread, oregano, and sizzling pancetta were ever-present.

While reveling in the sensuousness of it all, a familiar cloud of loneliness dampened my mood. I desperately wanted to experience this intimate place with Alec—to clink our glasses, share our food, and delight over the flavors together.

"What *is* it with you?" Viv said. "You've got that spacey look again."

I scrambled to find a suitable reply. "Oh, nothing. I guess I was just thinking about, oh . . . things like . . . why those designers in Milan—you know, those two guys whose studio we visited—why they're supposedly so great. I don't get it."

It was a ridiculous comment coming from me, but it was all I could think of. I only hoped it sounded convincing enough to divert Viv and give me time to climb out of my gloom.

Viv narrowed her eyes. She was on to me, and I worried she would call my bluff. But even if she did, I'd have to lie. I couldn't tell her about Alec. It would solve nothing. To my amazement, though, she let me off the hook.

"You mean Dolce & Gabbana? I thought you didn't care much about them. But, okay, here's my two cents. It's all about originality. I mean, ya gotta admit, turning lingerie into a dress to be worn in public is pretty gutsy. Nobody else is doin' anything like it. When that collection comes out, it's gonna knock the fashion world on its ass. I mean, look at Armani's power suits, with those honkin' shoulder pads. Nothin' sexy about that. He wants his clothes to make women look macho. And that's fine and dandy, but Dolce & Gabbana, they're goin' off-road. They want women to look sexy again in a whole new way. It's risky. It's a leap."

She paused. "I guess it's sorta like Donatello. He took a sexy risk, too, with his *David*. And like you said, no one else had the creative imagination—let alone the balls—to make that leap."

Although I'd asked the question to buy time, Viv's answer enlightened me. I had always thought of clothes from a practical point of view. I wanted them to look nice, sure, but they were, first and foremost, functional. For Viv, though, it was the opposite. Clothes were, first and foremost, art. And that eye-opening insight gave me just the redirection I needed to duck out from under my dark cloud and escape Viv's scrutiny.

"So, what's going on with you?" Viv asked. "The first couple of times you got that weird look on your face, I thought you missed your daughter. But it's more than that, isn't it?"

*Guess I was wrong about escaping scrutiny.* "Why do you say that?"

"Because when you're not Professor of Almighty Art, you're on some other planet that's super upsetting to you, something way beyond missing a kid who's safe and sound at camp. What gives?"

"Nothing gives," I said. I couldn't talk about this, but she had me cornered. I needed to change the subject. I needed to—yes—turn the tables.

"What gives with me? What about you? Who called and left that message yesterday? It was your mom, wasn't it?"

Viv jerked her head back. "That's none of your goddamn business."

"Well, my 'other planet' is none of your business either."

We glared at each other until finally looking down at the table as if fascinated by our cutlery. The stalemate left me both frustrated and relieved. As important as I thought it was to address Viv's issues with her mom, I needed my personal life to stay personal even more. Telling Viv about my heartbreak would only defeat my purpose—to keep my feelings of misery in check, to keep them from drowning me.

Viv and I dined in awkward silence. Although my risotto smelled divine, I felt too unsettled to enjoy its taste. Instead, I focused on Viv's destructive mother and my crippling attachment to Alec. Tired of silently fretting, I finally broke the ice.

"Want to order dessert?"

"Yeah," Viv said, leaping on the safe topic. "So, what looks good to you? What about this?" She pointed to the *Cantucci e Vin Santo* on the menu. "Have you ever had it? I've read about it, and it sounds delish.

What you're supposed to do is take these almond biscuity things—that's the cantucci part—and dip them in Vin Santo, which means holy wine. Don't you just love that highfalutin name? It's like it came straight from heaven. Or maybe someone blessed it. Wouldn't that be a primo job—blessing wine? Of course, you'd have to taste it before you blessed it, just to be sure it wasn't poison. Good thing you don't have to be a saint to drink it, though"—she laughed—"or they'd be out of business."

Viv was back to her old effusive self. But I couldn't tell if it came from nerves or just her typical need to share everything that crossed her mind. Well, almost everything.

"So, what d'ya think? Wanna try it?" she asked.

"Sounds perfect to me."

But, of course, it wasn't perfect. We were two women in pain and determined to suffer in silence, as if that would solve everything. But it wouldn't. Both our issues were too personally disturbing to stay buried. They had to surface eventually. The only question was when.

# NINETEEN

**WALKING UP VIA RICASOLI** from the restaurant, we soon spotted the *Galleria dell'Accademia* with its colorful ribbon of tourists trimming the sidewalk edge of the building's drab exterior.

Viv and I joined the line, patiently waiting our turn until we finally stepped into the vestibule and followed the arrows to the museum proper. Rounding the corner into the gallery's vaulted passageway, Viv stopped cold, drawing in a sharp breath. There, at the far end of the corridor in front of a classically inspired niche and framed with a massive Roman arch, stood the monumental figure of Michelangelo's *David*. Even Viv could see he was worth the wait.

Inching down the hallway, I gave Viv time to absorb the statue's magnificence before explaining the four other Michelangelo works lining the wall. "These sculptures of prisoners or slaves were originally part of a 1505 commission for the tomb of Pope Julius II. But when the Pope died only eight years later, the church downsized the project, and Michelangelo abandoned these pieces. Aren't they marvelous?"

"Yeah, but they're not done."

"Right. And that's what makes them so compelling." I scrunched my shoulders toward my ears. "Can't you just feel the tension? Half finished.

Half unfinished. They look like they're in an eternal struggle to escape the raw marble."

"Wow," Viv said. "How many people can do somethin' half-assed like that, and it still turns out primo?"

"Well, I wouldn't put it that way." I frowned at Viv. "But it is amazing how powerful these unfinished works are. And it's also amazing how well they demonstrate Michelangelo's philosophy. He believed every block of marble contained a statue, and his job as the artist was to free that statue from the stone imprisoning it."

Viv and I moved back and forth from one sculpture to another. And although each work existed in a different stage of completion, their mutual tension was overwhelming, their fates the same—eternally trapped.

I turned away. A knot formed in my gut. Their imprisonment reminded me of my predicament—the emotional quicksand in which I'd sunk myself and from which I felt powerless to escape, no matter how hard I tried. I looked at the sculptures again, seeing my own anguished face reflected in their painfully angled heads. It made me shudder. I had to try harder.

*No, that's not it at all,* my mother's voice corrected me. And suddenly, I was nine years old.

"Try to pick up your pencil," Mom said as I grappled with my multiplication tables.

"What for?"

"Just try."

"Okay." I picked up the pencil.

"No, I said try to pick up your pencil."

I picked it up again, wondering why we were playing this stupid game.

"No. I didn't say *to* pick it up. I said, *try* to pick it up."

"Oooh, I get it." I launched into a melodramatic performance, acting

like I was desperately trying to pick up a pencil that wouldn't budge.

"Good," Mom said. "Can you see how trying and doing are two different things and two different attitudes? Tell yourself you *are* learning your multiplication tables, not trying to learn them. If you see yourself as successful, you will be. So, stop trying, and do it."

♾

The memory of my mother's wisdom both soothed and provoked me. She was right. Trying had gotten me nowhere, especially when it came to Alec. Why couldn't I just "do it"—make things happen—the way I did with those college kids at the Duomo? I didn't try to turn things around with them; I *did* turn things around. And that was the take-charge attitude I needed.

But it was easier to jump in and fix things with strangers. I had nothing to lose. Repairing my own life, though, was a different story. What if I failed? I couldn't handle another disappointment. And even though I hated feeling stuck, its familiarity offered me a powerful, subversive perk. As long as I kept trying instead of doing, I could avoid facing the unknown.

Standing at last in front of *David*, I focused back on my job. "Spectacular, isn't he? If you think back to Donatello's and Verrocchio's bronzes, this marble giant seems more like Goliath than young David."

"No shit," Viv said. "And what a body." She looked at me with eyebrows raised.

"Yes," I said with a sigh. "I think Michelangelo was gay. And to answer your inevitable question, it's because of his writings and his obsession with the idealized male nude, not because of what he did. There's no real evidence of him acting on his inclinations."

"So we know he was gay because he carved sexy naked men? You already said that was a weak link when we talked about Donatello."

"He also wrote poems to men and said in one that the highest form of love couldn't be for a woman because a woman wasn't worthy."

"Oh," Viv said, "well, that pretty much seals the deal. But there's no need to bad-mouth another great artist like that. I think the less said, the better."

What was with her? She itched to know the story and, at the same time, wanted to sweep it under the rug like a dirty little secret. She was driving me crazy with this "gay cover-up" philosophy of hers.

"Okay, so, back to David," I said, swallowing my irritations again. "Besides the size and material, what else do you notice that's different with this *David*?"

"He doesn't have a sword."

"Right, and Goliath's head is not at his feet, either. Instead, Michelangelo's *David* is holding a slingshot over his left shoulder and a rock in his right hand. This is not that self-satisfied moment after David's triumph, but the second right before the battle begins. And look at the way this *David's* standing."

"*Contrapposto* pose, right?" Viv said, inching toward me.

"Yes, same as the other two. But look at the toes of his left foot, how they're poised at the edge of the base, ready to push off at a moment's notice. And even though Michelangelo's *David* is nude like Donatello's, this body is muscular, building dynamically from small hips to broad shoulders. And look at his expanded chest, how his ribs push out against his skin. It's as if David has just sucked in a deep breath and is holding it." I inhaled, dramatically holding my own breath.

"He sure has big hands," Viv said, planting her feet apart and crossing her arms.

"Yes, he does. And look at those protruding veins, swollen with the coursing blood of a body preparing for action. And what about that expression? His nostrils flared, his lip curled, and his brow furrowed. He's electric with tension. And which way is he looking?"

"Out to his left," Viv said, glancing over her shoulder then quickly back to me, eyes wide. "Um, Claire . . ."

"Yes," I said, ignoring her interruption. "You're right. He's not looking pensively down—like Donatello's. Or proudly up—like Verrocchio's.

But pointedly out at his giant adversary. He's not at rest. He's a ticking time bomb."

As I spoke, *David*'s tension became mine. I felt like a rubber band stretched to its limit, continually tormented by emotions I could neither hurdle nor release. *David*'s stress was set in stone forever. But what about mine? Would I always feel this way? Or would my emotions finally overrule my head and break loose, like Tintoretto's angels?

I took a deep breath and refocused on my lecture. "With this work, we've again entered Leonardo's realm—the High Renaissance—where artistic genius is king, and the Renaissance rules of intellectual balance and rational order are either brought to perfection like Leonardo's *Last Supper* or pushed to the brink like Michelangelo's *David*. They did whatever it took to create the greatest masterpieces of the day."

A burst of applause met my ears, and I spun around, startled to find a crowd gathered behind me. I blushed at the unexpected attention but also felt thrilled, my confidence surging for the second time that day.

"I tried to tell you . . ." Viv began to explain, but a commotion in the back of the group stopped her. A young man, muscling his way to the front, was meeting with resistance. He continued shoving, unconcerned with his rude behavior, until people finally moved aside and let him through.

I cringed as he rushed my way, bracing myself for impact. But just before he reached me, he slid to the floor on one knee. "Will you marry me?"

In the second of stunned silence that followed, I recognized Jim— the college boy who had tried to balance the egg earlier—and I broke into relieved laughter as the crowd hooted and clapped with approval. I helped Jim up and rewarded his performance with a hug. Looking over his shoulder, I smiled at the jovial group and noticed Simone. She was standing with a man apart from the others and waved at me. As I waved back, I felt a warm sense of camaraderie along with a sneaking suspicion that our paths would somehow cross again.

# TWENTY

**I HAD NO BUSINESS** answering the phone in Viv's bedroom, but I did so without hesitation. She was in the shower, and I knew she'd hate to miss a call from her husband. So, of course I answered the phone. At least that was my excuse.

"Hello? Yes, operator, go ahead. Hello? No, this is Claire. I'm Viv's instructor. May I take a message? Okay, hang on, let me get a pencil. What was your name again? Tony. Okay. And your phone number, Tony?"

"What're you doing?" Viv demanded, stepping from the bathroom wearing the hotel's monogrammed bathrobe and slippers with one of their towels wrapped around her head. She looked like a walking advertisement for the place.

"Oh, hold on a minute, Tony, here she is." I shrugged innocently at Viv. She scowled back.

"What do you want, Tony?"

I didn't have a chance to find out who Tony was, but from the tone in Viv's voice, I could tell she didn't like him much.

"Yeah, I got the message you called, but important to you doesn't mean important to me." She put her hand on her hip and tapped her

foot. "Well, you got me on the phone now, so, what do you want? Yeah, I did. Yeah, why? What?"

Viv sat down on the bed, listening for several minutes in silence. "I don't give a shit what you do. Leave me out of it. Nope. Good riddance to bad rubbish is all I gotta say. Bye."

She sat perfectly still. Her terrycloth headdress slumped to one side like a melting scoop of vanilla ice cream. But she didn't seem to notice.

"Fuck!" She kicked a slipper at the baseboard and began to cry.

"What's wrong? Who was that?"

"My brother," she said between sobs.

"You have a brother? You've never mentioned him before."

"Yeah, that's because he's an asshole."

"What'd he say to you?"

"He said Sonia died."

"Oh, Viv, I'm so sorry."

"I'm not. The fuckin' whore can rot in hell as far as I'm concerned."

I flinched at the venomous sting of her words.

"You know what my brother said, that little shit? He said she died talkin' to me on the phone. Nice guilt trip, huh?"

I knew this probably wasn't the time to use logic, but I couldn't help myself. "Wouldn't you have known if your mother died talking to you? I mean, she would have—you know—stopped talking."

"Well, I guess she did, sorta. I was screamin' at her on the phone when all of a sudden, she started talkin' gibberish. Then the phone went dead. At least I thought it did. I was sure she'd hung up on me, and that pissed me off even more. I had the hotel call her right back so I could rip her a new one. But the line was busy. So I just figured she'd blown me off and hopped on the phone with one of her johns." Viv wiped her eyes. "Anyhow, Tony said when they found her, she was lyin' on the floor by the wall phone with the receiver dangling off the hook. They said she had a stroke. So maybe she did die talkin' to me. Maybe I killed her." Viv broke down again.

"This is not your fault, Viv."

"I don't know why I'm crying. I hated the bitch."

We sat together in silence for a moment. "I know why you're crying," I said. "It's because your story with her is over, and nothing can change for the better now. You're stuck with what it is. And that's so heartbreakingly sad." I closed my eyes to block my tears. "My mom died five months ago, and I felt that same 'end of story' loss, except in my case I've been lamenting a story I can't even remember. I don't remember her from my childhood."

"How could you not remember your childhood? Everybody remembers their childhood, like it or not."

"It's not that I don't remember it. I just don't remember my mother in it. My dad? Yes. My sister? Definitely. But not my mom. Since we've been on this trip, though, I've had a couple of flashbacks about her, and it felt like she was trying to guide me."

"I think you're lucky you can't remember your mother. I wish I could forget my childhood with Sonia. I'd like to forget everything about her. But I can't. She was unforgettable—like a horror film.

"She worked at night and slept during the day but still found time to treat me like shit. I was her whippin' girl. Could never please her. Didn't want to after a while. She locked me in the closet when I pissed her off. I spent a lot of time there. I think that's when the panic attacks started. I never knew when she'd open that door and what would happen next. I used to dream of killin' her. Now, it looks like I have. Ha, dreams do come true."

I couldn't imagine feeling that much anger toward anyone, but I didn't have Viv's mother. Even without memories, I knew my mom wasn't like Sonia. I would have remembered that. How horrible to live with such fear and hatred.

"Maybe now that your mother's passed," I offered gently, "you'll finally be released from all that anger. It must have been eating you up inside your whole life."

"Yeah, maybe," Viv said. "But I know there's a ton of awful shit in this world that's even worse than Sonia. And I swore I'd never let her break me. I'd never give her that power."

Viv straightened her shoulders and squinted her eyes—her whole face a picture of stony resolve. "My motto's always been: 'Get over it.' If I'm not happy with life, it's got nothin' to do with her. It's up to me and nobody else."

Viv shot to her feet. "You hear that, Sonia? You hear that? I'm unbreakable, and you're nothing! You will never have power over me you sick excuse for a mother. Fuck you!" She collapsed back on the bed, air hissing from her pursed lips like a punctured inner tube.

I sat motionless, feeling the shockwaves from her primal scream reverberate inside me. After a minute, I reached out to touch her arm, wary of another explosion.

She jerked her head up and looked at me, clear-eyed. "So, what about your mom? Was she gone a lot? I still don't get why you can't remember her."

Viv's flip from wild outburst to cool composure threw me until I realized she was living her motto, asserting her power.

"Well," I said, "I know my mom stayed home until I started kindergarten, and after that, her teaching schedule was basically the same as my school schedule. So when I was home, she was home too, but apparently not interacting with me."

Viv listened attentively, showing no sign of the turmoil that must have still churned below the surface. "If your mom didn't do anything with you that you remember, who did?"

"Oh, my older sister. We did everything together." I smiled. "She's crazy."

"Like crazy in the head?"

"No, like fun crazy. She was a non-stop vaudeville act when I was a kid. It was like growing up with a female Charlie Chaplin."

"Well, maybe that's it, then. Your mom was around, but your sister upstaged her, and your mother didn't mind."

"Maybe," I said. "I know I was well taken care of. I had plenty of clean clothes, good food, a nice home. My mom had to be the one who orchestrated all that. My dad was gone too much."

"She sounds like a puppet master pulling strings behind the scenes." Viv chuckled. "Either that or a maid."

"I know," I said, heartened by Viv's lighter mood. "I think she was both. And a disciplinarian. I don't remember getting into trouble myself, but my sister did."

"If your mom was that far out of the picture, who taught you the ropes? Your sister?"

"I guess so."

"How much older is she?"

"Three years."

Viv smiled, a mischievous look in her eye. "Wait, I've got it. It's clear to me now." She put her fingertips on her forehead and gazed at the ceiling. "You were raised by—hold on, it's coming—a pint-sized Charlie Chaplin and a strict, puppeteering maid."

"Ha. You might be on to something there." I visualized Bergie as a wooden puppet with a toothbrush mustache and bowler hat. She dangled from strings controlled by a giant French maid who swatted at her with a feather duster.

The image made me smile, and Viv—undoubtedly conjuring a vision of her own—began chuckling . . . which made me chuckle . . . which made us both burst into laughter until I heard someone else laughing too—my mom. I sat up and turned to Viv.

"Okay," I said, struggling to stifle my giggles. "I have a story for you about my mother. One day—I must have been about ten—I saw her put a huge bundle of dirty clothes in the refrigerator as if it were a perfectly reasonable thing to do. But it didn't make sense to me, so I asked her what she was doing.

"She said, 'What?' like she didn't understand the question. So, I rephrased it. 'Why did you put the dirty laundry in the refrigerator?'

"She looked at me like one of us was crazy and said, 'Did I do that?' Then she opened the refrigerator door and saw the dirty clothes wadded up next to the pitcher of Kool-Aid. She shrieked with laughter. 'Oh, for heaven's sake. Now where do you suppose I put the milk?'"

Viv snorted. "So, where *did* she put the milk?"

"Where else? In the dirty-clothes hamper."

Viv howled, her snorts multiplying.

"But wait. You can't possibly appreciate all this unless you can visualize my mom's laughing face—eyes crinkled shut, tears streaming down her cheeks, and her nostrils quivering like Jell-O. It was as if her nose enjoyed the joke more than the rest of her face."

At this point, Viv collapsed on the bed, rolling from side to side, laughing, snorting, and crying all at once. And I laughed along with her. Up until then, my few memories of my no-nonsense mom never involved humor. It surprised me to see this other side of her—a fun side, a side I'd forgotten I also had. And one I could now share with Viv at the very moment she needed it most.

# TWENTY-ONE

**LEAVING FLORENCE, VIV AND** I both looked forward to our next stop—a *pensione* in the hills of Tuscany right outside Siena. Once there, we planned to install ourselves by the pool and do absolutely nothing. Although Viv appeared to have recovered from the shock of Sonia's death, I imagined her emotionally depleted and knew the break would do her good—not to mention me.

We had turned off the autostrada several miles back and now traveled a small country road, winding us closer to our destination. Rectangular fields of sunflowers patterned the rolling hills around us like giant throw rugs, and great swaths of fleecy clouds floated across the sky. Their vast, gliding shadows muted the brilliant yellow blossoms like large, cooling hands.

The smell of freshly cut grass permeated the car and reminded me of my childhood summers at my grandmother's. The old cedar trunk in the basement harbored a wealth of tantalizing treasures, including my mom's formals from high school and college. Donning her gowns, Bergie and I would parade around the lawn, pretending to be princesses or actresses. The memory filled me with nostalgic pleasure until, without warning, our brand-new Mercedes-Benz broke down.

Anxiety rose in my throat. My mind raced. What were we going to do? What was Viv going to do? Would this trigger a panic attack? Oh God, where were her pills?

We looked at each other, and I started talking as a diversion. I tried to sound confident, explaining we'd simply have to wait for a car to come by, and we'd be fine. I kept talking, searching for a topic to keep her engaged, to keep her from a meltdown.

"You know, I've been meaning to ask you, how did you and Tom meet?" Although I was sure my voice betrayed my apprehension, Viv looked pleased by the question and remarkably unconcerned about our stranded situation. It was as if she'd been waiting all this time to tell me about her wonderful husband. So she did.

"We met at the Normandie Casino, you know, the one in Gardena. I was a cocktail waitress, and he was a bookie."

My stomach flipped. Wait. He was a *what*?

"I mean, not just any bookie. He was the top dog. Everybody knew him, and all the girls had the hots for him. But to hear him tell it, the minute he laid eyes on me, he was a goner." Viv gave me a shy smile.

I felt the blood draining from my face. Tom was a bookie? He said he was a financial speculator . . . oohh . . . same thing.

"And he totally went for it. He made me feel like I was somebody, bringing me super-expensive gifts all the time and taking me on these exotic trips to die for. We went to Hawaii, I can't tell ya how many times. And I could buy anything I wanted. He was my sweet, sweet sugar daddy. And he knocked my socks off. Then one day, just like that, he popped the question, and we had Jason two years later. Boy, did that change things. Kids are a kick in the butt, but I guess I don't need to tell you that."

Viv looked at me, my eyes undoubtedly the size of golf balls, but she didn't seem to notice. "Anyway, Tom's still a primo bookie—you know, super good with numbers—but it's tricky spending his money. We can't get a loan to buy a home 'cause we can't show where the money comes from. He'd like to get out of the business, even if it means making less.

I'd be happy if he could get out too. *Super* happy, especially now with Jason and all, but gambling's all he knows. So we're stuck. And I really want a home for Jason with a big backyard and a treehouse. I want him to have everything I didn't. And I always wanted a treehouse as a kid."

Viv told the story of her husband with the loving pride of a pastor's wife. And I listened with the horror of a hell-bound sinner.

Oh my God. I was traveling with the wife of a criminal.

And he was laundering his money through me.

Oh my God. I was an accessory to a crime!

I broke out in a sweat, picturing Viv and Tom as Bonnie and Clyde— no longer the sophisticated couple I had originally perceived, no longer reminiscent of the art-patronizing Medici. Far from it. They were gangsters. And gangsters had guns. I glanced sidelong at Viv. Did Viv have a gun? I began to hyperventilate. Forget about the dead car. *I* could have been dead.

*Okay, deep breaths.* I had to get a grip. Tom was not a doctor or a blueblood, but he wasn't a murderer either. Right? No, of course not. Bookies didn't kill people. They just placed bets. So what if it was illegal? Viv wasn't concerned, so there was no need for me to be. Right?

I gave Viv a nervous smile and tried to gain more perspective. Lots of things could have been worse. But the only thing that came to my unhinged mind was the thought that *I* could have been married to a bookie, and *that* would have definitely been worse. My life was far from ideal, but at least I could document my income.

At that moment, a car came into view, and I waved it to a stop. Using my limited Italian and doing my best Marcel Marceau impression, I conveyed our problem. The driver nodded and drove off.

"That was lucky," Viv said, popping a piece of gum in her mouth. "How long do you think it'll take him to get help?"

I marveled at her upbeat attitude, wondering if that was a gangster thing—pretending to be brave when she was actually scared to death, like me.

"I don't know." I sighed. "I just hope someone comes before the

buzzards start circling." I closed my eyes and massaged my temples, envisioning Viv as Faye Dunaway holding a machine gun to my head.

"Well, that's a cheery thought," Viv said, chomping her gum. "You really are uptight, aren't you? Have you ever thought about seeing a shrink?"

"A shrink? Are you kidding me? I *saw* a shrink, and believe me, it was no help at all . . . zero . . . zilch . . . . zippo . . ."

"Okay, take it easy, Claire. I was just curious. You're so touchy."

"Of course I'm touchy. We are sitting here in a broken car on a back road in a foreign country, and that man who just drove off may have been our only hope."

I decided not to mention that being stranded with an outlaw didn't help my mood either. Nor did I acknowledge my other fear—that the man who'd driven off could have been a thug too who planned to come back with his cronies and kidnap us. But then, in that case, it would have been good to have a gun-toting gangster on my side. Oh God, I was losing it.

"Don't worry," Viv said, patting my leg. "We'll be okay. I've got a good feeling about that guy. He'll get us help."

And they called *me* Pollyanna.

"So," said Viv, "tell me something about you. How'd you meet *your* husband?"

I looked away. I was not in the mood for chitchat, and I had no desire to share the details of my personal life with a mobster's moll.

"I bet you were childhood sweethearts. Am I right? I have a sense about these things."

Realizing I had to say something, I resolved to keep it short. "Well, to tell you the truth, we're getting a divorce." Viv looked dismayed, so I quickly reassured her, "Oh, no, it's okay. It's been coming for a while. But I do feel kind of like an escaped balloon." I floated my hand above my head. "I've never been on my own before. It's unnerving. And what's worse, my soon-to-be ex-husband wants nothing to do with me or our daughter. I'd hoped we could be friends and raise Amber together. But

then the other day it dawned on me: we were never friends in the first place. How sad is that?" I couldn't stop talking, my nervous energy having taken up residence in my vocal cords.

"I guess we were totally mismatched from the start, but I was too star-ry-eyed to see it. Even now, when I picture him, I still get goosebumps. Why is that? How can someone so wrong for me still turn me on?" I looked down at my hands, considering which hangnail to torment next.

"Anyway, our relationship kept going in circles. After sweeping me off my feet like Prince Charming, he turned cold and controlling, with a violent temper. And I spent all my time tiptoeing around him, trying not to set him off. Eventually, I'd gather up enough nerve to break up with him. But when I did, he'd become this loving, attentive person overnight, and that passionate chemistry zoomed right back in. So we'd reconnect, and almost immediately Kurt-the-Wonderful would evaporate into thin air, starting the pattern all over again. Every time I couldn't stand it any longer and built up enough courage to leave, he'd flip and sweep me off my feet just like before. But I couldn't see it. I kept clinging to those fleeting moments of nirvana and telling myself everything was fine, when in reality, that was only an illusion."

Before I knew it, and having long forgotten my vow to keep it short, I found myself gushing about Alec, the man who *did* give me the love and friendship I craved—how we'd met, how he fulfilled me in ways I didn't know existed, and how destroyed I was when he'd ended it for the sake of his family. I struggled to hold back tears. I couldn't break down now. We were already broken down.

"So Alec totally floats your boat. Okay," Viv said. "But think about it. As a married man, he could only give you what you wanted in spurts, and that doesn't seem much different from those 'fleeting moments of nirvana' with your husband. Sounds to me like you stepped in it twice. I think it's time to chalk up your Romeo to experience and maybe give your husband another shot. You do have a kid together. You know Kurt-the-Wonderful's in there somewhere. Maybe you can get him to come out and play for good."

"What are you talking about? Alec's the wonderful one, not Kurt. Alec's perfect for me. He's my soul mate."

"And he's married," Viv reminded me.

"Well, yeah, but that doesn't make him less perfect."

"No? It sure as hell makes him unavailable."

I started to protest but didn't have a comeback. How could Alec be perfect if he wasn't available? I'd never looked at it that way before. I saw his unavailability as a circumstance beyond his control. But it wasn't. It was his choice.

I turned to gaze out the car window. Viv's words had hit a nerve, and my anxious mind slid from fearing her dysfunctional lifestyle to wondering about my own. Was I only attracted to men who loved me part-time? And if so, how did that happen?

Viv yawned and opened the car door. "Well, looks like you're done talkin'. I'm gonna stretch my legs before that brandy-totin' Saint Bernard comes to save us."

I shot her a distracted smile and turned to stare out the window again. Feathery cypress trees lined the road, looking like tall, tapered brushes dipped in green paint, and I watched while Viv walked beside them. She appeared small now, reminding me of myself when I was a little girl.

"Look what me and Bergie made," I yelled, racing into the kitchen, my seven-year-old bare feet slapping loudly on the linoleum floor. "Look, look—you're not looking."

"It's 'Bergie and I,' not 'me and Bergie,'" my mother corrected. "And please don't yell."

"Okay, look what Bergie and I made."

"That's nice," she said, glancing up from grading papers. "Now go back with your sister and make some more. I have work to do."

"But you didn't even look at it."

"Yes, I did. It's nice. Go make another one."

"You say it's nice, but you don't mean it. All you care about is your stupid work."

My mother slammed her pen on the table. "Get down off your high horse, Sister Sue. I don't have time for this. My grading's not done. I need to start dinner. And your father will be home any minute. Now go."

I ran to my room in tears, vowing never to cry again.

The sage-like smell of the cypress trees brought me back to the present. But thoughts about the memory lingered. A parent now myself, I could see why my mom had been angry. But it wasn't my attitude alone that pushed her over the edge. She simply had too many things to do. But she always had too much to do. She reminded me of Cinderella, taking care of everything for everybody else before she could do what she wanted. And in my mother's case, she wanted to teach.

But my father didn't like the idea. Having a working wife embarrassed him. He felt it made him look like he couldn't support his family. In arguments, I had heard him deride her income, saying it only made them pay more in taxes, and when it came to her roles, he was firm—wife, homemaker, mother—not breadwinner. Only after taking care of all her primary responsibilities could she then "go to the ball." No wonder she didn't interact with me much—her plate was too full.

Thinking of plates reminded me of childhood dinners, and my mind shifted again—this time to a memory of my parents from when I was about eight. It was a typical weekday just before suppertime.

"Hi, honey, my martini ready?" Dad called, striding in from work and heading for his leather chair.

Bergie and I bounded into the living room for hugs while Mom popped out of the kitchen with his ice-cold martini.

"Here you go," she said, handing him his drink then turning to us. "Okay, kids, off to your homework. Scoot." She disappeared into the kitchen again as we scrambled back to the dining room to listen in on our parents.

"Thanks, hon. What a day I had. One crisis after another. When's dinner going to be ready?"

"In about a half an hour."

"Did you pick up my cleaning today?"

"Yep, it's in the closet."

"What about the dog food?"

"No. I had a faculty meeting and couldn't do both before getting the kids. We still have dog food. Oh, that reminds me, I need to feed Jethro. Hang on, I'll be right back."

"What the hotel?" Dad said, using his faux profanity. "Honey," he yelled. "Something's burning. Honey!"

Mom raced back inside. "Oh, shoot, it's the onions."

"Cratzle, wife. Sometimes I wonder where your head is."

My mother didn't respond.

"Could you get me another martini?"

It wasn't exactly a funny memory, but I chuckled anyway, partly because it was such a fifties cliché and partly because my parents were so clueless. I was sure my dad didn't realize how overbearing he was, and my mom never said anything. That's why he got away with it; she let him. I smirked. So she was my doormat role model. That explained a lot.

But they were both simply products of their time. Men were expected to be in charge, and women were expected to go along with it. Only my mom took it way too far.

As a father, though, I thought my dad was wonderful. When he was home, he made a point of spending time with Bergie and me. I remembered the day the three of us gathered in his study to record a play on our

new reel-to-reel tape recorder. I couldn't read yet, so Dad stopped and started the recorder to allow me to memorize my lines—one at a time.

"Okay, girls, are you ready?" Dad asked.

"Yep," we said in unison.

He clicked the start button, and the tape reels slowly began to circle. Bergie and I chirped into the microphone, trying to sound like crickets as Dad narrated.

"In a remote field on the border between Texas and Mexico, two men silhouetted by the setting sun stared each other down." He signaled for Bergie to start.

"This is your last chance, Mallon: either you go my way, or else," Bergie threatened, sounding more like a fairy princess with a sore throat than a desperado. She solemnly nodded at me.

"You can't scare me with your threats. I didn't kill the old man, and you know it." I spat the words out with as much venom as I could through the helium-filled voice of a pixie.

Dad clicked the stop button and played the short scene back. Bergie and I clapped with glee, marveling at our achievement. I was especially excited. I'd done it. I'd remembered my one line and recited it perfectly.

That sweet memory made me smile. My sister and I loved being with our dad. He paid so much attention to us when he was home. But that was just it. He wasn't home much. He traveled internationally for work but always brought back treasures from his journeys, which made us long for his return even more.

So there was my male role model: domineering on the one hand, loving on the other—but only in spurts.

# TWENTY-TWO

**ROADSIDE ASSISTANCE FINALLY CAME** to fix the car, and we drove the last few miles to our *pensione*—a charming, restored farm-house dating from the fourteenth century and the only lodging on our trip chosen by me. It perched on a hilltop overlooking undulating rows of grapevines and olive trees, all leading to the picturesque skyline of medieval Siena.

Since we had wasted most of the day broken down on the road, we quickly checked in, threw on our swimsuits, and headed for the pool. Set apart from the farmhouse and surrounded by lavender and rosemary bushes, the pool felt like a secret hideaway. I arrived before Viv and snapped off a sprig of lavender, holding it to my nose as I eased into a poolside chair. No one else was there.

Viv showed up a few minutes later. She walked over to my side, assumed a glamour-girl pose, and waited to be noticed. I looked up at her face, struck by her carefree expression. She showed no residual effect from our stranded day on the road and seemed completely released from her mother's demons. I admired her resilience and wished I could emulate her.

"Ah-*hem*." Viv cleared her throat and glided her hands along the length of her torso as if presenting herself in a beauty pageant.

Only then did I notice her swimwear, a skimpy bikini revealing an overabundance of soft, pale flesh and looking at least one size too small. But it wasn't the bathing suit's size that made me gawk.

"Is that a leather bathing suit?"

Viv twirled playfully to provide a full view. "Isn't it dreamy?"

"Why would you buy a leather bathing suit? You can't even swim in it, can you?"

"It's not *for* swimming." Viv looked at me like I was from Mars. "It's a fashion statement. I think it's a Nina Ricci, but I can't be sure 'cause the label's gone. It was on the Nina Ricci rack in that store, though, so it must be hers. I love her clothes, don't you? I had no idea she made leather bathing suits. And this was a steal. But now that I think of it, a real Nina Ricci would have cost *beaucoup* bucks. Oh well, that's okay. I'm gonna pretend it's legit anyway. I just love her work, and I love this bikini."

Viv did another pirouette. "I bought it in Milan at that cute vintage boutique. Remember the one?"

"You did? How did I miss that? We were only in that store for a second. Must have been one quick purchase."

I wondered if that explained the fit. She bought it so fast, she didn't even try it on? Why on earth would she do that?

"So, who's Nina Ricci?" I asked, trying to say something nonjudgmental.

"You don't know who Nina Ricci is?" Viv shook her head. "Well, she's this super-famous designer who started her own design house in Paris in the early thirties and is known for making these super-feminine outfits. Then to rev up interest in haute couture after World War II, her company staged a show in the Louvre—I mean, *the Louvre*—with over a hundred mannequins dressed in the hottest fashions from the top Parisian designers. And the show was such a smash hit, it even went on tour in the US. Isn't that rad?"

Nina Ricci or not, I still found a leather bathing suit absurd, but I tried to see it from Viv's perspective—for its originality, not its function.

"So you're wearing a work of art," I offered.

"Bull's-eye," Viv said, collapsing triumphantly into her chaise lounge.

We stayed by the pool until sunset, enjoying the views of the Tuscan landscape and saying little. Viv had brought her magazines to read and I had my notes, our rituals now familiar, even comforting, like an old married couple.

I should have felt relaxed in a peaceful setting like that. The lavender aroma alone should have soothed me, but it didn't. I felt agitated and began to search for the source of my discomfort. Viv had squelched the nightmare of her mom. We were safe, no longer marooned on the road. And I had even managed to rein in my fears about being an accessory to Tom's illegal activities. So why the disquiet?

Viv got up and stretched. "I'm gonna get dressed for dinner. I'm so stoked we're staying in a *pensione*. Primo call. I'd slit my wrists if we had to get in that car again."

"You and me both. Shall we meet in the dining room in about an hour?"

"Sure. Sounds good." Viv picked up her magazines and headed back to our rustic retreat.

I lingered a few minutes longer, still unsettled. If I were the superstitious type, I would have said I had a premonition, a foreboding. But I brushed the idea away. I wasn't superstitious.

Gathering my notes to go inside, I watched the vibrant pink clouds glow optimistically above the hills until vanquished by an ominous gray—the same menacing gray the landscape had surrendered to earlier. With the shadowy conquest now complete, I strolled back to the farmhouse, its glimmering windows beckoning, and I diagnosed my malaise as a simple case of hunger.

I woke the next morning in a liberated state of mind. A full day of nothing lay ahead. The agreement Viv and I had made the previous evening was to go our separate ways. If we ran into each other during the day, fine. Otherwise, we would simply meet for dinner. Without an agenda, I was in no hurry to leave my room for breakfast. I even hoped if I waited until right before they stopped serving, I might miss Viv altogether and eat alone for a change.

A few minutes before ten, I stepped into my denim shorts and threw on my Simon and Garfunkel T-shirt. Descending the antique staircase, I absentmindedly hummed my favorite Paul Simon song, "Bridge over Troubled Water."

"Hello, Claire." The voice echoed up the stairwell. He stood by the bottom step, holding two cups of coffee. The light from the foyer window haloed his hair, making him look like he'd dropped from the sky—a fallen angel. I felt my knees buckle and grabbed for the railing.

"Kurt? What are you doing here? How did you find me?"

"Nice to see you too, Claire." Kurt's sarcastic retort hung icily in the air for a moment. This clearly wasn't the reception he'd wanted, but he quickly disguised his irritation. "How did I find you? Oh, that was easy. I just called Amber's camp and told them I'd lost your itinerary. They were happy to help her dad." He gave me a cocky grin.

"But I thought you never wanted to see me or Amber again." The hurt tone in my voice came as a surprise, as did my goosebumps.

"I was upset before. But I've come to my senses." He held out one of the coffee cups like a peace offering and gave me a puppy-dog look. "Would you like to have coffee with me in the garden?"

For the first time on the trip, I longed for Viv's presence. "Okay," I said, trying to keep my voice from shaking. We walked out onto the expansive lawn and came to a wooden bench near a bougainvillea bush exploding with cranberry-colored blooms. The bush made the bench conspicuous and me more comfortable being alone with him. He sat close by my side, and my feelings pitched from one extreme to the other. Dread gripped my heart while the muscles between my thighs involuntarily twitched.

"I want to get back together, Claire. I know we've been through some terrible times, but we've been through wonderful times, too, and we have a daughter together. I think we owe her this. We owe *us* this. Let's forgive each other. I know I can be hotheaded at times, and I realize now that I pushed you away. But I can change. I'll go to counseling with you. I'll do anything to make it work."

Who was this person? Ah, yes, this was the person Kurt became when he wanted something—all sweetness and light. I warned myself not to fall for it.

"I don't know what to say. You flew all the way over here just to tell me this?"

"Yes. Doesn't that show you how serious I am? You know I love you. I've always loved you. We just started too young to know what we were doing and made some big mistakes along the way, both of us." He took my hand. "Let's start over, Button. We can do this."

My heart flipped. "No. We can't . . . I mean, I can't. I'm in the middle of a tour. I have to take care of business. I can't go off on some tangent right now. I mean . . . I need to think about this." Unlike my acrobatic heart, my hand remained quietly nestled in his.

"Yes, absolutely, think. But while you're thinking, let's go into Siena and have some fun. You know I've never been there."

Of course I knew he'd never been there. That was one of the many problems. He never wanted to go to Europe. It seemed the more I wanted it, the more he resisted. Anger climbed up my throat, but I swallowed it back down while other feelings rose instead. He had come all this way. He was trying so hard. And he was so gorgeous.

"Oh, there you are," Viv said, rounding the corner from the pool. "Who's this?"

Kurt stood immediately and shook Viv's hand. "Hi, I'm Kurt, Claire's husband."

"Oh . . . wow . . . well, I'm Viv, Claire's pain in the ass." She winked at me. "Just kidding. I'm her student."

"Nice to meet you, Viv. Now, I know you two are on tour together,

and I hate to disrupt your plans, but would you be terribly upset if I stole her away for the day?" He was as smooth as melted chocolate, so warm and sweet, so un-Kurt-like.

"Hell, no," Viv said. "I was on my way to tell ya, Claire, there's a fashion show in town in one of those palazzos. I forget the name, but I'm dyin' to go. I was gonna ask you to join me, but you two go ahead and do your own thing. I'll take a taxi into town."

"Are you sure you want to go alone?" I asked, trying to send her an SOS expression. But my urgent wince must have come across like a guilty smile.

"Sure, I'm sure. You guys have a ball." Viv winked again. "Don't give me a second thought. I'll be happy as a clam in butter sauce." She bounded across the lawn, looking like she would leap up and click her heels at any moment.

"Guess the day is ours," Kurt said with a self-satisfied grin. "I took the liberty of asking Giuseppe and Anna if they would make a picnic basket for us—just in case. Shall we go inside and see if it's ready?"

Just in case? Right. He knew exactly what would happen. This was all part of a carefully orchestrated plan. I wouldn't have been surprised if that fashion show tip for Viv was part of his scheme too. I wouldn't have been surprised by anything he might have done to get his way. Anything to manipulate me. So why was I tingling?

Giuseppe and Anna Martelli, the *pensione* hosts, presented the picnic basket with pride. The handmade twig basket was lined with a red gingham tablecloth and filled with local specialties, including a pound of Toscano *Salame*, a round of pecorino cheese from Pienza, and a fresh loaf of *pane sciocco*. All this, along with a blanket and a bottle of Chianti.

"Oh, my gosh, this is way too kind of you. So much food and such a beautiful basket. Thank you," I gushed while Kurt stood proudly behind me.

Anna Martelli nodded. "*Prego, signora*. Me *e Guiseppe siamo molto felice* making help. We keep secret. No break surprise." She zipped her mouth and grinned. "Signore Markham, he say you like surprise. *Molto*

*romantico, no?*"

I smiled, trying to stay calm as Kurt's plan unfurled flawlessly around me like a fishing net. But instead of feeling serene, I felt like I'd swallowed Mexican jumping beans.

After loading the picnic paraphernalia into Kurt's rental car, we headed out for the Giardini La Lizza, a well-treed park at the north end of town by the Medici Fortress. I'd never heard of it.

"How did you know about this place?" I asked as Kurt spread the blanket beneath an expansive chestnut tree. He was doing this for me. He hated picnics. I loved them.

"Giuseppe and Anna recommended it," he said.

It bothered me to hear him use their first names so casually. I didn't even call them by their first names, and this was my trip, not his. How dare he worm his way into my world as if he enjoyed being in Europe. Too little, too late.

"So, how's the trip been going?" Kurt asked, pouring wine for both of us. "Viv seems nice." He held up his glass. "Here's to us."

We clinked glasses and caught eyes for a moment. I looked away first. "Oh, Viv's okay. We don't have much in common. Sometimes she's engaged in the art, but mostly she prefers shopping."

"I heard from Anna that your car broke down yesterday. That must have been frightening. Glad I didn't know until afterward. I would have been beside myself with worry. It does make me nervous, you two girls traveling alone over here. Lots of things could go wrong."

"Well, they haven't," I snapped. "Yesterday was a fluke. More of a nuisance than anything else. We're doing fine." Was I really angered by his proprietary behavior, or was I trying to hide how nice it felt to be cared about? I couldn't tell.

Kurt slid behind me to rub my shoulders. His large hands made me feel tiny and protected, giving me such a sentimental rush that, for a second, I wanted to collapse back into his powerful arms. But instead, I leaned forward, brushing invisible debris from the blanket and those dangerous feelings from my heart.

Our picnic brunch stretched into two hours as the wine and conversation flowed. Kurt was funny, tender, attentive—all the things he usually wasn't. He asked me lots of questions about the trip and the art we'd seen—meaningful questions, as if he truly cared. We laughed about the good old days when we were young and clueless and marveled at how fast the time had gone. As we reminisced, I felt a pang of homesickness, and I wanted to be with our daughter. I wanted us together again as a family.

"Remember when Amber was three," I said, "and I took her to see *Star Wars*? Remember what she said to me afterward?" I looked at Kurt with exaggerated seriousness. "'Mom, from now on, just call me Darth.'"

Kurt laughed. "Of course I remember. What an adorable character she is." Hearing Kurt describe Amber as adorable flooded my body with warmth and a twinge of guilt. Could it be he stayed away this whole time not to be cruel but because it hurt him too much to see her? Was Amber a crushing reminder of the life he left all because of my infidelity? I quickly shook my head, trying to dismiss my speculation.

"Yes, she is quite a character," I said. "Whatever happened to Princess Leia? My sweet little girl wanted to be the villain instead of the princess. Where did I go wrong?"

"You didn't go wrong. Any couple can have a princess, but we have a powerhouse who thinks outside the box." Kurt hugged me.

"That's for sure," I said, ducking out from under his arm. "Want some more wine?"

Reaching for the Chianti, my whole being surrendered to nostalgia and ached for love. Alec had left a gaping hole in my heart, and I wanted so badly to fill it, to stop it from hurting. Kurt was still my husband. Maybe we *could* fix things, as Viv suggested. Perhaps I'd been wrong about Kurt. I'd certainly been wrong about Alec.

"Let's go into town," Kurt said, finishing the last of the wine. "You can show me around."

His suggestion surprised me. He wanted a tour? What in the world would I show the man who, until this day, had expressed no interest in

art, history, Italy, or anything outside the United States, for that matter?

"Okay," I said, deciding that whatever I did, it would be better than wallowing in nostalgia. Driving into the historic center of town, I tried to put my sentimental journey in perspective. Kurt and I were divorcing for a reason. Weren't we?

We parked near Siena's Duomo—a dramatic green-and-white-striped church flanked on two sides by a piazza that provided a rare open space in the densely built medieval city. Once inside the cathedral, the stripes intensified as they wound around the clustered columns and scaled the upper walls.

"Did that church make you dizzy?" I said as we stepped out into the crowded piazza.

"Yes. I'm glad to be outside."

"You don't think it's the wine, do you?"

"Certainly not. But perhaps we should grab a drink at that bar over there, just to make sure it isn't the booze."

"Nice try." I giggled. "We haven't even seen Duccio's *Maestà* yet." I grabbed his hand. "Come on. The museum's right here."

Kurt resisted my pull, reeling me back into his arms to steal a kiss—a spontaneous romantic gesture totally out of character. I knee-jerked and batted him away. Mistake. I'd learned years ago never to embarrass him in public by disagreeing with him, raising my voice, or heaven forbid, raising my hand. I cringed.

He stuck out his lower lip in an exaggerated pout. "No? I just thought we could both use a little inspiration first. But okay, you win. Lead the way, Joan of Arc." He grinned like it was all in fun.

His nonchalant response to my rebuke amazed me, not to mention his display of affection in such a public place. Once again, this wasn't like him. Maybe he *was* changing.

Entering the museum, I guided Kurt toward Duccio's multi-paneled *Maestà*—a painting created early in the fourteenth century as the altarpiece for Siena's Duomo. But now it resided—at least most of it—in the cathedral's museum.

Gazing at the seven-by-thirteen-foot main panel, I pointed out the work's split personality. "This is a Proto-Renaissance piece, which means it has one foot in the Middle Ages and one foot in the Renaissance. You can see the Middle Ages part in the flat gold background, those huge gold halos, and the figures looking like they're stacked on top of each other instead of standing on the ground in a three-dimensional space. All of this helps to play down the real and emphasize the spiritual—the main goal of medieval art."

Kurt nodded thoughtfully and appeared mesmerized by the glittering masterpiece.

"But the work also includes a naturalism that would eventually become full-blown in the Renaissance. So even though the figures look like they're lined up on wall shelves in a world with no depth, their shaded bodies suggest the 3D bulk of people with real weight. And while the background is gold, offering no earthly reference at all, Mary's throne appears solidly three-dimensional, with an early stab at linear perspective."

I pointed to the base of the throne. "And Duccio's inscription provides another Renaissance tell. It asks the Virgin to grant peace to Siena and life to Duccio because he painted her." I wondered how closely Kurt listened and if he would catch Duccio's self-proclaimed importance, so unusual for medieval artists but typical of the Renaissance.

"Well, he sure had balls," Kurt scoffed. "Felt a little entitled, did he?"

I laughed. "So you *were* listening."

"Of course I was listening. Now I'm hurt. I listen to you, Claire."

"I was just teasing," I said, thrown off by Kurt's unexpected sensitivity. "You're right, though. Duccio did have balls. And he was a master rule breaker. Most of what we know about him, outside of his art, comes from fines he got for all kinds of misconduct like not paying his debts, not reporting to military duty, and, of all things—given that he painted the great *Maestà*—for practicing sorcery."

Kurt laughed. "Nice to know even your esteemed artists can misbehave at times, and you still manage to love them." He put his arm around

me and gave me a squeeze that was too quick to elude.

It was true. I did love my artists, no matter how dastardly they were. And sometimes it even made me love them more, but I reminded myself, my soon-to-be ex-husband was not an artist.

Kurt and I ambled hand in hand down the cobblestone streets until we came to the historic Piazza del Campo, Siena's main square. It fanned up and out from the fourteenth-century town hall—Palazzo Pubblico— and provided an airy contrast to the narrow passageways leading to it. Il Campo, as the locals called it, had been used over the years for fairs, markets, tournaments, and horse races—the latter a tradition that continued.

Since Kurt seemed to be enjoying the art, I decided to take him inside the Palazzo Pubblico and show him the *Allegory of Good and Bad Government* by Ambrogio Lorenzetti. The companion wall paintings depicted views of the town of Siena and the surrounding countryside—a rare secular subject for the early fourteenth century.

Kurt listened carefully and looked closely as I described the unique qualities of the frescos. After some thought, he said, "I like the construction workers on that roof up there. If this is supposed to be Siena under a good government, I think the guys on the roof convey the perfect message of day-to-day economic health that everybody who saw this painting could understand." Then he frowned at the fresco. "As opposed to those dancing girls. As lovely as they are, I can't imagine that they showed up every single day and danced around the town. They must have had something else to do." He softly touched the small of my back.

I grinned, enjoying the vocal and insightful Kurt beside me as well as the chills tiptoeing up my spine. "Good observation," I said. "I'd never thought of it like that." I looked up at his hypnotic green eyes and saw a different person, a man interested in my world, a man who was doing everything right.

Foot-weary and hungry again, I suggested we stop for a bite to eat. Kurt guided me to Tre Cristi, a traditional Sienese restaurant in a fifteenth-century building tucked just beyond the tourist sites. As with

the Giardini La Lizza, I was surprised Kurt had found this restaurant. He knew I loved dining in historical settings and must have picked it out ahead of time, especially for me—just in case.

Finishing our dinner with sambuca, I leaned back in my chair, delightfully tipsy, and watched Kurt handle the bill. I thought about how often I'd dreamed of being in Europe with him and what it would be like. But this was nothing like my dreams. This was better than anything I had ever imagined.

Kurt looked up from the check and smiled. "Ready?"

We reached the *pensione* as darkness fell. Before stepping inside, Kurt pulled me close and kissed me—a long, hard, impassioned kiss. I offered no resistance.

"I'm staying in your room, you know," he whispered.

I didn't know. But I hadn't thought about it, either. Of course, where else would Giuseppe and Anna put my husband?

My heart quickened. "You can't."

"Why not?"

"Because"—I floundered—"because it's a single bed."

"Well," Kurt paused, pulling me close again, "that works just fine. We only need one."

# TWENTY-THREE

**I WOKE LATE THE** next morning, hungover and panicked. What had I done? I knew we'd had sex, and that was disastrous enough, but what did I tell him? Did I say I wanted to get back together? I looked frantically around the room. Where was he?

"Hello, Sleeping Beauty," Kurt said, walking through the door with two cups of coffee. "It's too late for breakfast, so I brought you some java." He was showered, shaved, and dressed in a pair of gray silk shorts with a yellow Hawaiian shirt, looking like the quintessential California tourist.

I buried my head in the pillow.

"Well, something must have worn you out last night. Can't imagine what that was." He set the coffee cups on the bedside table and leaned down to kiss me. I stiffened.

"What's wrong, Button?"

Hearing my pet name made me shudder. "I'm uncomfortable," I said, turning on my side to look at him again.

"I bet you are. You were quite an animal last night, just like old times." He stroked my hair, as if calming a skittish cat, and grinned at me.

My eyes widened. I saw it. I'd almost missed it. But there it was, as plain as day—the arrogant grin of a conqueror, a man who had just

trapped his prey. I thought I'd glimpsed it before, every time he'd coaxed me back from leaving him. But there was no mistaking it this time. I could almost hear the metal door of the cage clang shut and the padlock click. He looked triumphant as he eyed me—his hunting trophy.

I jumped out of bed. "Get out. This is wrong. I'm not falling for this again. You tricked me last night. It wasn't you. You were pretending to be someone else. You were pretending to be—" I caught myself and froze.

Kurt stared down at me, his green eyes iridescent with anger. "Who was I pretending to be, Claire?" He said in a slow soft voice, "your new lover?" His upper lip stretched tight against his teeth—that distinctive sign of his barely controlled fury.

I feared what came next. The memory was seared into my brain, and when triggered by that look, it paralyzed me. He knew the power he had. I could see it in his eyes. He knew the fear of physical violence was more effective than the act itself and, of course, impossible to trace. He didn't have to hit me to get his way.

But even aware of the superior power of psychological abuse, it still took considerable self-control for a violent man to keep those impulses in check. And that was the struggle I saw playing across his face.

"No, Claire, you knew exactly what you were saying and exactly what you were doing last night. So, who tricked who? Who was pretending? And to think I came all this way to give you another chance. But now I can't imagine why. Why would I ever want a cunt like you?

"Oh, and don't worry. You'll get your divorce." He stopped scowling. His top lip stayed taut while his bottom lip curled up like the artificial smile of a clown. "But I'm going to take full custody of Amber."

"What? You can't do that. You haven't even seen Amber since we separated. Why would you want custody?"

"Why do I want custody?" He reached into his pocket, pulling out his wallet. "Because you're an unfit mother."

"What?"

"Yep, it's a damn shame you didn't think of that consequence, Button, when you decided to cheat on me. He flicked a business card on the

floor and turned to leave. "You'll be hearing from my lawyer."

In an instant, my body shot across the room as if launched by some invisible force. "You don't want her. You're just using her to hurt me." I seized his arm and wrenched him toward me. "So, which one of us is truly unfit? Which one is so depraved he would use his daughter as a weapon? Well, I won't let you. I won't let you hurt her or me. Do you hear that?"

He slowly pried my hand off his arm. "We'll see," he said, bending my fingers backward and forcing me to my knees. "We'll just see, now, won't we, Button."

He turned and walked through the door, closing it behind him with quiet precision. I collapsed on the floor.

"Claire, you in there? Claire?" Viv let herself into my room. "Holy crap, are you okay? I saw him leave. He looked bonkers. What happened?"

"I'm okay," I said, turning to face Viv with dead eyes. A moment passed. "No, I'm not. Kurt's taking me to court for full custody of Amber. He says I'm an unfit mother."

"What? Why? How can he do that?" Viv sank to the floor beside me.

"He's mad at me, and this is his way to get even. He's using Amber to hurt me. She's only a means to an end for him."

"What a fucker! What a low-life, dirty little bastard." Viv's angry outburst gave voice to my blocked emotions. "But even if he tries, there's no way he'll get full custody. You're not an unfit mother."

"Well, he thinks I am."

"Why?"

"Because I committed adultery."

"Just because you had an affair doesn't make you an unfit mother. Lots of people have affairs."

"Yeah, but lots of people aren't married to Kurt. You should have seen the look in his eyes. If there's a way to turn adultery into a case for sole custody, he'll find it."

Viv and I sat quietly on the floor. I ran my fingers along the cracks

between the floorboards while Viv looked out the open window, across the rows of grapevines and olive trees. A slight breeze brought a whiff of jasmine into the room.

"Hey, listen," Viv said with some reluctance. "Maybe Tony can help."

"Your brother Tony? I thought you hated him."

"Yeah, well, we're definitely not buds. I wrote him off when I was sixteen and haven't seen him since. I guess that makes it more than fifteen years now."

"You haven't seen your brother for over fifteen years? Why?"

"Well"—Viv hesitated—"he's eight years older than me and was in law school when I was in high school, so I never saw him much anyway, but he came by the apartment sometimes to see how I was doin'. I remember him being a crusader kind of guy. He said he wanted to go into law because he wanted to fight for causes, and I thought that was super cool. I liked the idea of my brother being a fighter."

"He sounds wonderful. What happened?"

Anguish crept across Viv's face. "Well, this one night, I was home with my next-door neighbor, Suzie. She came over a lot because both our moms worked at night, you know, and neither of us had a live-in dad. Anyway, we were playin' cards, and the TV was goin'. The news came on, and Suzie said, 'Hey, I think that's your brother.' I looked at the TV and saw a bunch of guys marching with banners and flags. The newsman said it was a gay pride parade—a new way for gays to stand up and be heard.

"I didn't see anybody I knew and thought Suzie was just bein' a shit. Then they showed a close-up of two guys kissin'. One was Tony. Me and Suzie 'bout fell off our chairs. I was speechless, but not good ol' Suze. She started laughin' like a loon and said my brother was a queer. So I punched her. I guess I shouldn't a done that, but I did. Suzie screamed like a banshee and high-tailed it outta there." Viv clenched her hands.

"Next day at school, I was standing by a bunch a other kids when I heard a couple a guys sniggerin' behind my back. Then those same dickheads walked in front of me and started pawin' at each other like

they were makin' out. Well, this cracked everybody up, and it hit me like a lead balloon what Suzie'd done. She'd told 'em. She told the whole damn school my brother was a fag. I was so pissed. I was already an outsider—a loser—and now it was tons worse. How could my brother do that to me? He wasn't a fighter. He was a faggot. I never spoke to him again. Well, except when he called to tell me Sonia died."

"Oh, Viv, what a sad story for both of you."

"Well, yeah, I guess." She pressed her fingers to the corners of her eyes. "Anyhow, I only brought it up 'cause he's a lawyer, and maybe he can help you."

"But you were so mean when he called about your mom. I can't imagine he wants to talk to you again, let alone help me. Why would he do that?"

"Because he's like that, or at least, he used to be. He likes to fight for causes, and you got one."

"I don't know what to say, Viv. You honestly think he'll help me?"

"Well, the only way to find out for sure is to call him. I've still got his number crumped up in my purse somewhere. Throw on your robe, and let's go downstairs. What's the worst that could happen?"

Hearing Mara's phrase come from Viv's mouth felt oddly comforting, and I got up to grab my robe.

There was only one phone in the *pensione,* and that was in the parlor, directly off the foyer and next to Anna and Giuseppe's private quarters. It was a small, whitewashed room with a high wood-beamed ceiling and tall, shuttered windows. A red-and-white-striped sofa and two yellow stuffed chairs completed the picture, along with an antique sewing machine made into a table.

Viv and I sat in the chairs while Anna settled on the sofa. She started the international calling process, then handed the phone to Viv.

"Hello, Tony? It's Viv . . . Vivien . . . Scarlett Vivien, you know, your sister. Oh, I'm sorry. I wasn't thinkin' 'bout the time difference. Everything go okay with the funeral? Good. Thanks for doin' all the dirty work. So I've got a favor to ask. I've got this friend. She's my instructor

here in Italy. Yeah, that's the one. She needs some legal advice. Can you talk to her? Thanks. Here she is."

Viv gave me the phone and gestured in the direction of the swimming pool. I nodded and waved for her to go.

"Hi, Tony. This is Claire. I'm sorry about your mother. And I so appreciate you taking the time to talk with me. I'm not even sure where I should begin. It's all so overwhelming . . ."

Viv returned as I was finishing the call. "Yes, that's it. All I can think of anyway. But you also need to know Kurt will do anything and everything in his power to win. Yes, I understand. Thank you so much. Uh-huh, you too. Goodbye."

"What'd he say?"

"He said this wasn't his area of expertise, but he'd do some research and get back to me."

"But did he sound positive?"

"No. He seemed more cautious than positive."

"Oh, well, that's just him. He can come off like a flatliner, totally low-key, but don't let that fool ya. Underneath, he's a tiger." An undercurrent of long-buried pride infused Viv's voice. "I remember this one time when I was eleven, he came to pick me up from school. But when he got there, a bunch a rich kids were callin' me names—white trash, trailer trash, shit like that.

"So Tony walks over, grabs my hand, and just stands there staring at 'em. I'll never forget it. My big brother planted there like my bodyguard, daring those assholes to say one more thing. I even remember what he said, word for word." Viv switched to a deep, self-important voice. "'I'm a lawyer, and if this ever happens again, I'm not only going to personally see that each and every one of you gets expelled, but I'm also going to sue you for slander. And when I'm done, your parents won't have a pot to pee in.'"

Viv giggled. "Then he tugged my hand, and we walked off. I was floored. He fooled 'em. Scared the shit out of 'em too. They never bugged me again. And he wasn't even in law school yet. He was just a frat boy."

She stopped, allowing a tender smile to cross her lips. "What's his expertise, anyhow? Did he say?"

"Yes, he told me he works for Lambda Legal."

"What's that?"

"It's a major non-profit that litigates on behalf of gays and lesbians."

Viv's smile faded. "Tony's a lawyer . . . for queers?"

# TWENTY-FOUR

**I COULDN'T WAIT TO** leave our *pensione*. The country air, so fresh when we first arrived, had turned stale, and the rolling hills, soothing before, looked like a sea of relentless waves poised to engulf me.

I sat on my bulging suitcase, trying to force it shut, and I began reminiscing about Rome, our next stop. "You know, my parents moved to Rome when I was a junior in college and lived there for four years."

"Mm-hmm," Viv said, showing no interest as she struggled with her own unwieldy bag.

But I continued talking, trying to keep my mind off Kurt's custody threat. "I used to visit them in Rome for the summers, and I remember my mom and me sitting on their vine-covered balcony in the mornings with our *cappuccini* and *cornetti*." I paused, imagining the sun warming my face and the sweet pastry melting in my mouth.

"My mom retired from being an eighth-grade English teacher when they moved to Italy for my dad's work. And she fell in love with the city. She would take the bus all by herself into town to have lunch with him, which was no small feat since they lived in a northern suburb of Rome—an hour-long series of bus rides to the city center." The clasps on my luggage snapped into place. "Ah, got it. Need help with yours?"

"Okay," Viv said, her mind clearly elsewhere.

I plopped down on Viv's gigantic suitcase, continuing to reminisce. "When I was there, I would join my mom on her treks into town. And she would guide me from one overcrowded bus to another until we reached the piazza where my dad worked. No matter how jammed the buses were, she always managed to get us both on board. I can still see my little five-foot mom elbowing her way onto the bus and into the thicket of people, leaving a clearing just big enough for me to follow."

The nostalgic vision comforted me, and I longed to feel that way again—safely guided. I closed my eyes as another memory pervaded my mind.

"One summer, my mom had two broken ribs, but we took the buses into town anyway. Squeezed in the back on a horribly claustrophobic ride, I asked her how she broke her ribs. 'Oh,' she said without a second thought, 'riding the bus.'" I laughed. "She was fearless."

Calling my mom fearless sounded odd to me. But maybe, in her own way, she was all along. Working despite Dad's opposition, teaching teenagers in the throes of puberty, and giving it all up—work, friends, and family—to move to a foreign country.

Viv appeared to have heard nothing I said, or if she did, my story inspired no response. Sliding all my weight to the front edge of her suitcase, it finally closed, and Viv clicked the locks. Both our bags now properly secured, I went downstairs and asked Giuseppe to help us out to the car.

Once on the road, I tried to stay focused on my memories of Rome but couldn't. Kurt's custody threat was too overpowering. I understood he wanted to hurt me. I'd hurt him. And he wanted to get even. But I still couldn't comprehend his willingness to use Amber to do it. How could a father be so callous? And then I remembered this wasn't the first time. Our baby Noel was the first time.

Although my temples pounded in protest, my mind sank back to that soul-crushing day. I remembered the antiseptic smell of the hospital room, and it repulsed me as I relived the suffocating agony of Noel's death.

I saw Kurt rising to shake the doctor's hand, saying, *It's for the best.* And I reeled from the memory. I hated him for saying that, then and now. But instead of lashing out at him, I turned on myself. Maybe I didn't deserve a baby.

I dug my fingernails into the padded steering wheel, furious that I'd allowed myself to think like that. If anyone didn't deserve a child, it was him. I visualized us again sitting in the hospital room just before learning Noel's fate, both of us racked with fear. The vision was brutally vivid. I could see the coarse stubble of Kurt's beard, the cracked skin of his chapped lips, and the look in his eyes—that now unmistakable expression—panic. My breath caught in my throat as a chill ran through my body, and I finally saw the truth. The fear we felt that day wasn't the same fear. I was afraid she would die. He was afraid she would live. Noel's death was the best for him.

# TWENTY-FIVE

**IT'S BEEN SAID THAT** driving in Rome is an exercise in insanity
and should never be attempted. But we did it. We drove straight through
the congested city to its heart: supervised by whistle-blowing traffic
cops, reprimanded by honking horns, overcome by ambulances with
*eee-aah, eee-aah* sirens, and swarmed by grumbling motorcycles. Our
reward—the Grand Hotel Roma.

At this late point in the journey, it dawned on me that Viv had chosen
our hotels, not Tom, and that she'd picked each one for its celebrity
status. Our sumptuous hotel in Rome, for example, was opened in 1894
by César Ritz and had now become a fashion venue for haute couture
designers like Valentino and Gucci. In every city on our itinerary, Viv
had placed us at the very center of the fashion world. It also finally
hit me that Viv was not only a dedicated fan of haute couture but also
"haute" society, and she had carefully designed this trip to experience
the lifestyles of the rich and famous.

But as splendid as our luxury venues were, I still only had eyes for
art—my place of refuge. And I knew Rome would not disappoint. No
matter how mind-boggling Florence was with its abundance of art
venues, Rome was heart-stopping. There were great works of art at

every turn, from pre-Roman Etruscan times to the seventeenth-century Baroque period and beyond.

As usual, though, Viv's mind was on a different track. She had gone through all of her traveler's checks and had called Tom to wire more money. The money, she told me, was now being held for her at the American Express office in the Piazza di Spagna. And that was all she cared about.

"Hurry up." Viv said, pacing my room.

I was going through my usual arrival ritual, putting my makeup kit by the bathroom sink, placing my toothbrush in the water glass, laying my nightgown on the pillow, and hanging my most wrinkle-prone clothes in the closet.

"Let's go. Good God, you're slow as molasses goin' uphill in January."

"Okay, okay, I'm ready."

Fifteen minutes later, we were leaning against the stone parapet at the top of the Spanish Steps leading down to the Piazza di Spagna.

"Tom sure indulges you," I said, scanning the one hundred and thirty-five stairs we had to descend to get her money.

"Why shouldn't he? We've got to spend the loot on something, why not on me?" She smiled and did a half-curtsey. "What's that oval thing down there? It looks like a giant sunken birdbath."

"Oh, it's one of Rome's worst fountains. Pietro Bernini made it. He was a minor seventeenth-century sculptor, but his son, Lorenzo, became one of Rome's greatest artists. It's a sinking boat." I had never paid much attention to the unimpressive fountain before, but now I found it depressing in its perpetual state of semi-drowning.

We started down the steps. "But you know," Viv said, "that's how Tom shows me he loves me, giving me things. And I think it's so sweet. I love presents. Of course, it might also have something to do with my panic attacks. Remember I told you they happen when I feel unsafe? I think he gives me things to keep me feeling safe too."

"Do you feel unsafe now?" I could hear the anxious pitch in my voice.

"I'm fine." She glanced at her watch. "Hey, look at the time. We gotta run."

"But it's not even noon yet. They don't shut down until one."

"I know, that's why we gotta go."

The long line in the American Express office—the lifesaver for US citizens abroad in those days—set Viv on edge. She repeatedly glanced between her watch and the wall clock while chewing her gum with the force and speed of a jackhammer, as if that would make the line move faster by example.

I stood out of the way, against the windows, puzzled by Viv's jittery behavior. They certainly weren't going to kick her out at one o'clock. But even if they did, the office would open again at four. It wasn't like her money was going anywhere.

She should have been more worried about where that money came from. Did she ever even think about it being illegal? What if the Mafia showed up at her door and wanted to break her husband's legs? Wasn't there a rumor that Frank Sinatra threatened to break Mario Puzo's legs for making *The Godfather*? How could she be so blasé about Tom's illicit occupation? I'd be an emotional wreck all the time . . . but then, wasn't I already an emotional wreck?

Looking over at the line again, I saw Viv wringing her hands. Her nervousness made me nervous, so I turned to the window to focus on the people outside. A long-haired teenage boy, hugging his precious guitar, ran to join his friends sitting on the Spanish Steps. A smiling young mother, skillfully bouncing her baby on one arm, used the other to push a stroller—now repurposed as an overflowing shopping cart. An older woman and her grown daughter sauntered by, deep in conversation, arms linked tenderly together. And two besotted lovers stopped right in front of the window to share a passionate embrace, blissfully oblivious to my observation. It seemed like everyone I saw was engaged with their heart's desire, and I longed for my own, wondering if Kurt really was going to take my daughter away and if my world would ever feel whole again.

I turned from the window, my heart heavy in my chest, and looked once more at the line. She was gone. I quickly scanned the room and glimpsed a woman bolting out the door—Viv.

"Wait!" I yelled, racing after her. She didn't look back as she plunged into the sea of bodies milling around the Piazza. "Vivien, stop."

She kept going, zigzagging through the crowd, skirting the Bernini fountain like a car on two wheels, and zeroing in on Via Condotti.

I wasn't far behind when I saw her duck into the first shop on the corner—Dior. By the time I got inside, though, Viv was nowhere in sight, and I was mystified.

Going to check the dressing rooms, I sighted her from the corner of my eye, speeding toward the exit, shopping bag in hand. How'd she do that? She just got there.

"What are you doing?" I snagged her arm as she bounded through the door.

"I'm shopping," Viv squealed. "Oh look, there's Gucci. Quick, let's go."

"Wait a minute. You ditched me back there. What's going on?"

"Oh, sorry 'bout that, but don't you see I'm running out of time? The stores are gonna close. Anyhow, I knew you'd find me. I mean, where else would I be? C'mon, Gucci's waiting." Viv smiled at me like a three-year-old at Christmastime and scrambled off down the street.

This wasn't Viv's first shopping spree on the trip by a long shot, but she'd never been so obsessed that she forgot about me completely. Of course, she'd never been out of money before, either.

Looking down the narrow street lined with designer stores and clogged with shoppers, I saw Viv nosedive into Gucci, her shopping bag gripped tightly in hand.

The scene reminded me of Viv's other shopping binges and made me think of that bathing suit she said she bought in Milan. We were together the whole time, but I never saw her buy it, let alone try it on. And she certainly didn't have time to try anything on in Dior just now either. She only had time to grab, buy, and run.

Ambling toward Gucci, I continued to ponder Viv's odd behavior. She reminded me of those crazed contestants on *Supermarket Sweep*, racing to fill their shopping carts with anything and everything before their time was up.

*Oh, God!* I stopped mid-step. *How could I have been so blind? Was I that self-absorbed?* I leaned against a storefront window, dumbstruck by my latent recognition of the obvious. Viv was a bona fide shopaholic.

Appalled by this latest revelation, I recalled what I knew about the disorder. It was an uncontrollable urge to buy things with no concern for need, cost, or even usability. Compulsive buying like that filled an emotional void and was sometimes a substitute for human love. Well that certainly fit Viv to a "T," considering her mother. I shook my head. What a mixed-up mess she was: the illegitimate daughter of a prostitute, the wife of a bookie, and a shopping addict with an anxiety disorder to boot.

I started walking again toward Gucci, buffeted by a swell of consumers. No wonder Tom gave me so much money. Viv would have spent it all on shopping instead of essentials. He was betting—as he did—a stranger would be more trustworthy than his wife. Well, that wasn't much of a gamble. Anyone would have been more careful with money than Viv.

Continuing my mental diatribe about Viv's disconcerting shopping addiction, my judgmental thoughts abruptly redirected. I realized I, too, was addicted. But at least Viv could *have* the objects of her affection.

So, the rest of that day—apart from the *pausa pranzo*, the traditional Italian lunch break—we shopped on Via Condotti and Via del Babuino, two of the most exclusive and expensive shopping streets in the world.

Viv was ecstatic. Me? Not so much.

A "normal person" would have seen the writing on the wall far earlier and surrendered to Viv's whims without a struggle, hanging up her mortarboard to enjoy the ride instead. But not me. Just the thought of giving Viv free rein made my head hurt. Who knew what she'd do with unbridled freedom? What if it caused a panic attack? It didn't comfort me at all that Viv had come this far without having one. It only made me think that when she did, it'd be the "big one," like that California

earthquake they'd been predicting for years. Not a reassuring thought.

But it wasn't only about Viv. I needed to stay on task for myself. It seemed to be the only way to keep my thoughts from permanently plunging and my fears from skyrocketing. Besides, I had no idea how else to behave. So I planned a rigorous art itinerary for Rome that included one of my favorite museums—the Villa Borghese.

Walking to the Borghese on a sweltering day, I routed us through the villa's expansive gardens to take advantage of the shade. Finding a wooden bench under the lofty canopy of an umbrella pine, we stopped for a break, and I told Viv the story of the wily cardinal who built the villa.

"Cardinal Scipione Borghese commissioned his villa to be built in the seventeenth century but never intended to live in it. It functioned instead as a party house, a showcase for his impressive art collection. And even though Scipione was a cardinal and the nephew of Pope Paul V, he was far from pious. In fact, he had an extensive collection of pornography."

"Ha! You're kidding. What a dirty ol' man"—Viv grinned mischievously—"of the cloth, no less."

"Yep, totally sleazy, but there's more. He was also rumored to be gay." This detail, I realized too late, I probably should have left out.

"Really? Did the pope know he was gay?"

Viv's response to the word "gay" with no mention of a cover-up plan, came as a pleasant surprise.

"I assume the pope knew," I said, "since he banished his nephew's live-in boyfriend, Stefano. But when Scipione fell deathly ill the moment his boyfriend left, the pope reinstated him. It's also interesting to note that when Stefano returned, Scipione fully recovered. One might even say miraculously."

"Total schemer."

"Oh, yes, that he was. He definitely had the pope in his back pocket. That's how he managed to get himself ordained as a priest and then a cardinal. The pope even made Stefano a cardinal."

"No way. He made the boyfriend a cardinal?"

"Yep," I said, impressed by Viv's continued restraint. Still no suggestion to sweep those gay secrets under the rug.

"But that's not all," I went on. "Both nephew and uncle loved art, so when Scipione arranged for a famous Raphael painting to be stolen from a church in Perugia for his personal collection, the pope conveniently turned his head. The church knew who took it, but no one pressed charges."

"What a crook. Unbelievable."

I smiled to myself. Viv didn't appear to catch the irony of a bookie's wife calling out a crook.

"And, on top of that," I said, "Scipione also urged the pope to confiscate one hundred valuable paintings from a Roman collector and then donate them to Scipione's personal estate."

"Holy shit, they were both crooks."

I smiled again. "That certainly seems to have been the case. It's no wonder the new Protestant religion accused the Catholics of corruption and nepotism. How could they not?"

I looked out over the manicured lawn and found myself mentally sliding from Catholic corruption to my own. The vista reminded me of El Dorado Park at home and the lazy afternoons I'd spent there with Alec—lost in time, safe from the world, and loved. I longed for that again. That feeling of completion, the sense that everything would be okay. I imagined the two of us entwined on the grass, filled with contentment. I felt the softness of his touch and the warmth of his breath on my hair until our enmeshed bodies morphed into that drowning boat from the Piazza di Spagna.

"I guess if Tony lived back then, he woulda taken ol' Scipione's side," Viv grumbled, rescuing me from my sinking vision.

"Why would you say that?"

"Well, didn't you say Tony's thing was sticking up for queers?"

Guess I'd been too quick to admire Viv's restraint. "Geez, Viv, what *is* your problem? Your brother's helping people in need, not the Scipiones of the world. Gay's not a synonym for bad, you know. He's standing up

for people who've been victimized by society. And now more than ever, they need defending. AIDS has everybody scared, and when people are scared, they look for scapegoats. As far as I'm concerned, your brother's a hero." I stopped, shocked by the powerful sound of my voice.

"I don't know why he doesn't leave well enough alone," Viv complained, holding her head in her hands.

"Because it isn't well enough! Because he's a crusader. And he cares about people. You told me that yourself. He stood up for you when you were young, remember? He even cares about me, and he doesn't even know me!"

Viv slid her hands over her face and began to cry.

"Oh, I'm sorry, Viv. I didn't mean to yell at you. I don't know what came over me."

"It's not your fault." Viv took short, halting breaths. "It's Tony's. He had to know I'd be dead meat when the kids at school found out my brother was a faggot. What kind of asshole woulda done that to me? All he had to do was lay low, but nooo, not him. He had to go paradin' himself around for all the world to see and turn me into the laughing-stock of the whole goddamn school. And now, I find out he's still out there crusadin' for gays, and *bam-o*, that whole fuckin' mess is back in my face again, just like high school."

I put my arm over Viv's shoulders. "But you're not in high school now, Viv, and Tony being gay isn't about you. It never was. It's about him. He wasn't trying to hurt you. He was trying to stand up for himself in a society that saw him as a freak of nature. That took courage. You think you were harassed as his sister? Imagine what he must have gone through. You should be proud of him instead of mad at him. He's making a difference."

"Yeah, I know, I know, but I can't go there."

"Why not?"

"Because I'm too fuckin' pissed off. That son of a bitch ruined my life." Viv sniffed and reached into her purse. I jerked my arm off her shoulders and sucked in a quick breath.

"What's wrong?" Viv said. "You okay?" She produced a tissue, and I exhaled a slow stream of air.

"Oh, I get it. It's a nose rag. See? Not my pills." She waved the white tissue in the air. "Good God, you're jumpy. I thought for a second I was gonna have to give you CPR." She paused. "And I don't even know CPR." Viv laughed, switching in a flash from her pain to playful teasing. "A lotta good you're gonna do me in a panic attack."

I giggled in return, but it came from a sense of relief rather than a sense of humor. I worried about Viv, now more than ever, and not only because of her panic attacks. Her childhood wounds were so deep, I wondered if she could ever fully recover. But even as scarred as she was, she never allowed herself to be victimized by her past for long. And I admired her for that.

Viv stood and brushed her skirt. "Okay, Madam Art Historian, where to next?"

"Are you sure you're up for it? We could sit here a while longer if you like. You were pretty upset there."

"Nothin' a little art won't cure, right?" Viv winked. "Of course, if you're tired of art, we can always go shopping."

"No, no, that's fine. If you're ready, I'm ready." I sprang to my feet. "But the bigger question is"—I raised my eyebrows—"are you ready for one more *David*?"

"There's another *David*? Well, butter my butt, and call me a biscuit."

"What?"

"Oh, nothin'. Let's go see our boy."

# TWENTY-SIX

CLIMBING THE STEPS TO the Borghese Gallery, I prepared Viv for the sculpture we were about to see. "Lorenzo Bernini carved this marble *David* in the seventeenth-century Baroque period. You might remember I mentioned him before. He was the son of Pietro Bernini— the artist who made the boat fountain." The minute those words left my mouth, the disturbing vision of Alec and me as the sinking boat reappeared.

I rushed Viv through the museum entrance and straight to Bernini's *David*. "Well, here he is. What do you think?" I hoped an insight from Viv would clear the drowning nightmare from my mind.

"So what's with the flying cloth? It looks totally bogus. Are we supposed to believe the wind came up and plastered a random wad of fabric smack on his dick?"

I smiled. I knew she wouldn't disappoint.

"Well," I said, my head now properly cleared, "that strategically placed drapery has a lot to do with a decree the Catholic Church made during the Counter-Reformation."

"During what?"

"The Counter-Reformation. It was the Catholic response to the

Protestant Reformation, a movement to combat not only Catholic corruption and nepotism but also idolatry."

"Wait a minute. I thought that whole fear of idolatry thing ended before the Renaissance."

"Well, it did, but a lot of people were uncomfortable with all of the nudes the Catholic Church collected and commissioned during the Renaissance, and they accused the Church of practicing idolatry. Eventually, the Protestant Reformation forced the Vatican's hand on the issue. So hiding genitalia was an attempt on the part of the Catholics to clean up their act."

Viv shook her head with amusement.

"The original decree, though, was vague, saying works of art needed to focus on piety and couldn't be so beautiful that they inspired lust. But the local bishops were much more fanatical about it. New and existing artworks were to have no exposed genitals, which led to the practice of plastering fig leaves on ancient nude sculptures."

"Ha. Wonder which unlucky artist got that job? Can you imagine a cocktail party conversation with him? 'So, what do you do for a living, Julius?' 'Oh, I decorate dicks.'"

"Right." I smiled. "But if you worked at the Vatican, things got even more bizarre. The ancient sculptures there became the focus of a concentrated campaign to chisel off all exposed penises."

"What? No. What a hoot." Viv licked her lips and thoughtfully stroked her chin like a bearded wise man. "I can see it now. The pope in his big ol' hat and screamin' red cape getting up slowly from his throne and turning to his flunky." She raised her head high, pointed her finger at me, and dramatically cleared her throat. "You, my child, go forth amongst the evil statues and hack off all their pee-pees." She finished with an orator's gesture.

I chuckled. "Perhaps you missed your calling."

Viv gave an exaggerated bow.

"You know, you would've gotten along great with Bernini. Theater thrilled him too. He produced, wrote, and acted in plays. He even

designed the sets and composed the music. You can also see his love of theater in his sculptures. In fact, some have suggested that Bernini's enchantment with dramatic expression inspired the entire Baroque art movement."

"Ah, yes," said Viv, still in character. "'The world's a stage, and each must play a part' . . . to quote the King."

"What king?" I frowned at Viv. "That's from Shakespeare."

Viv eyed me with the smug superiority of a person not to be challenged. "Shakespeare? Pfft! I quoted the King—Elvis Presley—from the song, you know, 'Are You Lonesome Tonight?' A catchier version, don't you think?" She rolled her arm forward with a flourish. "Shall we proceed?"

Caught up in Viv's comedic routine, I bowed my head ceremoniously. "By all means, Your Holiness."

The momentary silliness felt good, a refreshing break from facts, and fears, and constant longing. It also gave me a window into the power of Viv's survival technique—using the restorative effects of comedy to defeat tragedy.

Viv and I walked closer to *David* and found ourselves moving instinctively around him. Unlike the frontal poses of the other works, this *David* spiraled in space, caught in the act of flinging that famous stone. The pent-up emotional energy, so powerfully depicted by Michelangelo, erupted with Bernini.

"Look closely at *David's* face," I said. "What concentration and intense anger. Bernini was a master at depicting emotion, and we know he studied his face in the mirror to capture the feelings he wanted to express."

I reflected for a moment on the other works we'd seen. "You know, I think Bernini's *David* is my favorite of the four."

Viv looked at me, puzzled. "That's weird. You're so serious and—I don't know—uptight. I thought Michelangelo's *David* would be your fave. I mean, it's not like Michelangelo's guy has no feelings, of course. They're just all balled up . . . like yours."

I gave a short, artificial laugh at Viv's keen insight and tried to appear unruffled. "Oh, you think you know me so well." Then to change the subject, I did what came naturally—turned it into a teaching moment.

"But this does bring up the question of why those two artists chose to depict David the way they did. The differences between the contained emotions of Michelangelo's *David* and the explosive emotions of Bernini's reveal the differences between the times in which they were made."

I was sure Viv knew what I was doing—switching the spotlight from me to history—but she didn't let on and allowed me to move back to my comfort zone without comment. Maybe she *did* know me well.

I cleared my throat and began to explain in my most professorial tone. "Since people in the Renaissance believed that physical existence was as important as the spiritual, they began to investigate their tangible world, developing their intellectual skills in the process. Rational analysis soon became more important than blind faith. That's why the mathematical system for linear perspective wasn't figured out until the Renaissance and why Michelangelo's *David* is shown with such intellectual control over his rising passions. Cognitive thought ruled the day."

Viv appeared to be listening, so I continued. "Renaissance inquiry into the here and now led to all kinds of astonishing inventions and new revelations. The discovery of bacteria, for example, was only possible after the invention of the microscope toward the end of the sixteenth century. And the telescope, created less than twenty years later, provided definitive proof that all planets, even the Earth, orbited the sun.

"So, by the seventeenth-century Baroque period, the perception of the world as static and one-dimensional had been completely shattered. And in its place, a brand-new vision emerged. The world was now understood as a dramatic explosion of matter in motion through time, space, and light—a perspective also embraced by Baroque artists." I shot Viv an excited grin. "Let's go take a look at another Bernini sculpture, and I'll show you what I mean."

I'd done it. I'd slipped safely back into my academic cocoon, and all was well.

Advancing toward the adjacent gallery, I slowed to clear my head and absorb our opulent surroundings—patterned marble floors and walls, intricate friezes of bas-relief sculptures, and dynamic ceiling frescoes—a complex fusion of texture, color, and pattern, perfectly reflecting the new Baroque awareness of a manifold cosmos. Enveloped in this visual symphony, I presented the context for the work we were about to see.

"This next sculpture tells the ancient story of Apollo and Daphne from Ovid's *Metamorphoses*. It starts with Apollo making fun of Cupid's archery skills. Offended, Cupid retaliates by shooting Apollo with an arrow that makes him fall in love with the wood nymph, Daphne. And then he shoots Daphne with an arrow that makes her detest Apollo." I tilted my head toward Viv. "Moral of the story here—don't ever make Cupid mad."

"Guess not."

"So anyway, the love-struck Apollo starts chasing Daphne, who finally, in desperation, calls to her dad—the river god—to make her undesirable. Then, the moment Apollo catches her, Daphne's dad turns her into a laurel tree. But even that doesn't stop Apollo. He proclaims, right then and there, if she can't be his wife, she'll be his tree." I leaned once again toward Viv. "Interesting isn't it how he immediately turns his loss into a win."

"Yeah, pretty clever."

"But he doesn't quit there," I said. "To aggrandize the significance of his triumph, Apollo declares that wreaths made from Daphne's leaves will symbolize victory for all time. And they have. Remember the wreath on the hat of Donatello's *David*?"

"How could I forget?" Viv launched into an imaginary striptease while mouthing "You Can Leave Your Hat On."

I feigned disapproval and finished the story. "And to make sure everyone knows this tree belongs to him and is thus truly exceptional, Apollo decrees that she'll be forever green because he's forever young. So, what does Daphne think of all this?" I paused for effect. "She nods in agreement."

I could tell the myth had captured Viv's imagination. "Isn't that a marvelous story? And wait till you see the sculpture. Wait till you see how Bernini turns marble into flesh and flesh into wood. You won't believe it."

The sculpted figures now before us soared up and out into the room with an urgent sense of drama. Daphne looked over her shoulder in fear, feeling Apollo grab her abdomen just as it crusted into wood. At that same instant, her hands, imploring the heavens, grew tiny branches, and the tousled strands of her hair sprouted leaves. Coarse bark crept down the smooth skin of her left leg, and her toenails appeared to liquify before turning into fibrous roots. Neither Apollo nor Daphne seemed to be aware of the magic of that moment.

As I stood there, spellbound by Bernini's mastery, I thought I saw Daphne glance my way. I rubbed my eyes and gave her a second look. But now the sculpture had entirely reconfigured. Daphne chased Apollo. I turned away and back again, but the illusion held, and I fell spellbound once more.

As Daphne ran, her face was stripped of all charm—eaten away by futile desire—while her legs, in the form of tree trunks, pumped ceaselessly, going nowhere.

In contrast, Apollo stood still and showed no interest in her tedious churning. Without charm or any relevant purpose, she'd become a meaningless curiosity—half-human, half-tree—eternally stuck in limbo.

I shut my eyes, wishing the troubling vision away. When I slowly reopened them—one at a time—the sculpture had returned to normal, but I had not. My body felt clammy, and my mind was a jumble of unsettled thoughts.

Viv remained transfixed by the sculpture and appeared not to have seen what I saw. Taking a cleansing breath, I tried to focus on my earlier lecture in hopes of retrieving my rational self.

"Do you see how well this sculpture reflects its times? How beautifully it captures that dramatic explosion of matter in motion through time, space, and light?"

"Yeah," Viv said, "especially that movement-through-time thing. It

looks like time-lapse photography. I mean, it's totally mind-blowing how Bernini freeze-frames the exact moment Apollo touches Daphne and the exact same moment she starts to change. And then somehow, it's like he rolls the camera as you walk around it. Totally awesome."

"Yes, it is," I said, feeling more clearheaded by the second. "And look how Daphne's outstretched arms not only show movement through time but also movement through space. And how the deep carving and overlapping shapes add drama to the piece by creating strong contrasts of light and dark. The whole thing is so quintessentially Baroque." I smiled at Viv. Our shared enthusiasm for the sculpture banished the last remnants of my alarming vision. "Did you also notice how the bark on Daphne's body conveniently hides her genitals the same way the drape hides Apollo's?"

Viv nodded emphatically.

"So here, once again, we see that new modesty imposed by the Catholic Counter-Reformation."

"Yeah," Viv said, "Bernini took that stuff to heart, didn't he? And some of his cover-ups work fine, like Daphne's bark. Since turning into a tree is part of the story, the bark could be anywhere on her body and not look stupid. But flapping a piece of cloth in front of Apollo to hide the family jewels? That's totally hokey. And making Daphne sprout a branch right into his crotch just in time to snag it? Beyond hokey."

I had never paid much attention to that detail before. But there it was, springing from the bark on Daphne's former leg, a leafy branch thrust into Apollo's groin and perfectly positioned to capture and hold the flying material. It actually did look "hokey."

"But I have to admit," Viv continued, "a bunch of fabric stuck in a tree limb at Apollo's dick makes more sense than *David*'s diaper slammed in place by the wind alone." She paused as if picturing *David* in her head. "And did you happen to notice that even though *David*'s cloth clings to the top of his right thigh and dips between his legs, it barely reaches his left thigh and falls just short of covering his crotch completely?"

She raised her eyebrows and gave me a devilish grin. "I mean, be

honest, when you looked at him and noticed that suggestive little peek-a-boo, weren't you just dyin' for the wind to stop?"

I shook my head, amazed at how her mind worked with such precise attention to detail and such uncensored abandon at the same time. I wondered what that felt like—uncensored abandon.

"Hey, what does this say?" Viv pointed to a Latin inscription on the sculpture's base.

"Oh, that's important too. I almost forgot. Here's the translation: 'Those who love to pursue fleeting forms of pleasure, in the end, find only leaves and bitter berries in their hands.' Interesting, isn't it, how the inscription warns about the empty results of lust when the original message celebrates a victory derived from defeat. They could hardly be more different." I paused, thinking about the two interpretations, and realized how my vision of Daphne lusting in vain after Apollo aligned with the inscription. "I guess it's all how you look at it," I said. "It's either a story of triumph or futility. It's a choice."

"Why would they give it such a downer meaning?" Viv asked. "Did Bernini write it?"

"No. Cardinal Maffeo Barberini wrote it before he became Pope Urban VIII. It's supposed to provide a moral excuse for Scipione commissioning such an erotic pagan sculpture in the first place." I smirked. "One more example of the Church trying to justify its less-than-saintly aspects."

"Well, that sounds like the painting we saw by that Giorgione guy," Viv said. "I don't care what anybody else thinks. I still say the naked mother in that painting is a prostitute, and the storm is just a fake moral message to throw people off of the work's real purpose: to give the good ol' boys boners. Same, same."

I touched Viv's elbow to guide her into the next room, amazed by her insightful comparison of the two works. "You ever thought about being an art historian?"

# TWENTY-SEVEN

**RETURNING TO THE HOTEL** after a full day of exploring Rome, I watched Viv slip the concierge a coveted one-hundred-dollar bill in exchange for a sealed envelope.

"What was that about?" I asked.

"Oh, I thought it was time we go out on the town and kick up our heels for a change. We need to have some fun."

"What do you mean? We've been having fun." I wasn't thrilled about kicking up my heels. I was thinking more along the lines of soaking them.

"Claire, you have the screwiest idea of fun I've ever seen. I'm talking about real fun. We're goin' to a nightclub."

"So, you have to bribe a hotel concierge to get into a nightclub in Rome?"

"No, not if you want to go to any ol' nightclub, but"—Viv gave me a proud look —"you do need clout where we're going. And that is"—she played air-drums—"Jackie O." Viv finished her announcement with a triumphant smile, as if she'd accomplished the impossible, and I should have gasped with amazement.

"What's so great about Jackie O'?" I asked, wishing it were a Roman bath instead of a nightclub.

"Do you live under a rock? Jackie O' is the hottest nightspot in all of Rome. Anyone who's anyone will be there. Think you're up to it?"

I wasn't but said I was. I couldn't let Viv go alone, even though the whole idea seemed ridiculous. I mean, how "hot" could a nightclub be?

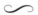

At Jackie O's red door, Viv presented her envelope, and the doorman let us in. A hostess showed us to a red leather booth in the far corner, and Viv, taking on a theatrical air of worldly refinement, ordered a bottle of pink Champagne—as outrageous in price as the bribe we paid for entry. When the bottle arrived cradled in its bucket of ice, Viv poured foaming pink bubbles into my glass and hers. After making a toast to Rome, she stared out into the smoky room, resting her elbows on the table with her glass held aloft and her free hand touching her cheek.

She looked like a different person, demure and elegant. But something seemed familiar about her pose. I finally recognized it. Viv was mimicking Holly Golightly in the famous poster for *Breakfast at Tiffany's*, only with a champagne glass in her hand instead of that insanely phallic cigarette holder. She definitely had it down, and I half expected her to speak with Audrey Hepburn's accent any second. I wondered how many times Viv had watched that movie and practiced the pose.

Eventually, a tall man with smooth, dark hair asked me to dance. I looked across the table, and Viv nodded her approval—as if I were her subject and she the queen. As my partner and I squeezed onto the dance floor, Viv continued to sit in her regal pose, surveying the designer-dressed, yuppie crowd. It was so surreal.

But the whole trip had been surreal—traveling around Italy with a woman so damaged from childhood that success meant marrying a bookie and compulsive shopping topped her list of laudable pastimes. Yet this same person was introducing me—a self-proclaimed worldly art historian—to international experiences I'd never known: celebrity hotels, designer boutiques, and now a high-society nightclub. And while

my disadvantaged companion pursued her dreams, having the time of her life, I wallowed in the mire, wasting mine. Agonizing over Kurt's threat and longing for Alec were exercises in futility. The time had come to get out of my head and join the present, or at least try.

*No,* my mom corrected me. *Do it.*

I smiled and looked up at my dance partner, aware for the first time of his classically proportioned face and his smooth olive skin. I also noticed how unusual it felt to have a strange man wrap his arm around me—and how good.

Catching my smile, he pulled me close, our bodies pressed warmly together. He leaned his head down, his mouth brushing my ear. "Are you having a good time?"

"Yes," I said. "Yes, I think I am."

"You sound unsure. Don't you normally have a good time?"

"Of course I do." I pushed back and looked at him. His dark brown eyes locked with mine. "It's just that I have a lot going on and that sometimes gets in the way."

"Well"—he pulled me close again—"perhaps I can help take your mind off things." He drew my hand to his chest, his heart beating against my palm. Dancing so intimately with a total stranger felt surprisingly comfortable. I wasn't at all self-conscious and didn't feel the need to please, as I typically did around men. Instead, I felt remarkably stable on my feet with no fairytale urge to be swept off them.

I nestled my head in the hollow of his shoulder and closed my eyes, remembering Mara's liberating catchphrase. *What's the worst that could happen?*

He pressed his lips once more against my ear. "You know, I saw you in Florence."

I jerked back. "You did?"

"Yes. I was at the *Accademia* when you were describing Michelangelo's *David*. You were terrific. So animated."

"Oh, well, I guess I do get a little carried away around art. I should probably learn to tone it down a bit."

"Oh, no, don't do that. You're perfect just the way you are."

My heart swooned. No one had ever called me perfect before, and I basked in the compliment until an alarm went off in my head.

"But wait a minute. You were in Florence the same time I was, and now you're here when I'm here? Who are you? Are you stalking me?"

He laughed. "My name's Leonardo Angelini, but you can call me Leo. And I'm not stalking you."

"I'm Claire . . . Claire Aileron," I said, using my maiden name for the first time since I was twenty-one. The sound of my own name startled me, as if I were introducing a different person, someone I didn't know. And I perceived this woman—this Claire Aileron—as strong and independent. Not a doormat. She was also a woman completely disarmed by Leonardo Angelini's laugh and having difficulty maintaining her guard. She found herself more flattered than frightened by this potential stalker.

"Let's go sit down, Claire Aileron, and get acquainted, so I can prove to you I'm innocent." Hearing him say my restored name sent a thrill of recognition through my body. That independent woman was me.

I looked for Viv and saw her sitting in the far corner, the same as before, perfectly content and in perfect Holly Golightly style.

Slipping into the booth next to Leo, I pretended a wariness I no longer felt but kept up the ruse to learn more about this charming man. I folded my arms on the table and leaned toward him with a serious face, hoping I wasn't overdoing it. "If you're not a stalker, how did you happen to be in precisely the same place as me twice? That hardly seems coincidental."

"I can tell from your voice I'm going to have a hard time convincing you of this, but it actually was a coincidence. I have a company that provides study-abroad opportunities in Europe for US colleges and universities, and I'm making the rounds of our summer programs to see how they're doing. I was in the *Accademia* with one of our Florence groups, and now I'm in Rome to check on our programs here."

"Okay," I said, working hard to keep up the charade of suspicion. "The *Accademia* I can accept, but Jackie O'? I'm figuring you don't hold classes here." I raised one eyebrow and inspected the room with exaggerated

scrutiny. "Nope, not a single US college student in sight. They do stand out, you know." I looked at him and struggled to suppress a grin. He was so handsome, so Italian, but he spoke such perfect American English. Interesting.

Leo laughed again, an easy, relaxed sound. "You're right, and oh-so-astute," he said with inflated praise. He was onto me but continued to play the game. "I came here with some Stanford folks we've been wining and dining, hoping they'll use our services for their semester-abroad programs next year."

"But you're alone," I pressed, unable to help it at this point. I was having fun being in the driver's seat and enjoying how he responded— eagerly. He wanted me to believe him. He wanted me to like him. I leaned back in the booth, relaxing my hands in my lap and eyeing him openly.

"Yes, I'm alone," Leo said. "We were all leaving together when I saw you, and I told the rest of the group to go ahead without me. I couldn't believe it was you and wanted to meet the woman who inspired my student to spontaneously propose. Are you satisfied now, Nancy Drew?"

"Jim is your student?" I laughed, visualizing Jim first with a chocolate egg stuffed in his mouth and then skidding down on one knee at my feet. "Well, any friend of my fiancé is certainly a friend of mine. So you're in the clear for now, Mr. Angelini, but don't you leave town."

Leo smiled and leaned back into the booth, our shoulders now touching. "Oh, but I must, Detective Drew. I leave for Paris tomorrow."

"You're kidding. I'm leaving for Paris tomorrow too. Now *I'm* stalking *you*." I laughed, feeling at ease with our bantering. "Are you checking on another program?"

"No. I've already checked on those programs. I live in Paris. I'm just going home."

"To your wife?" It slipped out before I could stop it. I blushed and ducked under the table, pretending I'd dropped something on the floor.

He waited for me to resurface and smiled his broadest smile yet. "No, I'm divorced. But I *am* going home to my cat, Aimée, and she happens to

be partial to red-headed female detectives. Would you like to meet her?"

"Well, I . . . I . . . don't know what to say. I'm . . . um . . . tour guiding, you know, and I've got a schedule to follow, and . . ." I felt like a teenager asked out on a first date. The conversation had moved so quickly from my control to his.

"No pressure, Claire. Here's my card with my home phone number. I have no plans for the next few days, so if you can find the time and feel comfortable, I'd love to see you in Paris."

My lips parted slightly in a dreamy grin that blossomed across my face into my broadest smile yet. "Would you care to dance, Leo?"

# TWENTY-EIGHT

**I WOKE WITH A** start. Something crept across the floor. A spider. A tarantula! I screamed but made no sound. Pressing my shoulders against the headboard, I gathered all my pillows around me for protection. After a moment, I saw the tips of its hairy legs slowly picking their way up and over the footboard. I shook with fear, hearing the soundtrack from *Jaws* playing somewhere in the background.

But then I noticed there were several other people in my room. They were having a cocktail party, ignoring the tarantula and me completely. I yelled to them for help, but again, no sound. I wondered why they weren't scared of the hairy monster, why they didn't rush to my rescue. They acted like it didn't exist. Well, I thought, gaining perspective, maybe it didn't. Or, if it did, maybe it couldn't hurt me. I gathered up all my nerve and stared at the creature creeping ever closer. It had piercing iridescent eyes. Flipping the bedspread in a panic, I knocked the thing to the floor and leaped out of bed, my heart pounding. I grabbed my shoe and smashed the spider. Holding my breath and cringing at the thought of what I would find, I lifted the shoe.

A shrill ring sliced through my nightmare, and I jerked awake in a

cold sweat. "Hello? Yes, operator, this is she. Yes, please connect us." It was six a.m. on our last day in Rome, and the caller was Tony. He told me what he'd found out, and I listened mostly in silence, answering his few questions with "I don't know" and taking my apprehensions out on my fingernails. By the end of our conversation, I felt completely overwhelmed. "I don't know what to say. Yes, of course I will. Of course. Thank you so much for all your efforts on my behalf. I so appreciate it. And, Tony, take care of yourself."

I slid out of bed and knocked on Viv's door.

She opened it, squinting at me. "It's too early to get up. I thought you'd be asleep till noon after last night. What a hunk-a-hunk-a burnin' love he was."

"I just hung up with Tony."

Viv's eyes sprang open. "Come in. Come in. What'd he say?"

I walked over to the bedside chair and gripped its back with both hands. "Tony said he talked to a child custody attorney in California who confirmed that in some cases infidelity could be used as grounds for sole custody since the goal is to determine what's best for the child."

"*Pfft.* That's a no-brainer. Of course, staying with you would be best for Amber. Case closed."

"Well, according to your brother, the 'best interest' clause gives the court broad discretion in establishing custody, so broad there often isn't a strict right or wrong decision. So the success of any child custody case depends a lot on the skill of the lawyers and the opinion of the judge, who can basically decide whatever he wants." I sighed.

"It's the subjectivity of it all that scares me the most. Kurt knows a lot of top lawyers from his business dealings, and I'm sure he'd hire only the best, who would do an outstanding job painting me as an irresponsible floozy. He also went to college with the sons of several important L.A. judges, who I'm afraid would take Kurt's side over mine. You know, the good ol' boys' club." I wrinkled my nose. "Anyway, after talking with the child custody expert, Tony called Kurt's lawyer to find out if Kurt actually intended to go through with the suit."

"And?"

"And the lawyer's drawing up the paperwork now. Kurt's suing me for sole custody of Amber based on my infidelity." I flopped into the chair, burying my face in my hands.

"But wait. He can't just accuse you without some kind of proof. Can he even prove you were unfaithful?"

"Tony asked me the same thing, and I honestly can't say. I know Kurt suspected I was having an affair. But he never confronted me about it, so I assumed he had no proof. Truth be told, though, I don't know what he knows. I suppose he could have had me followed. I figure that's the only way he could have gotten any concrete evidence. So, since he's going ahead with the suit, I guess that's exactly what he did. Which means I'm sunk." I lowered my head again, my heart an iceberg in my chest.

Viv walked over and put her hand on my shoulder. "Let's get outta here. Let's go for a walk. The fresh air will do us good, help us think. We could even stop someplace for coffee and a couple of those corny things you talked about."

I turned toward the window, seeing nothing.

"They're called *cornetti*," I said, rubbing my cuticles raw.

We walked the short distance to the Piazza della Repubblica and discovered Caffè Piccarozzi tucked beneath the semicircular portico edging the vast open space. Sitting down at an outside table facing the piazza's fountain, we ordered *cappuccini* and *cornetti*. The nostalgic combination, though, did nothing to change my mood, and the two of us sat in glum silence.

I started thinking out loud. "I'm not proud of having an affair. I know it was a cowardly way to deal with a bad marriage. But it *does* take two to tango. It's not like he was so faithful to the marriage vows to 'honor and cherish' either." I sipped my coffee while Viv, licking the powdered sugar off her cornetto, nodded in support.

"I know that sounds like I'm making excuses for my behavior, and I guess I am. But it *is* curious how transgressions within a marriage are viewed differently than those outside it. Somehow psychological and emotional abuses between husbands and wives don't carry the same weight. They're not seen as betrayals. They're considered minor offenses, little slip-ups, something a good spouse should learn to forgive for the sake of the marriage."

"Ain't that the truth," Viv said. "It's the same thing with parents and their kids. They can get away with murder as long as it's all behind closed doors. And a kid's got no choice but to take it." She bit her cornetto in two.

"You're right. It's even worse for kids. They're really stuck. But why do adults put up with it? Maybe it's because that kind of controlling abuse is tricky to define—sometimes masquerading as being protective or corrective or even the result of "loving someone too much." I looked down at the mosaic floor, watching the pigeons scavenge for crumbs. "Or is it because women are usually the victims and more likely to suffer in silence?"

"Well, I sure as hell wouldn't suffer in silence," Viv said. "Did that enough as a kid."

"But a lot of women do"—I paused—"like me. And why is that? I know the fear of physical violence is a big part of it. But I think it's also a subliminal thing. Our culture deems us the weaker sex, and our lower status was drummed into our heads from birth, whether we realized it or not, making us feel more vulnerable. And then there's the unworthiness we inherited from Eve. Maybe that's why some women put up with abuse from their husbands. Somewhere in the recesses of their subconscious, they think they deserve it."

I tore off a piece of my cornetto and stuffed it in my mouth, chewing angrily at first, then pensively as my mind slid back to my marriage.

"You know, what's even more troubling to me than our cultural conditioning is my personal blindness. I put up with Kurt's behavior because I thought he couldn't help it, and I believed deep down that he honestly

loved us. But he didn't, at least not the way I define love. If he truly loved Amber, he wouldn't be threatening to tear her away from her home right now. And Noel—the baby we lost? He never cared about her." My throat tightened—anger fused with grief.

Viv reached over and squeezed my arm.

"Then there's me. That whole 'I love you, let's start over again' thing in Siena was just a ploy. And I almost fell for it . . . again. But now I see it had nothing to do with truly loving me. It was more about recapturing his possession. Why couldn't I see that?"

"Don't get down on yourself, Claire. Lots of women fall for the wrong guy. It's our stupid hormones. They mess with us big time, and it makes us act like those three little monkeys, ya know?—blind, deaf, and dumb."

I gave Viv a weak smile. She was trying so hard to be helpful. "Yeah, I suppose, but I think in my case, you could add brain-dead to that list. It never occurred to me that Amber and I were part of his accumulated wealth—status symbols. But now, I'm beginning to think our biggest benefit to him all along was that we verified his upstanding, traditional values, giving him that coveted stamp of approval—the good family man." I smirked. "I bet he's not nearly as upset about losing Amber and me as he is about losing his image."

"What a prick," Viv said.

"Yeah," I muttered, "and I'm an idiot."

Viv fumed at her coffee and cornetto while I gazed at the nine-teenth-century fountain commanding the piazza. Four nude water nymphs frolicked around its edges while the naked sea god, Glaucus, rose triumphantly in the center above them. I'd never liked the fountain. The figure of Glaucus squeezing water like guts from a dolphin repelled me, especially since the artist, Mario Rutelli, intended it to symbolize the arrogant concept of man's "rightful" rule over nature. And the erotic poses of the nymphs reminded me of *Playboy* centerfolds explicitly positioned for the prurient enjoyment of men.

As I watched the streams arcing up from the fountain's circular pool, my vision blurred with frustration. But my mind's eye sharpened as a

series of images appeared in the spraying water. I saw the noble Cleopatra declaring she will not be triumphed over, the brilliant Theodora passing laws for women's rights, the powerful Isabella d'Este, presiding as ruler of Mantua, and my fearless mother riding the bus with broken ribs. The spider from my nightmare appeared next, looking like Charlotte from *Charlotte's Web* instead of a monster. And the final illusion—a deflated Kermit the Frog balloon sinking into the water.

I leaped up from my chair.

"Whoa, what're you doin'?" Viv grabbed our cups on the wobbling table.

"What am I afraid of? He's just a puffed-up blowfish, and it's about time I poked him."

"Huh? Where're you going?"

"Back to the hotel to call Tony."

⌒

I started the phoning process while Viv sat beside me on the bed. As I waited for the hotel operator to call back, my hands shook.

"Hello? Yes, operator, please connect me. Hello, Tony? Claire." I gulped. "We've got to stop him. We've got to fight this. He can't win custody of Amber. He doesn't want her. He doesn't even spend time with her. There's got to be a way I can fight back. I'll do anything. I don't care what it takes."

I chewed on my lower lip while Tony talked. "Right, that's true. It's been months. Yes . . . well, I think so. Okay, yes . . . go on." As Tony continued to fill me in, I listened intently, my eyes growing wider by the second.

"Oh my God, really? Then that's what I want to do." I sprang to my feet. "I want to counter-sue my husband for full custody of Amber. Proof? Of course I have proof. Tons of it. You tell that lawyer his motherfucking client hasn't got a chance." Tony laughed into the phone and made one last comment.

"Ha!" I smiled. "I accept that as a compliment . . . I think."

As I hung up the phone, Viv looked at me like I'd gone mad. "You're going to sue Kurt? On what grounds?"

"Tony said if I can prove Kurt has relied excessively on me to take care of Amber, I have a case for sole custody."

"That's great." She paused. "But what about Kurt's case?"

"He's bluffing. He must be. As far as I can figure, the only way he could prove infidelity is if he had me followed, right? But the more I think about it, he would never have done that. He would have been too embarrassed to admit to anyone he was being cheated on, even a private detective. It would have been too damaging to his manhood— that precious image of his.

"And besides, if he'd had proof of my affair, he also would have known with whom. And he would've used that knowledge to make me end it. Of course, he would have been subtle about it. He didn't want me to hate him, just fear what he might do to Alec if we didn't stop." The thought made me shiver.

"But that never happened. He used an entirely different tactic, an easier one that wouldn't embarrass him and would make him appear in control. He tried to frighten me back into our relationship by leaving me first and dumping all the house and family responsibilities in my lap while I was still in shock over my mother's death. He counted on my dependence on him, confident I couldn't possibly make it on my own. Bottom line, he didn't think he needed proof of my infidelity. He simply needed to leave me, and I'd crumble."

Saying that aloud sent fireballs through my veins, forging my resolve. What arrogance and what a mistake. I didn't crumble then, and I sure as hell wasn't going to crumble now.

My mind raced as the pieces fell together. "And that also explains why he *had* to make the grand gesture to come to Siena. It was his last resort. If he'd known who my lover was, threatening to hurt Alec would have been his first course of action. But without that knowledge, he concocted a different plan—leaving me in the lurch with nowhere to turn except to

him. And when that plan didn't pan out, the only thing left was to woo me back. It took much more effort, but it had always worked in the past.

"So, you see, he's got to be bluffing. He thinks just saying he has proof of my affair will scare me off. Intimidation has always worked on me . . . until now."

"But what if you're wrong? What if he does have proof?"

"I'm willing to take that risk. Tony thinks I have the stronger case anyway. Even though Kurt *has* paid child support, he hasn't seen Amber at all since he left, and he told me he never wanted to see either of us again. I guess they consider things like that as 'intent to abandon.'"

"Fuckin' fantastic!" Viv yelled. "You got him by the balls."

I frowned. "Well, there's only one little hitch. I don't have any concrete proof of his 'intent to abandon.' It's pretty much his word against mine."

"What? But you told Tony you *did* have proof."

"I know. I lied. Nobody knows that, though, except you and me. Kurt doesn't know."

"You're bluffing too? You don't think Kurt's going to call you on that? You're the one easily snowed, not him."

"No. He won't question it." I shot her a reassuring grin. "When he learns I'm countersuing, it'll throw him off his game completely. He won't be expecting me to stand up for myself. I've always been a doormat. So he'll figure if I'm fighting back, I must have proof of my claim, which he knows is legitimate anyway."

I began pacing, a self-assured bounce in my step.

"Either way—whether he has evidence or not—he'll drop his case because my grounds of abandonment are inherently stronger, and there's no way he'll risk losing, especially to a woman, especially to me."

I could see Viv wasn't convinced, her face a map of worry.

"But isn't dropping the case the same as losing? He'd be giving up. He doesn't sound like the type of guy who'd do that, either. I mean, even if he has no real proof and believes you do, why wouldn't he go ahead with it anyway? You said yourself, the 'best interest' clause isn't black-and-white and gives the judge the power to decide. You also said he would

hire the best lawyers and would stop at nothing to win. Even if he lost the first round, he could always appeal. He could just keep hammering at you and win that way."

I pondered Viv's comments. She had a point. She had an *excellent* point. My newfound confidence faltered. Who was I kidding? He would never give up without a fight. That would make him look weak. He'd fight me every step of the way. I sank into the bedside chair, my grand expectations of victory sinking with me.

"Hey, don't pay any attention to me. What the hell do I know?" Viv said, appearing to sense my downward spiral. "You're the one who knows the man, not me. I guess I got scared for you. But don't let me throw you off. I'm behind you all the way. You can do this."

"Of course I can," I said, no longer believing it.

# TWENTY-NINE

"YOU KNOW," VIV SAID, looking at her watch, "it's almost ten. Do you still wanna see that special show you got us tickets for? You were pumped about it the other day. What's it called?"

It took a minute for Viv's words to register. My predicament with Kurt played through my mind in an endless loop, like one of those songs that sticks in my head when I'm trying to sleep.

"Oh, it's called 'The Draw of Women: Renaissance to Rococo.' I suppose we should go. We paid for it."

∽

I moped through the exhibit, barely looking at the artworks and offering no explanations. But Viv soon picked up the slack, providing her own commentary for the works she found most interesting or most ridiculous.

"What's the deal with the bubble boobs? I mean, look at this one by that van Cleve guy. That boob looks totally fake, like the artist stuck it on as an afterthought." Viv giggled. "And look at that baby. What a sly

dog, palming his mom's fake boob and leering at us with that nasty little smile. Nothin' sweet and innocent 'bout *that* kid."

Viv's irreverent comments normally got a rise out of me, but not this time.

"Hey"—Viv grabbed my arm—"look over there. Can't imagine what he did to deserve that."

The startling painting, *Judith Slaying Holofernes,* jerked me from my thoughts. I'd never seen that version in person before. I'd seen Caravaggio's rendition on earlier trips to Rome and another one by this same artist in Florence. But at that moment, that one painting rocked me to my core like nothing I'd ever experienced.

"So, what's going on here?" Viv asked. "I mean, why's she cuttin' his head off?"

"The story comes from the biblical Book of Judith," I said, feeling oddly detached from my words and pulled—body and soul—into the picture. "The man is Holofernes, an Assyrian general who set out to conquer the Jews. When Judith's town was about to surrender, she took matters into her own hands. She snuck into the general's camp, got him drunk, and cut off his head. Inspired by her bravery, the townspeople rose up and drove the army away." I'd told that story often, but this time it felt personal, like Judith's courage was coursing through my veins.

"That's one ballsy gal," Viv said. "Not a squeamish bone in her body. Look at that face—cool as a cucumber. She looks like she's slicing a pork roast instead of sawing off a head."

"Well, of course she's cool," I said. "She can't let emotions get in the way of her goal. Everything depends on it."

I looked back at the painting and felt sucked in again, bewitched by those glowing skin tones and shimmering sheets dripping in blood. Holofernes's head looked poised to burst through the canvas at any moment, and the frightening immediacy of it all took my breath away. But instead of recoiling, I wanted to cheer. What a powerful image by such a capable artist. And who better to capture the stony resolve of Judith than this specific painter?

I turned toward Viv. "Have you ever heard of Artemisia Gentileschi—the Baroque artist who painted this? She had a lot in common with Judith."

"She?"

"Yes, the artist of this painting was a woman, and incredibly gifted. She also had remarkable personal strength. She and Judith are both heroes in my book."

"Why's the artist a hero?"

"When she was a teenager, Artemisia's father—also an artist—hired a man named Tassi to be her art teacher. Tassi raped her."

"Holy crap!"

"Right. But when her dad found out, he took the man to court. The seven-month trial became a public sensation. At one point, Artemisia was even tortured with a contraption similar to thumbscrews to determine if she was lying."

"Jesus!"

"But she persevered. And Tassi was eventually convicted, although not before declaring Artemisia a whore and doing as much damage as he could to her name."

"What a scuzzbucket. Poor woman."

"I know. But she wasn't about to let a scuzzbucket stop her. After the trial, she married quickly to save her reputation. Her husband, though, turned out to be another loser, and the marriage only lasted ten years. But that didn't stop her either. She raised her daughter on her own, supporting them both entirely from her art. The finest courts in Europe hired her to be their painter, and she became the first woman to enter the Academy of Art and Design in Florence."

"Wow! Both those gals kicked ass even with all the odds stacked against 'em." Viv patted my shoulder. "Pretty good role models, huh?"

∽

Judith's and Artemisia's stories followed me back to the hotel as feelings of anger, defiance, and triumph knotted together in my chest. I went to my bedroom to calm down but couldn't relax. I saw myself as Artemisia—sitting in a courtroom and tortured with thumbscrews. But instead of enduring the pain, I buckled.

Disheartened by the vision, I thought back on those times I'd let myself be a victim instead of a victor, to the moments when I'd gathered the nerve to leave Kurt, only to stay on the promise that he loved me. It was easier to give in to that illusion than to face the reality—to recognize that what he truly loved was possessing me.

I knew Amber's fate would be the same. After the thrill of winning her custody, like a prize at a carnival, Kurt would treat her as something he owned instead of someone he loved. His self-satisfied conquering smile flashed in my head, and my entire body exploded with rage.

I imagined myself as Judith marching boldly into my enemy's camp and emerging with Kurt's severed head in my bloodied hands. I had never felt such violent urges in my life. My vision dimmed, and my body burned from the inside out. I was no longer angry. I had become anger.

With the single remaining sliver of my rational mind, I remembered the guided imagery from therapy and knew I needed to control my breathing to regain my equilibrium. I willed myself to sit and breathe with measured rhythm, deeply and calmly, until the fire began to cool and I could contain my fury.

The whole draining experience left me feeling stripped bare, as if I'd been through some kind of purification ritual. And from the ravages of my rage, a clarity grew. In the past, I'd thought anger was a useless emotion. But I now understood, once harnessed, anger could crystallize my courage. And I realized the only way Kurt could ever defeat me was if I let him—if I perceived him as the victor and me the vanquished. I thought back to Bernini's *Apollo and Daphne*—a story of triumph or futility. It was all in how you looked at it.

Viv glanced up from her magazine as I walked into the living room. "Are you okay?" she asked.

I sank into the couch beside her. "Yes, better now. I'm going to hold my ground against Kurt no matter what."

Viv slapped the sofa. "Good for you. I knew you would." She gave me a long look. "You sure seem different, though. What changed?"

I glanced down at my fingers, resting unmolested in my lap. "I'm fully aware that by standing my ground, I could be facing a horrendous court battle, but that no longer scares me. And that's what changed. If he wins, I'll find a way to take him back to court. And if I win, he could do the same thing. But no matter what, I won't quit. I'll do whatever it takes to protect Amber." I paused. "Except I'm pretty sure I won't have to."

"What d'ya mean?"

An unfamiliar sense of well-being flowed through my body and made me smile. "Because, as my friend Mara once told me, Kurt really is just a puffed-up blowfish."

Viv looked puzzled.

"Did you know a blowfish can inflate to four times its regular size to scare off its adversaries? But the effort to do that saps all its strength."

"Thanks for the animal lesson, Claire, but I don't get the connection."

"Okay, this is what I see: When Kurt decided to pursue this whole lawsuit thing, he expected his work to end there. I'm sure he figured just the threat of legal action would scare me off immediately. In his mind, simply launching that threat would assure his victory—game over." I moistened my lips.

"I know he's not prepared for me to countersue. Nor is he prepared for all the time and energy a court battle could consume. So once he realizes I *am* countersuing and won't back down, he'll have no choice but to search for another plan—something easy that won't drain his resources but still makes him look like a winner. And I'm sure it won't take him long to find it. All he has to do is drop his case."

"Okay, I see the blowfish thing now. He pretends he does—but really doesn't—have the *cojones* to follow through with his threat, especially if it means a big ol' court battle. I get that. But I don't get how quitting makes him a winner."

"It all depends on how he looks at it. With the right perception, he won't *be* a quitter. He'll be a hero."

"Huh?"

"All he has to say is he's taking the high road and dropping his case for Amber's sake, acknowledging that children need their mothers. He can then announce to everyone that he believes shared custody is the best solution for his beloved daughter. That way, he'll look like a paragon of virtue while I look like a scheming bitch, suing for full custody. And although making me the bad guy won't punish me as much as winning full custody would have, he'll keep what's most precious to him—his image."

"Wow, talk about scheming . . ."

"Yeah, I know." I smiled at Viv, feeling exhausted but centered. She looked drained too. I hadn't thought about how my misery was affecting her. But now I could see it did, and I realized how much of my burden she'd been shouldering. That kind of selfless support reminded me of her brother.

"You know, I couldn't possibly get through all this without Tony. He's quite a guy, that brother of yours. You know what he called me?" I giggled. "A badass super-bitch. I think he meant it as a compliment."

"Of course that's a compliment. What else would it be?" Viv's face lit up with a glint of pride.

"You should go see him, Viv. Get to know him again."

"Yeah, I should," she said, walking to the window. "You know, after I sorta fell apart yesterday, I've been thinking about what you said. I got it all wrong about Tony. I jumped to a conclusion that made no sense and never looked back. He was the only one who ever cared about me, and I couldn't believe it. How could anyone love unlovable me? So, to my fucked-up teenage brain, marching in that parade was his way of saying what I always feared he would, that he really *didn't* give a shit about me, just like everyone else. And that threw me over the edge. But that's so stupid. He wasn't trying to destroy me. What was I thinking?"

"You were only a kid, Viv—a kid in a terrible place. But you can

change that now. I know it would mean the world to him if you came back into his life."

"Yeah, maybe after this trip, I'll surprise him with a phone call. But I dunno. He doesn't know about Tom and for sure wouldn't think much of Tom's job—Tony bein' a legal eagle and all. I'm just not sure what I wanna do. I need to think about it."

"Don't think about it, Viv. Do it."

"Easy for you to say. I'll do it if and when I feel like it. There's a lot of things to chew on here. I mean, you just don't walk up to somebody you've ignored for fifteen years and say, 'Hi, how's it hangin'? Long time no see.' And, who knows, maybe he doesn't want me back in his life, let alone my family."

I sighed. "I know I sound pushy, and it isn't my place, but I promised Tony . . ."

"Promised Tony what, to put your nose in our business? This is between me and my brother. So butt out. And you know what? The more I think about it, the more I think it's a bad idea. I mean, for Chrissake, he might even throw Tom in jail. Did ya ever think of that?"

"Viv, your brother has AIDS."

# THIRTY

**VIV AND I FLEW** to Paris that evening, the final destination of our three-week odyssey, and we took a taxi to our hotel in the Place Vendôme—the Ritz—a hotel sacred to both of us.

I loved its classical eighteenth-century façade designed by Mansart and its literary history. It thrilled me that Marcel Proust was at its inauguration in 1898 and that F. Scott Fitzgerald and Ernest Hemingway were frequent guests. I remembered Hemingway once wrote, "When I dream of afterlife in heaven, the action always takes place in the Paris Ritz."

For Viv, though, it was the fact that Coco Chanel lived at the Ritz for over thirty-five years and used it as a venue for the private fashion shows of top Parisian designers.

We were both in awe.

Our suite at the Ritz was unlike any we'd stayed in so far. An ornate marble fireplace surmounted by a gilded mirror commanded the sitting room, and an eighteenth-century writing desk was nestled in the corner. Fine decorative moldings detailed the walls, and the bathroom fixtures took the form of golden swans hovering over porcelain sinks and a claw-foot tub.

The suite alone made me sorry we hadn't planned more time for Paris. Viv would fly home in four days while Amber and Bergie would arrive in three, signaling the official end of my employment and the start of my family vacation in considerably more modest accommodations.

Amber flying alone for the first time still made me nervous, but it eased my mind to know that Bergie would meet her in New York and share the international leg of the flight. I was excited to see my daughter and show her Paris, not to mention the Ritz. This would be our big chance to make lasting memories, an opportunity I never had with my mom, and one that would bond us forever. No matter what happened next, Amber and I would always have Paris.

With such a limited time frame, I claimed our first full day in the City of Light exclusively for art. We went to the Louvre in the morning, but I also wanted Viv to experience a more intimate Parisian museum. So, in the afternoon, we explored the Rodin Museum, housed in an eighteenth-century mansion known as the Hôtel Biron.

Early in the twentieth century, the building had been leased to artists, including the writer Jean Cocteau, painter Henri Matisse, dancer Isadora Duncan, and sculptor Auguste Rodin.

When the property was sold to the French government in 1911, the tenants were evicted, except for Rodin, who'd offered the government all his works if they would establish the Hotel Biron as the Rodin Museum and allow him to live there the rest of his life. The French government agreed, and in 1919, two years after the artist died, the Musée Rodin opened its doors to the public with nearly three hundred works of art on display.

On the first floor of the mansion, in the room directly behind the main entrance and beyond the grand curved staircase, sat one of Rodin's most famous sculptures.

"Ooh," Viv cooed, "I've seen pictures of this one. It's *The Kiss*, right?" She fluttered her eyelashes at me. "*Très magnifique, n'est-ce pas?*"

Viv had begun peppering her speech with French phrases the minute we landed in Paris. I could only assume they came from the copious

numbers of fashion magazines she read.

"Yes, *magnifique* it is," I said, admiring the pristine white marble before us. "But you know, its original name wasn't *The Kiss*. That's just what people called it. Rodin created it as *Paolo and Francesca*—the ill-fated lovers in Dante's *Divine Comedy*. But there's nothing much about the sculpture that tells us that. So when folks started calling it *The Kiss*, eliminating the classical reference entirely, the name stuck. These two could be any couple from the past or present."

"Was he trying to copy Michelangelo? I mean, don't get me wrong. I don't wanna slam him or anything, but the guy's body sure looks like those slave sculptures we saw in the Louvre this morning. And all that rough stone reminds me of the ones we saw in Florence too. Don't you think?"

"Exactly. Even though Rodin's classical inspiration is imperceptible in his subject matter, it comes through loud and clear in his style. He idolized Michelangelo, but he didn't just copy him. He took Michelangelo's heroic style and gave it a modern twist. Do you see it?"

Viv looked carefully at the sculpture. "Were women that forward in the old days? She's sorta got him in a headlock."

I smiled, beginning to feel nostalgic about Viv's observational zingers. "Well, however forward women were, you would rarely see them depicted that way in art unless disguised as a goddess, like Venus. But this woman is one hundred percent human, and that's Rodin's modern twist. He's made a real woman the aggressor—her foot on his, her leg over his, her arm wrapped completely around his neck"—I nodded at Viv—"in a headlock, as you pointed out.

"But look at Paolo. He holds his back straight. Only his head bends into the kiss, and that's at least partially because of her powerful embrace. And his hands? One lies limp against the base, and the other sits lightly on her thigh, with his thumb barely touching her. He's participating in the kiss, but she's making all the moves, and he's a bit tentative about the whole thing. It's not his fire we feel. It's hers."

We both looked hungrily at the piece. I didn't know what Viv was

thinking, but in my mind, *I* was that passionate woman, still aching for a man I could never have—the man who completed me.

Continuing to study the embracing figures, I asked Viv if she knew about Camille Claudel, Rodin's lover.

"No. Is this supposed to be them?"

"Well, not initially. He started it before he met her, but I think it's fair to say the passion expressed in this sculpture mirrors the passion of their affair."

"That must have been some romance."

"Yes, but a tragic one. Camille was a gifted sculptor in her own right and met Rodin when she was only eighteen. She started as his student and then became his model, co-worker, inspiration, and mistress. She was single. But he had a long-term, live-in girlfriend, Rose. Based on their letters, Camille and Rodin's affair was intense. But Rodin would not leave Rose for Camille."

"Isn't that a typical man? Wants to have his cake and eat it too."

The hackneyed phrase smacked me in the face. I had always seen Camille and Rodin's relationship as uniquely passionate and profoundly tragic. Nothing about them was typical or trivial. I had certainly never considered them a cliché. But of course they were. They told the same age-old story as Paolo and Francesca—star-crossed lovers doomed by their foolishness. Like me with Alec. My heart recoiled at the realization.

"So, what happened to Camille?"

"Oh, she finally couldn't take it any longer. At the age of twenty-eight, she became a recluse, living alone in her studio and working constantly. She asked Rodin not to see her anymore, but she couldn't stop dwelling on him. Some said she hid in the bushes in the evenings outside Rodin's house to get a glimpse of him. At the age of forty-nine, her family had her committed to a mental asylum, where she stayed against her will until she died thirty years later."

"How sad," Viv said. "What a shithead he was."

"Well, it wasn't entirely Rodin's fault. He told her he wouldn't leave Rose, but Camille couldn't recover."

My heart ached for her. She was a beautiful, sensitive woman and a brilliant sculptor—better than Rodin if you asked me. If only she could have changed her perception—seen her life in another light—things would have been so different. But she couldn't change. She was stuck.

A sharp pain knifed my chest. I was Camille. Making her same mistake. Living the same cliché. I turned away from Viv and back toward the sculpture, feeling suddenly fragile. All that confidence I'd built dealing with Kurt melted when it came to Alec. Camille's heartbreak was mine, and I could feel myself sinking.

I walked around the sculpture, trying to regain my composure, and my eyes landed on the barely noticeable book in Paolo's hand. According to Dante, Paolo and Francesca's illicit passion ignited while reading the romance of Sir Lancelot and Queen Guinevere. That was the book Rodin depicted hanging forgotten from Paolo's limp fingers.

Still struggling to hold back tears, I focused on the book and, in its place, I saw my own, the one my mother had given me with Victor Hugo's poem. "Be like the bird," I chanted softly to myself, "be like the bird . . ."

# THIRTY-ONE

**PERHAPS BECAUSE OUR TRIP** was almost over, I didn't even mind when Viv suggested we go shopping on the Rue du Faubourg Saint-Honoré—another one of the most fashionable streets in the world.

"It's right around the corner from the Ritz," Viv cheerfully pointed out.

"*Quelle surprise*," I said with pretend shock. Of course it was.

In minutes, we graced the elegant haute couture street with our presence, and Viv delighted in the stylish luxury of it all, especially shopping at Chanel's original store—a fashion landmark on Rue Cambon just off the Faubourg Saint-Honoré.

Stepping inside, Viv explained to me in excited hushed tones, "So you know, Coco kicked off her collection early in the twentieth century, but it lost steam after she died. Lately, though, the fashion world's been all atwitter because the designer Karl Lagerfeld stepped in and got the company hoppin' again."

I could see Viv was thrilled about the rejuvenation as she looked reverently around the shop like a religious pilgrim in a church. Gliding over to one of the posh counters, she purchased a bottle of Chanel No. 5 perfume and came back to tell me its story.

"It first came out in the twenties and was given to Coco's top clients as a Christmas gift. She wanted to make a totally different kind of perfume. She said she wanted it to 'smell like a woman and not a rose.' In Coco's day, perfumes tended to smell mostly like one flower. The prim and proper ladies chose lavender, violet, or rose, while the racy gals wanted stronger smells like musk or jasmine. But Coco's perfume was a mix of both, just like her—a modern, complicated woman, way more mysterious than a rose." Viv flashed a smile and continued.

"The formula created for Coco is said to have about eighty different things in it, and it was a smash hit right off the bat. Then, in the fifties, it got even more famous when Marilyn Monroe told reporters all she wore to bed was Chanel No. 5. Can you imagine? She was such a hottie.

"Anyway, they say her perfume maker gave Coco a bunch of formulas, and she instantly picked the fifth one. When someone asked what she wanted to call it, she said she always started her collections on the fifth day of the fifth month and that the number five seemed to bring her luck. So, she named it No. 5—simple as that."

"How do you know all this?" I asked, unable to disguise my amazement.

"What? You think you're the only one who knows stuff?"

"No, no, I didn't mean that. It's just that I studied for years to learn what I now know about art history."

"Well, so did I," Viv shot back. "Just because I don't have a college degree doesn't mean I don't know stuff. I just did it on my own, the hard way, like Ginger Rogers—backward in high heels." She lifted her nose in the air. "Shall I go on?"

"By all means," I said, clearly put in my place. I thought back to the other times Viv had talked about fashion and designers. She'd been trying to educate me all along. But I'd been too absorbed in my internal drama to notice.

"And here's another thing I bet you don't know," Viv said, putting her hand on my shoulder. "Chanel No. 5 is in the permanent collection of the Museum of Modern Art in New York for the bottle design that Coco

did herself. And she made the cap in the shape of the Place Vendôme, exactly where the Ritz is. How rad is that?"

"Chanel No. 5 is in MoMA's permanent collection? Seriously?"

"Yep, seriously. Doesn't that make you adore Coco Chanel? You know her most famous quote, don't you?"

I shook my head.

"'A girl should be two things: classy and fabulous.'" She wove her arm through mine. "And that's us, n'est-ce pas?"

As Viv beamed at me, I felt a deep fondness for this one-of-a-kind woman who had shared my life for the past three weeks, come to my aid when I needed it most, and introduced me to a Europe I'd never known.

I smiled back. "Classy *and* fabulous? That's most certainly us. Where should we go next, Hermès?"

<center>∾</center>

A few hours later, Viv and I stopped by the Ritz's reception desk to drop off our bags and take a break. Our Paris shopping spree was a grand success. After Chanel, we went to Hermès, Givenchy, and Yves Saint Laurent. Even I bought something without Viv's nagging—a classic Hermès silk scarf I felt sure made me look "top dog."

"So 'fess up, Claire—which designer's your fave?"

"Oh, I don't know, I love my new Hermès scarf, and I love those Armani power suits too. It's all a little overwhelming, though. There are so many designers."

"Oh? And what about all those artists and all that art you've been draggin' me around to see? That's not overwhelming?"

"Touché," I said, caught off guard as always by Viv's quick comebacks.

"*Bonjour, mesdames,*" the hotel receptionist said. "You have a visitor." He nodded toward a gentleman sitting in one of the gilded Louis XV chairs at the far end of the spacious lobby—a diminutive man with thinning gray hair. He wore a navy-blue Brooks Brothers suit and had a brown leather briefcase beside him on the floor. His face was hidden

<center>247</center>

behind *The International Herald Tribune.*

Viv and I looked at each other. Neither of us knew who it could be.

We approached the stranger, shopping bags still in hand.

Viv asked brusquely, "You here to see us?"

Two eyes peered above the paper. "Vivi? Of course, it's you. I'd recognize you anywhere. You look great." He stood to embrace her, but she stepped back. He looked unwell. "It's me, Tony."

"Jesus, Tony, I didn't recognize you." She kept her arms close to her sides. "You're so skinny—well, I mean, skinnier than I remember. What're you doin' here?"

Discouraged by Viv's rebuff, he turned toward me. "I came on official business to personally discuss the child custody case with my client. And I'm assuming that's you." He extended his hand. "I'm so pleased to meet you, Claire."

"Oh, you have no idea how very pleased I am to meet you, Tony. No idea." I bypassed the handshake and hugged him. "But you didn't tell me you were coming for a face-to-face meeting. This is way beyond the call of duty."

"I know, but I . . . I don't know. It just felt right to come, and I couldn't let this opportunity to see Vivi go by." He patted Viv lightly on her shoulder. She stiffened at the contact.

"But before we do anything else, I need to tell you, Claire, I spoke to your husband's lawyer and told him you intended to countersue for full custody of Amber. I explained your grounds and made sure he understood you had a considerable amount of evidence to back up your claim, and you were ready to hand it over upon request."

An involuntary squeak escaped from my throat. "Okay. So, what now?" I steeled myself for his answer.

"Now?" Tony paused. "Now, you need to agree not to countersue."

"What? Why?"

"Because if you don't countersue"—he handed me a legal document and pen—"your husband will drop his case, and the two of you will share custody of your daughter."

My mouth flew open. "Oh my gosh. It worked!" I scribbled my name on the document and hugged Tony again. "Oh, Tony, thank you. Thank you so much."

"Don't thank me. Just be glad you had proof. That's what scared them."

Viv and I exchanged glances. To keep from laughing, she turned away, appearing to be captivated by the carpet design while I coughed into my hand to stifle my giggles.

"I scared Kurt? Now there's a switch."

"Hallelujah!" Viv rejoiced. "Way to go, you badass super-bitch." Her voice echoed throughout the lobby as she squeezed me in a bear hug, almost knocking me over.

Tony looked around the empty lobby and laughed. "Well, that should jolt the upper crust out of their stupors, even on the top floor." He brushed his hands with exaggerated finality. "Well, ma'am, I guess my work is done here."

He turned to face Viv. "Except for you, that is. So, where do we begin, Vivi?" His voice was hopeful, but his eyes betrayed his uncertainty.

Viv stared at him, saying nothing. She appeared frozen in time, like petrified wood.

"I have an idea," I said. "Let's go to the Salon Proust here at the Ritz for their afternoon tea. I don't know about you two, but I'm famished." They both nodded, looking grateful for my intervention. "I'll go give our bags to the bellhop at the front desk. You two go ahead. I'll catch up."

When I reached their table a few minutes later, brother and sister were in animated conversation. Their initial apprehensions appeared to have worn off, and the old memories had won out.

"Yeah," Viv said, "like the time I told you I'd swallowed a watermelon seed and was gonna die when that big ol' melon grew up inside me and busted my gut wide open, and you just laughed and called me an idiot. But you were the one who told me that would happen in the first place. You were such a jackass." Viv furrowed her brow at her brother, laughing at the same time.

"I was not. How did I know you'd be so naïve? I mean, come on, Vivi,

you can't blame that on me." Tony's smile rejuvenated his gaunt face.

The waiter arrived with our tea service, including a three-tiered silver tray piled high with the most delectable-looking treats: smoked salmon and cucumber sandwiches, stilton and fig tarts, scones, petits fours, madeleines, lemon cakes, *pain au chocolat*. One would have thought they were feeding the entire court of Louis XIV. And much to my surprise, the service also came with a bottle of Dom Perignon Champagne.

"I ordered it," Tony said, reading my mind as the server poured our glasses. "It's on me. I figured we needed to celebrate." He picked up a glass and looked at Viv. "To my little sister, Vivi. Thanks for still being naïve enough to give your older brother a second chance." He winked at her, and Viv's eyes glistened.

After a few moments of concentrated eating and drinking, Tony turned to Viv. "So tell me about yourself. What do you do? Are you married? Do you have kids?"

"I'm married. My husband's name is Tom. We have a son, Jason," Viv said with an unusual economy of words.

"Great, what does Tom do?" Tony reached for the scones. "Have you tried these yet? They're phenomenal. Food hasn't tasted this good to me in months."

Viv took a scone from the tray and cut it in two. She placed a dollop of cream on the edge of her plate and then a smear of jam beside it before carefully applying just enough of each onto one of the scone halves and taking a small bite.

It looked like a stall tactic to me. Viv didn't usually eat with such dainty and deliberate manners.

"Well, it's sorta hard to explain what Tom does. He . . . um . . . basically helps people . . . um . . ." Viv shot me a panicked look.

"What Viv's trying to say, Tony, is that Tom's a financial speculator."

"Yeah, that's it. I keep forgettin' that fancy title of his." Viv gulped her Champagne.

Tony gave her an approving nod. "He must be good with numbers."

"Yep, he sure is." Viv looked at me again with that same deer-in-headlights expression.

"So, Tony, how long are you staying here in Paris?" I asked.

"Only tonight. I have to be back in New York by tomorrow afternoon, so my flight leaves tomorrow morning at eight."

"Oh, that's too bad," I said. "Where are you staying?"

"Here at the Ritz."

"No shit!" Viv exclaimed. "You must be makin' out like a bandit. I thought non-profits paid peanuts." Her measured words were gone, and her blunt, colorful expressions back in fine form.

"Well"—Tony laughed, clearly not offended—"you're right about the pay, it isn't much, but the work is so badly needed and so rewarding. You can't imagine how people with AIDS are treated. Homophobia and AIDS-phobia have become one and the same. Working to help people who bear the brunt of society's ignorance gives meaning to my life . . . what's left of it." His voice trailed off.

Viv reached over to touch his knee. "Claire told me about your problem . . . your AIDS problem. I'm so sorry." She paused and then released a stream of apologies. "I'm so sorry for so much. I'm sorry I got pissed at you for being gay. I'm so sorry I shut you out. I'm sorry I haven't seen you for fifteen fuckin' years. And now, goddammit, after pissin' away all that time, I'm just so sorry we're down to the goddamn fuckin' wire." Tears spilled from her eyes.

Tony put his hand on hers. "It's okay, Vivi. I only learned I had AIDS a month ago myself, so I didn't know we were down to the fucking wire either. And I'm sorry too.

"I found out when I went to see my doctor because I'd been losing a lot of weight. He had me do a complete blood workup, which included an HIV test. My T-cell count came back below 200. They did some other tests on me and said I also have what they call non-Hodgkin's lymphoma. It's a type of cancer that occurs more frequently in people with AIDS."

Tony paused to let his words sink in. He had to know it was a lot for Viv to absorb, as it must have been for him.

"Can they do anything for you?" Viv asked.

"Chemotherapy. That could buy me five years, but nobody knows for sure. A friend of mine died six months after his diagnosis."

Tony looked down at his plate, pushing crumbs into a pile with his knife. "There's a new drug I heard about called AZT." He tried to sound upbeat. "It got approved a few months ago. From what I understand, it can help keep the HIV from replicating, and if that's true, that's huge."

"Oh, Tony—" Viv began.

"Enough of this depressing stuff," Tony interrupted. "Who wants another scone besides me? Claire?"

"No thanks, I'm full." I brought my napkin to my lips. "Listen, gang, I don't want to be rude, but I know you have a lot to talk about, so I'm going to take my leave and go upstairs for a little afternoon siesta. And don't worry about me for dinner either. I have some things to take care of. You two enjoy your time alone.

"And, Tony, thank you so much for all you've done for me. And please let me know if there's anything at all I can do for you." I looked into his eyes with compassion.

"Don't forget this," Tony said, handing me my copy of the agreement. "Be sure to read it over carefully and let me know if you have any questions. I won't send it on until you give me the final go-ahead."

I smiled. "How can I ever thank you enough?" I turned toward Viv. "You are one lucky little sister."

"And don't think I don't know it." Viv grinned at Tony. "Well, I know it now, anyway."

I walked into the hallway outside the salon and flopped down in a gilded chair, flooded with contentment and feeling like anything was possible. Sitting there, relishing my new sense of bliss, I could still hear Viv and Tony talking.

"So," Viv said, "where do you go from here, and what can I do to help? I really wanna help if I can."

"Well, actually, you can." A moment of silence passed. "Is there anything better than this? Why can't I find this stuff in the States?"

Tony must have gone for that other scone. His voice sounded lightly breaded.

"I've got a proposition to run by you," he said.

"Okay, shoot."

"As you guessed, working for Lambda Legal doesn't make me much money. I don't even work there full time, and I only go in when they need me. But I do make a lot of money from my own company—Homogeny Works. I started it when I got out of law school to help gays and lesbians launch and sustain their own businesses. I guess you can say it's a kind of coaching service. It was nothing much in the beginning, but now I have over a hundred employees." Tony paused.

"Anyway, here's the thing. I need help keeping the company going. I don't want Homogeny Works to die when I do. It's my legacy, and this may sound silly, but I don't want to sell it either. I'd rather keep it in the family for you and—now that I know you have one—for your son. And, of course, your husband, if he's interested."

Viv said nothing.

"You did say your husband was good with figures, didn't you? I could really use help with the books."

Viv laughed. "Well, he sure as hell can do that!"

"Really? That's terrific. Then it's settled. When I get back to New York, I'll draw up the papers. I don't think you can possibly know how much this means to me." He paused. "I love you, sis."

There was a long silence. I imagined them hugging.

"You're right," Viv finally said. "These scones are primo." Her voice gushed with a joy that plainly transcended the pastries.

Their conversation thrilled me. Things didn't get better than that. Heading toward the grand winding staircase, I basked in the breathtaking grandeur of the Ritz and hummed my favorite Eurhythmics tune, "Sweet Dreams (Are Made of This)."

Once in our suite, I sat on the sofa, opened my purse, and began searching its contents. Where was it? I continued picking through my bag without success. It had to be in there somewhere. I couldn't have

lost it. Frustrated, I dumped my purse out on the couch, and a tingle of excitement ran through me. There, peeking out between the pages of my calendar, was the calling card of Leonardo Angelini.

# THIRTY-TWO

"**HI, COME IN. I'M** so pleased you found time to visit," Leo said, ushering me into his flat at the Place des Vosges, the oldest town square in Paris.

"Yes, me too." I smiled. "Viv's brother arrived unexpectedly, and they needed some alone time. So here I am." Stepping through the door, I was greeted with a plaintive meow from Aimée, demanding to be petted at once. I leaned down to stroke her while she smoothed back and forth against my legs, returning the favor.

"She's not normally that bold," Leo said. "But she *is* an excellent judge of character." He led me into his living room—a narrow space with tall gray walls, white wainscoting, and a floor-to-ceiling window opening onto the square below. A light breeze played through the room like music, importing from the restaurants on the ground floor the mixed aromas of butter, garlic, and rosemary.

Leo gestured toward the leather sofa facing the fireplace. "Please, sit down. May I get you a glass of wine?"

"Yes, thank you," I said, looking up at the elaborate molding on the ceiling. "This is a beautiful flat."

"Thanks. I'd like to take credit for it, but it was basically like this when I got it."

"So how is it you speak such perfect American English?" I asked, my blunt question sounding distressingly Viv-like.

Leo chuckled as if expecting nothing less from an amateur sleuth. "Well, Detective Drew, my parents emigrated from Rome to San Francisco when I was seven. But I visited my grandparents in Rome every summer and moved back to Europe after college. *And* to answer your inevitable next series of questions"—he shot me a knowing smile—"my ex-wife and I met while working for a travel agency here in Paris. After a few years, we decided to set up a business of our own specifically for US college students studying abroad. But then, you already know that part." He handed me my wine and raised his glass. "Cheers." We both took a sip.

"Do you and your ex-wife still work together?" I asked.

"Yep. Simone and I are still business partners, just no longer life partners, although we do share custody of Aimée."

"Simone? Not the same Simone I met in Florence?" I pictured her waving at me in the *Accademia* and remembered she was with a man.

"Yes, that's right. The Simone you met in Florence is my ex-wife. She's not really a tour guide, but our Florence instructor got sick, and since we were there to check on things anyway, Simone stepped in to help. She was totally out of her element and told me how you saved her from a mutiny. She does the accounting side of the business, normally. I'm PR." He took another taste of wine.

"And in the interest of full disclosure, I heard about you from Simone even before we saw you at the *Accademia,* which—like seeing you in Jackie O'—really was coincidental. Or perhaps I should say serendipitous?" He gave me an engaging smile. "So, what about you? What's your story?"

"Well, I'm also divorced, in progress anyway, and I have a nine-year-old daughter, Amber."

"Are you a professional tour guide?"

"No. I'm an art history professor. I usually teach summer classes in Europe, but this summer, when my class was canceled, Viv hired me to take just her around Italy and Paris."

"Lucky her." His admiring expression made me blush.

"Yes, well, I guess it was lucky for both of us." I smiled and sipped my wine.

"So where are you going after Paris?"

"Home to Los Angeles—well, actually Long Beach." I felt a sharp twinge in my chest. "Funny—calling Long Beach home just now sounded odd to me. Amber's coming to Paris tomorrow, so the most important thing about my home will be here." I looked toward the window, envisioning Amber and me sitting in that tiny park behind the Notre-Dame Cathedral, Berthillon ice cream cones in hand. The vision made my heart dance. I knew she would love Paris just like I did, and I couldn't wait to show her the sights.

"You know," I said, "I told Viv that separating from my husband made me feel like an escaped balloon. But thinking about Amber and me together in Paris makes me feel grounded somehow. Isn't that strange?"

"No, I don't think that's strange at all. I think that's what Paris can do to people." He locked his gaze with mine, and I noticed his thick dark lashes. Bedroom eyes. So sexy.

"Is that what Paris does for you? Makes you feel grounded?"

"Yes, it does. It makes me feel both grounded and exhilarated. I can't think of any place I'd rather live."

"Lucky you." I raised my glass to tap his, and we locked eyes again.

He smiled. "Have you ever thought of living in Paris?"

"Oh, my gosh, a thousand times. I dream about it. I think it's my favorite fantasy." I drank my wine and chattered on, aware of his appreciating gaze. "I took French in high school and college and fell in love with the whole French culture—from the language to the history to the art. I even like escargot. I think that makes me a genuine Francophile."

He continued to look at me, savoring his wine and saying nothing. The breeze puffed through the window again, this time offering the rich

scents of truffles and thyme. I took another taste of wine. His silence made me self-conscious.

"I'm sorry. You probably couldn't care less about my love affair with France. I don't know why I went on like that. I'm not usually this chatty."

"Would you like to work for me, Claire? Here in Paris?"

"Pardon me?"

"I know this sounds sudden, but ever since I heard about you from Simone and then watched you in action at the *Accademia,* I wished I could hire you. And Simone did too."

So that was the "admiration" I saw in his eyes. He was sizing me up as an employee, not a romantic interest. The realization punctured my ego.

"You're so good at what you do," Leo continued. "When you talk about art, you make it come alive. You're exactly what we need. One of the biggest challenges of my business is finding qualified educators to teach our standard courses, and European art history is, obviously, a standard course for us."

"You've got to be kidding. Qualified art historians must be a dime a dozen here."

"Yes, we have quite a few art historians, but most have accents difficult for many American students to understand. Remember Simone's accent? Americans don't hear other languages growing up, making accents particularly challenging. So they disconnect. It's one of the biggest dings we get every year on our program evaluations. The kids have a hard time understanding our instructors."

"But I have a job," I said, unable to reconcile his proposal with my reality.

"Yes, you told me, but this job would be different. Our art history classes take place in museums and galleries, churches and palaces. Not in classrooms. You'd be surrounded by the real thing all the time, and I saw how much that excites you."

He was right, of course. What made my heart race and my eyes dilate with pleasure was art—real art, right in front of me, life-sized, so I could see every detail, absorb every texture, and revel in every true color.

Art consumed my senses and made me feel alive all over. Nothing else affected me like that . . . other than love.

My mind whirled. Moving to Paris had always been just a dream. My go-to fantasy. I never once imagined it as a reality. "But how would that work? What about Amber? Where would we live?"

"Look, I know this is a huge proposition and a lot to consider, but it is doable. If it makes you feel more comfortable, you could come on a temporary basis at first. Maybe you could take a leave of absence from your college for a semester to try it out. I can find you an apartment. We can get Amber enrolled in a bilingual school. We can just try it out." He slid his warm hand over mine.

The affectionate gesture and the word "we" made the proposal sound even more enticing. Could there possibly be a "we" with Leo? I looked into his eyes and smiled.

"What a lovely idea," I said, feeling his fingers tighten around my hand. "Definitely something to think about."

<p style="text-align:center">∽</p>

Later that night, nestled in my bed at the Ritz, I gave Leo and his proposal more thought, letting my mind drift back to our cozy evening together. And although I found him extremely desirable in every sense of that word, my response to his allure surprised me. I felt no storybook longing to be whisked helplessly away to a happily-ever-after castle, no childlike yearning for protection. And most remarkably, no desperation to fill my empty heart. Instead, I felt balanced around Leo, comfortable in my own skin, and content to let things be.

I also felt like a clearheaded, confident woman with an amazing proposal to consider. And the "we" part of that proposal, though a tempting romantic add-on, wasn't the issue. This decision had nothing to do with a man. This was about Amber and me moving to Paris on our own.

I looked up at the crystal chandelier glittering above my bed and thought that if I lived in Paris, I could visit the Ritz any time I wanted.

*Well, at least I could visit the lobby.* I giggled.

But could I actually do it? Could I move to Paris? Would Amber be okay without her friends? And what about me? Was I willing to leave everything behind? My mother did it. Why couldn't I?

Fingering the smooth satin trim on the bed pillows, I continued mulling the possibility of Paris and remembered Alec's words: *What makes you happy, Claire?* My heart skipped a beat. Could I honestly start fresh?

The phone rang, jarring me from my thoughts. It was my sister. She was working her last flight before meeting Amber in New York and was on a layover in Greece. But her 747 had mechanical issues and was now temporarily grounded in Athens. There was no way she would get back in time to catch Amber's plane to Paris. She'd already notified the airline about the problem, and they assured her they would take care of everything. Bergie felt terrible but could do nothing about it. Amber would be crossing the Atlantic alone.

My heart stuck in my throat. Flying by herself across the US was one thing, but changing planes in New York and continuing on to France all alone? How would that even work? She was only nine years old. My mind shifted into overdrive.

Someone would have to help her off the plane, take her to the next gate, and stay with her the whole time. They'd need to explain what was happening and comfort her so she wouldn't get scared. They'd have to check if she needed food. Amber was a picky eater and tended to snack throughout the day. They wouldn't know that.

They'd have to make sure she had all her things with her: her plane ticket, her passport, her carry-on bag with her games and books, and the travel pillow I gave her. They'd have to pay close attention to her little pink purse, too, with its secret pocket for chewing gum. It was her favorite possession, and she'd be crushed if she lost it.

And who would they assign to her? A woman, I assumed, but would she be kind? Would she even like kids? I imagined Amber exhausted, confused, and frightened. She was expecting to meet her aunt in New York. What would she feel when Bergie wasn't there? Abandoned. Again.

Filled with apprehension and no longer able to lock up my tears, I finally broke down. Tintoretto's angels escaped, and I sobbed until nothing remained. Rolling onto my back, I stared at the ceiling, my chest still heaving. It seemed like all my life I'd been afraid to cry, afraid that if I did, I would never regain control. But as I lay there and my breaths slowed, I knew I'd been wrong. I needed to cry. The same way I needed to get angry. They were prerequisites to real control. Anger had crystallized my courage, and crying—I realized at last—could drown my demons but not me.

I slept little the rest of that night, disturbed by fitful dreams. Kurt encircled Amber in laurel wreaths, keeping her from boarding the flight to Paris. Leo repeatedly knocked on my door, only to morph into Alec when I opened it. And Viv skipped merrily around my room, her hands clutching shopping bags overflowing with money in the shape of transparent angels.

When the sun rose the next morning at six a.m., so did I. Although I felt drained and useless, I couldn't go back to sleep. Amber's flight didn't arrive until the afternoon, so the whole barren morning lay before me.

"Are you awake?" Viv asked, peeking around my bedroom door two hours later.

"Barely." I had folded myself into the bedside chair and looked at Viv with sleep-deprived eyes.

"What's wrong?"

I explained the story and started crying again. I pictured Amber curled up in her airplane seat tight like a fist, petrified.

Viv walked over and placed a hand on my shoulder. "She'll be okay, Claire. I saw kids flying alone lots of times on our trips to Hawaii, and they did fine. None of 'em seemed a bit scared except this one kid, but he was super young, and I don't know what happens with changing

planes and all, but still . . ." Viv stopped, undoubtedly sensing her pep talk was going in the wrong direction.

"I know," Viv said, shaking my shoulder, "let's go to a museum and get your mind off things."

I smiled at her selfless offer. "No, I'm not in the mood. Why don't you go shopping? I'll be fine by myself."

Viv started to protest, but I raised my hand. "Nope. Go. I mean it."

"Okay, if you insist. But I'm only doing this for you, ya know." Viv winked and put the back of her hand on her forehead in mock martyrdom.

"Get out of here," I said, trying to sound playful, but it came out flat instead of fun.

Watching Viv leave, I told myself everything would be fine. Amber was well taken care of, and I was overreacting. But I couldn't stop visualizing her frozen with fear. I kept feeling her helplessness and loneliness, her sense of abandonment and loss.

I picked up a magazine and tried to read but couldn't concentrate. I ordered room service but had no appetite. Filled with painful uncertainty, I longed for Alec to soothe my fears and make things right, as only he could do.

I looked around the room, searching for something to distract me. But nothing did—not the regal bed canopy draped from ceiling to floor, the elegantly dressed ladies smiling at me from their gilded frames, or even the bas-relief sculptures of frolicking cherubs above the doors. It was all too perfect.

Leaving the Ritz and the Place Vendôme behind, I wandered without purpose toward the covered arcades of the Rue de Rivoli, a bustling shopping corridor that bordered the Tuileries Gardens. I walked several blocks toward the Louvre, weaving mindlessly through a river of tourists, until I found myself at the Place des Pyramides, a small open square boasting an equestrian sculpture of Joan of Arc by Emmanuel Frémiet. I watched as waves of people spilled out from the covered arcades and nervously dodged the cars and mini-trucks speeding across the inter-

section. No one noticed the statue.

Although the artist was popular during his lifetime, and *Joan* probably his most famous piece, Frémiet was too traditional to be significant in a broader art-historical context, and his work paled in comparison to that of Rodin, his younger contemporary.

But there the golden sculpture stood on a tall stone pedestal in the middle of the square—a teenage girl in medieval armor sitting straight-legged on her mighty steed and holding a giant flag above her head. She looked glaringly out of place. But still, she sat, unflinching in the face of her more commercially relevant and less ostentatious surroundings and undaunted by being ignored by everyone except me. I couldn't stop staring.

I thought about Joan's improbable story. An illiterate teenage peasant living in fifteenth-century France who imagined herself personally defeating the English and restoring the French king to the throne—which was precisely what she did.

I looked up at her face. She appeared so pompous, so sure of herself, like she'd never made a mistake in her life. But, of course, she had. That's what teenagers did best. Only she didn't let her mistakes define her. What defined her was her vision, a perception of reality that nothing and no one could diminish—not losses or blunders from her past, worries about the future, self-doubts, nothing. She believed in herself and fearlessly lived the life she knew she was meant to live.

Still studying Joan, a light flashed through my head like the fleeting brilliance of a lighthouse flair. And I saw what held me back, kept me filled with doubts and fear. Unlike Joan, I never forgave myself for my mistakes. I let them define me and kept searching for someone to fix me, make me into a perfect whole. I never realized I was already whole just the way I was.

I turned and walked swiftly back to the Ritz, sat down at the antique desk in our suite, and, pulling out a sheet of stationery, began to write:

*Dear Alec,*

*I hope this letter finds you well. I'm writing to thank you for setting me on*

*a course I needed to travel but was afraid to. Thank you for sharing the ideas of Joseph Campbell. They're finally sinking in. And I can tell I'm no longer sleepwalking through life. Instead, I'm on my way to the life I'm meant to live. I'm not sure what that life will eventually look like, nor can I explain this feeling I have, except to say I'm ready to follow my bliss wherever it leads. I'm ready to believe in me.*

*I still love you, Alec. You proved to me that deep, caring love does exist. But I don't need you the way I did. I don't need you to complete me. My entire life, I've looked to men for that, starting with my father, as if men were artists and I a sculpture waiting to be formed and finished by them. But no man can bring me to life. Only I can do that. I now know I am the artist, and it's up to me to do the forming and the finishing. I owe this to myself and Amber.*

*All my love,*

*Claire*

I hurried downstairs, handed the letter to the receptionist for mailing and grabbed a taxi to the airport, a tangle of emotions in my throat.

# THIRTY-THREE

**STANDING AT THE INTERNATIONAL** arrival gate, I waited anxiously for Amber to appear among the horde of deplaning passengers. The crowded terminal throbbed with anticipation. Shrieks of happiness met my ears as haggard voyagers found their loved ones and buried them in hugs. Swept up by their jubilant energy, I couldn't wait to squeeze my own weary traveler. Streams of adult passengers swirled around me, and I scrutinized the spaces between them for her wild red hair, my hopes rising and falling with each child I saw.

Eventually, the throngs began to thin. Small clusters of reunited families and friends wandered off, encircled in each other's arms. Still no Amber. I chewed my bottom lip. My heart was a deafening drumbeat. Where was she?

"Mommy!" Amber called. I spun toward the heavenly sound and rushed to her side in tears. Amber smiled from pigtail to pigtail. She didn't even notice my crying because she was too excited to tell me how fun it was to fly all alone to Paris, and how grown-up she felt, and how eating with tiny knives and forks on a miniature tray was just like playing house, and her final news . . .

"Look at my wings." She pointed proudly to a small pin on her collar. "The stewardess gave them to me when I got on the plane and told me I'm a stewardess-in-training and that anytime I felt scared—but I wasn't, Mommy, I wasn't scared for one second—I just needed to remember I had wings."

"Yes," I said, hugging Amber tight. "You do have wings."

The second Amber's body hit the satin comforter on my bed at the Ritz, she fell asleep, and I wondered if she had slept at all during those long flights.

A few hours later, Bergie arrived, filling me with a rush of relief. Almost before she could set her bag down, I began describing my trip with an avalanche of words. I started with the dreadful story of Kurt but quickly moved on to my odyssey with Viv.

Bergie laughed at my disappointment over going to Dolce et Gabbana's studio instead of an art museum. She shook her head in disbelief when I complained about spending hours on the most exclusive shopping streets in the world. And she marveled at my total lack of appreciation for Viv's leather bathing suit. But when I told her how Viv had dragged me to drink pink Champagne at Jackie O', she collapsed on the bed in hysterics. The trip that had been so frustrating to me sounded like the chance of a lifetime to her—an exquisitely exhilarating adventure that I had missed completely.

I began to laugh with her in a way I hadn't laughed the entire trip— with total uncensored abandon. I had been too caught up in my personal pain and my feelings of responsibility to embrace the real meaning of that word—the ability to respond, the ability to engage in my experiences wholeheartedly.

Viv came back from shopping and found all three of us on my bed— Amber waking up, Bergie and me teary-eyed with laughter.

My sister immediately introduced herself and pointed to Viv's shopping bags. "Oh, look, what'd you buy?"

"Wait till you see," Viv said, pulling out two of her treasures—a black leather flight jacket and a pair of blue-and-white-striped overalls.

I assumed the overalls were designer and tried to see them with a more sophisticated eye, but they looked like they'd come from a country feed store to me.

Viv held the garments up for approval.

"Fabulous," Bergie said. "Give us a fashion show." And we all moved to the sitting room for the event.

Viv did her best to model her purchases. But when she couldn't get the jacket beyond her elbows, she tossed it to the floor and stepped into the overalls. Trying to make them fit, she tugged on the sides as she jumped up and down. But the overalls refused to cooperate and squeezed to a halt just below her bra, making her look something like a blue-and-white-striped sausage with its insides popping out on top. All four of us started giggling.

"What about your leather bathing suit?" Bergie asked. "I'd love to see that." Viv was so excited to share, she didn't even question how Bergie knew about the swimsuit. Racing to her room, she returned not only with the suit but also a leather skirt and jacket I'd never seen before. Bergie squealed.

Encouraged by a fellow fashionista, Viv attempted to model the skirt, but again, it was too small. This time, more intent than ever to make something fit, she dropped to the floor on her back and, like a cartoon caterpillar, arched her body up and down across the Persian rug while yanking at the waistband stuck at her thighs. Bergie, Amber, and I watched in silent amazement until we all, even Viv, burst into laughter.

"May I try it on?" Bergie asked.

"It's all yours," Viv said, still giggling.

The skirt fit Bergie perfectly, as did the jacket. She turned to the gilded mirror above the fireplace, smoothed on red lipstick, and spun back around with attitude.

"Wait!" Viv jumped up and reached for one of her shopping bags. "I've got just the thing." She extracted a narrow-brimmed leather hat

encircled by a band embossed with green leaves. "Here," she said, placing the hat in a sexy tilt on Bergie's head. "Now, you're perfect."

Bergie glanced in the mirror once more to confirm her perfection and began striding around the room, deftly crossing her feet in front of each other, thrusting her hips forward, and sucking in her cheeks to simulate an emaciated runway model. To conclude her spontaneous performance, she returned to the fireplace, posing with a model's pouty air of detached boredom, as if waiting for the paparazzi.

The three of us oohed and aahed in fake admiration. I felt like a different person—lighthearted, fun-loving, and thoroughly engaged in the moment.

A short while later, Bergie and Amber left to check into their budget hotel but quickly returned to luxuriate more in the opulence of the Ritz.

Viv, though, had made other plans. Once again, as in Rome, she bribed the concierge to get the two of us into a very exclusive, upscale nightclub. This one, she declared, was the absolute *crème de la crème*, and all the beautiful people would be there.

I'd brought only one semi-formal outfit—the tailored red pantsuit I wore to Jackie O'—and hoped it would do.

A few minutes later, Viv summoned the three of us into her bedroom with a mysterious air of excitement, and we watched as she dramatically whisked from her suitcase a floor-length strapless evening gown with a layered silk tulle skirt that appeared to inflate like a pink parachute once freed from the bag.

"*Très chic, non?*" Viv said as she carefully stepped into the voluminous gown. "It's a 1950s Chanel original that I found in this primo vintage boutique back home."

"Are you kidding me?" I said. "You mean you've been lugging that giant thing through this whole trip?"

"*Mais oui!*" Viv said with pride. "I brought it especially for this *magnifique soirée*." She tilted her head back, spread her arms, and twirled in place while the gossamer layers of her dress lifted and fluttered, like the billowing skirts of whirling dervishes. She stopped, allowing her

raiment to float back to the floor before adding, "And now that my *oh là là* moment is here, I'm totally stoked."

What could I say? Even though the gown fit her, she looked like she'd escaped from Fantasyland. The only thing missing: a magic wand.

I called for a taxi. It took a few minutes to cram all of Viv's dress and Viv into the cab. Once in, she and her outfit consumed the entire back seat. Bergie and Amber had no choice but to slide in beneath the diaphanous layers of her gown, making the two of them appear to be embalmed in pink cotton candy. I managed to dodge the spun sugar experience by sitting in the front.

In a few short minutes, we arrived at our destination, and I jumped out of the car. I had the concierge's note, but this time I saw no red door. I saw no door at all. So I knocked, well, on the wall. It opened. A hand took the note and disappeared. A second later, the wall reopened, and I waved for Viv to join me.

But joining me was not that easy. Attempting to exit the taxi by herself, Viv's expansive dress resisted, clinging stubbornly to every crevice of the backseat. It took all three of us to disengage her.

With Viv freed, Bergie and Amber got back in the cab for the drive to their budget hotel. I imagined they felt like Cinderella's ugly stepsisters, and I made a mental note to treat them to lunch the next day at the Ritz as compensation. Giving them a quick wave goodbye, I turned to accompany Viv into the famous, secret nightclub.

The dark interior made it impossible to see at first, but we could feel the energy and knew the place was packed. Viv quivered with excitement. I wondered how long she'd been dreaming of this moment, and it pleased me to share it with her. I still couldn't relate to the thrill Viv got from all this, but that didn't matter. I was going to have fun anyway.

We waited near the door until we could see well enough to proceed. The dance floor slowly came into focus, and only then did I notice how those *crème-de-la-crème* Parisians dressed. They all—every single one of them—wore jeans.

I almost fit in with my simple pantsuit, but not Viv. She looked as

misplaced as a fairy godmother in a James Turrell installation. Would she wilt from embarrassment? I began feeling awkward for her. Would she want to leave? How sad she must have been. At last in the place of her dreams, and yet so out of place.

I gave Viv a weak smile. She smiled back, winked, scooped up her fabric entourage with both arms, and waltzed proudly across the dance floor. The whole crowd stopped dancing and stared while Viv, seeing all eyes upon her, turned her head from side to side, smiling graciously at her admiring fans. *She* was the celebrity now. The one everyone wanted to see. The one they all loved.

Well, butter my butt and call me a biscuit.

At ten o'clock the next morning, a taxi pulled up in front of the Ritz to take Viv to the airport. We hugged and promised to stay in touch, but I knew we wouldn't. From here on, we'd go back to our separate and very different lives, and this magical mystery tour of ours would seem like a dream. For me, though, it'd been a dream come true—one that opened the door to reimagining my existence. But what about Viv? She'd done so much to help me grow on this trip, and I wondered if I'd done anything remotely meaningful for her. Then it occurred to me. Viv never did have a panic attack.

I smiled as Viv opened the door to the cab. She smiled back, handed me a sealed envelope, and we hugged goodbye again. As the taxi drove off, I waved until I could no longer see the car. Then, I read her note.

*I found this quote and thought of you.*
*Love, Viv*

> *"If you were born without wings,*
> *do nothing to prevent them from growing."*
> *Coco Chanel*

I pressed the note to my chest as tears filled my eyes, and I slowly looked around the vast octagonal space of the Place Vendôme. It had transformed into the cap for Coco Chanel's No. 5 perfume, and the obelisk in the center had become me. I wore bold primary colors and twirled confidently on tiptoe just like Niki de St. Phalle's triumphant winged sculptures. I smiled once more. Life imitating art.

BERGIE AT THE RITZ

# ACKNOWLEDGMENTS

In 2013, I told my friend Gretchen about an adventure I'd had as an art guide in Europe. When I finished the story, she said, "You should write that." I'd never considered the idea until then. Thank you, Gretchen. I owe the creation of this book to you.

A while later, I shared a preliminary draft with my friend, Alicia. After reading the story, she said, "You should publish this." That was just the encouragement I needed. From then on, Alicia became my steadfast supporter, inspiring me with a constant stream of famous author quotes and champagne memes. Here's to you, Alicia.

But I also required professional guidance. Enter Naomi Kim Eagleson of The Artful Editor, who told me, among other valuable things, that my story was in a straitjacket. A perfect visual for what I had to do next—break loose. After two years and many more drafts, I sought out Heather Webb, whose comprehensive editorial criticism transformed my whole tale. And finally, I turned to Rebecca Coleman through Reedsy for those essential finishing touches. Because of these women, my story became the novel it was meant to be.

Throughout this process, I took courses, attended conferences, and

joined writing groups. I even went to Jefferson, Texas, for the Pulpwood Queens Girlfriend Weekend, where I met some wonderful book-loving women and found my inner go-go dancer. (But that's another story!) Thank you, Kathy Murphy.

I'd also like to acknowledge my family and other friends for their unwavering support:

My sister: who has given me unconditional love since birth—except that time she tried to stab me with the scissors. And my daughter: upon whom I inflicted permanent damage by dragging her through so many art museums as a child.

My cousin Sally: a voracious reader and encourager of all things positive. My cousins Dave and Eric: who faithfully cheered me on. And my business-minded brother-in-law Mike: who never once told me I was crazy to do this.

To Elle: the source for that all-important question in my story, "What's the worst that could happen?" and the basis for the marriage proposal scene in Florence. And to Karen: who founded our Laid-back Book Club and who keeps me supplied with more book options than I could ever read in a lifetime.

To Nancy: whose meaningful insights were so crucial to improving my story. And Gail: whose sharp mind and eye helped tremendously with cover and layout decisions.

To Don: who became my writing pal and fellow whiner when the process of writing a novel overwhelmed us both. And Romalyn: who's been my intrepid guide through this wild world of publishing.

And to the many other early readers who encouraged me, please know you too played a part in building this novel: Beverly Bennett, Barbara Crane, Jan Jones, Judy Province, Mary (Mare) Stephens, Karen Dillon, and Kim Griggs.

I'm also grateful to my publisher, Mascot Books, for making this a reality: Jess Cohn, acquisitions editor; Julia Steffy, production editor; Jennifer Schwartz, copyeditor and proofreader; and Caitlin Smith, cover designer whose spunky imagery won me over immediately.

And now for the most important acknowledgment of all, I want to thank my husband, to whom this book is dedicated, and who truly is the wind beneath my wings. I love you.

# READER'S GUIDE

1.  In the second paragraph of this book, the protagonist, Claire, looks out the airplane window and sees life imitating art. What do you think of that idea? Have you ever experienced a situation where reality appeared to transform into art?

2.  This story takes place in the 1980s. How is that time frame revealed in this book? Were you reminded of any of your own '80s experiences while reading? Did the book tell you anything about the '80s that you didn't already know?

3.  What was your first reaction to Turrell's skylight (Chapter 13)? Did your opinion change by the end of that chapter? Would you call the skylight art? Why or why not?

4.  Do you agree with Einstein's quotation, "Reality is merely an illusion, albeit a very persistent one"? Have you ever experienced reality as an illusion?

5.  Claire and Viv begin as strangers who appear to have little in common. But as different as they seem, they have quite a bit in common. What are their similarities?

6.  Viv offers a detailed interpretation of Giorgione's *The Tempest* (Chapter 14). Do you agree with her? If not, what do you think the work represents?

7.  Which of the four sculptures of David—Donatello's, Verrocchio's, Michelangelo's, or Bernini's—do you like best and why? Have you seen any of these works in person?

8.  Claire ruminates on different ways spouses are unfaithful to their wedding vows. Do you agree with her perception of how those breaches are viewed by society?

9.  How do the artworks from the story inspire Claire to stand up for herself? How does Viv inspire Claire?

10. Claire suggests reasons why she thinks women are usually the victims of emotional and psychological abuse. Do you agree with her reasoning?

11. What are the main themes of the story? Which one(s) resonated with you the most and why?

12. Which places in the book have you visited or would like to visit the most?

13. How much did you know about Western art history before reading this book? What new things did you discover?

14. What do you imagine happens to Claire after the book ends? What do you think her bliss will be?